HOW TO MAKE
Art for Joy's Sake

Also by Kristy Rice

The Art for Joy's Sake Journal: Watercolor Discovery and
Releasing Your Creative Spirit

Watercolor Cards: Illustrations by Kristy Rice

The Painter's Wedding: Inspired Celebrations
with an Artistic Edge

Watercoloring Books:
Kristy's Spring Cutting Garden
Kristy's Summer Cutting Garden
Kristy's Fall Cutting Garden
Kristy's Winter Cutting Garden

Painterly Days: The Flower Watercoloring Book for Adults
Painterly Days: The Woodland Watercoloring Book for Adults
Painterly Days: The Pattern Watercoloring Book for Adults

Painterly Days: Set of 12 Colored Pencils
Painterly Days: Set of 18 Watercolors

HOW TO MAKE
Art for Joy's Sake

FREE-SPIRITED
WATERCOLOR

Kristy Rice

Foreword by Amy Palmer

SCHIFFER
PUBLISHING

4880 Lower Valley Road · Atglen, PA 19310

Library of Congress Control Number: 2020943440

Designed by *Danielle D. Farmer*
Cover design by *Danielle D. Farmer*
Type set in Sweet Sans Pro / Brisa

ISBN: 978-0-7643-6151-7
Printed in China
6 5 4 3

Published by Schiffer Publishing, Ltd.
4880 Lower Valley Road
Atglen, PA 19310
Phone: (610) 593-1777; Fax: (610) 593-2002
E-mail: Info@schifferbooks.com
Web: www.schifferbooks.com

For our complete selection of fine books on this and related subjects, please visit our website at www.schifferbooks.com. You may also write for a free catalog.

Schiffer Publishing's titles are available at special discounts for bulk purchases for sales promotions or premiums. Special editions, including personalized covers, corporate imprints, and excerpts, can be created in large quantities for special needs. For more information, contact the publisher.

We are always looking for people to write books on new and related subjects. If you have an idea for a book, please contact us at proposals@schifferbooks.com.

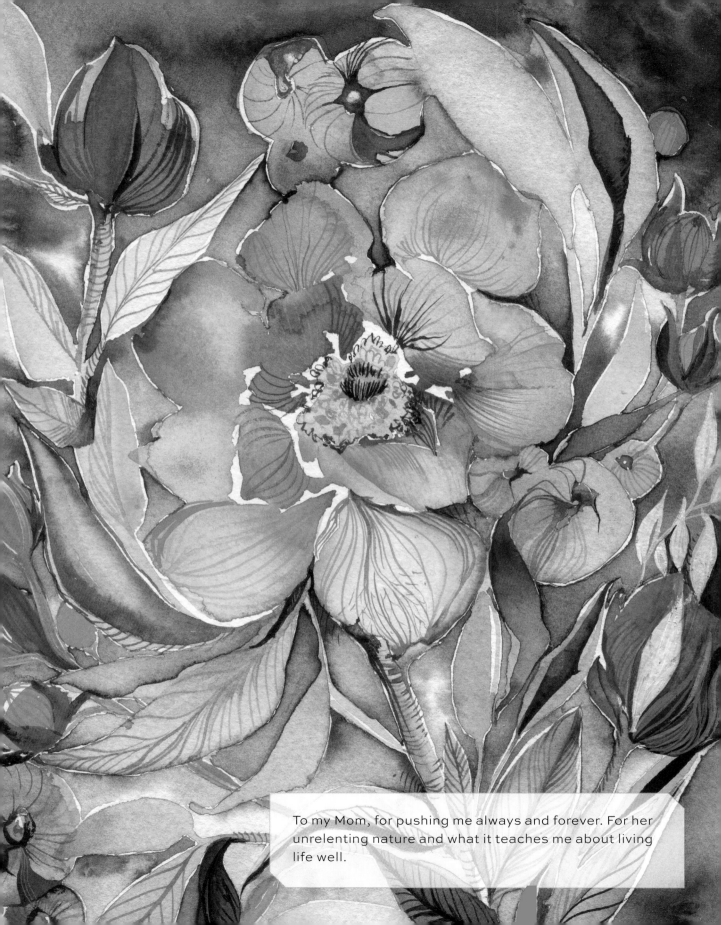

To my Mom, for pushing me always and forever. For her unrelenting nature and what it teaches me about living life well.

Contents

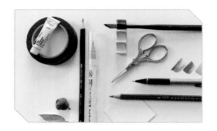

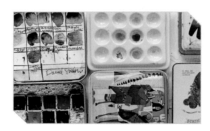

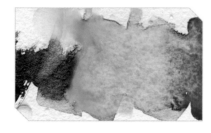

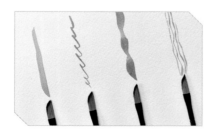

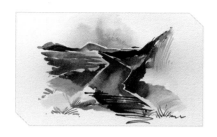
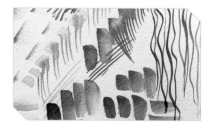

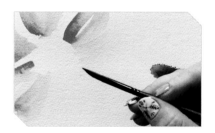

Foreword

If I've learned anything from being around Kristy Rice nearly all my life, it's that art is not just for people who go to art school or make a career out of it. I dabble in art, but I don't consider myself an artist. Yet, somehow, I feel like one when I'm with Kristy.

Fearless . . . this word pops into my head whenever I think of Kristy. So many titles (artist, author, my best friend) and so many adjectives (compassionate, reflective, gifted, inspired) apply, yet "fearless" captures a piece of Kristy that seems almost innate. In her case, being fearless doesn't mean reckless, careless, or inconsiderate. Kristy's brand of fearlessness flows within and fuels her passion for living a creatively full life, demanding that she follow her heart and her own intuition, rather than standards imposed by "experts," society, or people who simply like to make rules.

Kristy and I met in the midst of the full-fledged angsty, acne-ridden preteenage years. At different points, both of us experienced ridicule for everything from our clothes and body type to the way we spoke and carried ourselves. Often, I found myself trying to hide myself in the crowd. Not Kristy. From her bold hairstyles and brightly colored clothing to her tendency to voice unpopular opinions, she often had me questioning her sanity for inviting the criticism of others. At an early age, I found myself running interference, trying to protect her from others who disagreed or who were threatened by her sense of individuality. I didn't want anyone to hurt my friend. Eventually, though, I began to realize that Kristy doesn't make choices based on potential reactions from others. She didn't need defending. She was, is, and always has been motivated by the joy she finds in life, with all of its tricky emotions and messy experiences. And that joy, as she will tell you, is everywhere.

When we collaborate on projects like family cookbooks, home décor, or birthday parties for our children, Kristy and I view each one of these experiences as an artistic adventure because of the joy they bring in that moment. Kristy's adventures could be as large as designing stationery for a celebrity wedding or as small as hand-painting a lampshade for my daughter's nursery. In church, on the beach, in the middle of the desert . . . I can't tell you how many times I've been with Kristy and watched her whip out a sketchbook to capture a moment. The moment is what makes the art matter, not just the technique.

"Forget rules, forget right, remember joy." Kristy's mantra implores us to find joy within art by letting go of rules, expectations, and preconceived notions and really getting in there to embrace the outcome, wholeheartedly, in whatever form. Perhaps this is why Kristy prefers watercolors . . . a medium in which there are some tried-and-true techniques but many, many more happy accidents. Kristy, the trained artist, knows exactly how to blend that perfect succulent shade of green and expertly apply a dripping brush to a damp page, but she refuses to ever let her expertise overshadow that moment that water explodes with shades of color all across the page with much more excitement and wonder than even she could have imagined.

Art for Joy's Sake captures the experience, rather than simply the techniques, of watercolor painting. Sure, Kristy shows you how to do linework, how to mix colors, and how to paint wet on wet without putting a big hole in your paper. (Been there, done that!) Techniques are super helpful, especially when you are first learning.

But the more important lesson is so much more useful. We can all use a little art in our lives, no matter how much fear has been holding us back. I am grateful to my friend for always reminding me of that. Now, with an open heart, let Kristy show you how to harness your fear, embrace it, and let it go just before it overwhelms you . . . at that moment when technique gives way to freedom, when freedom leads to art, and when art meets joy.

Teacher, nonfamous painter, Kristy's best friend,

Amy Palmer

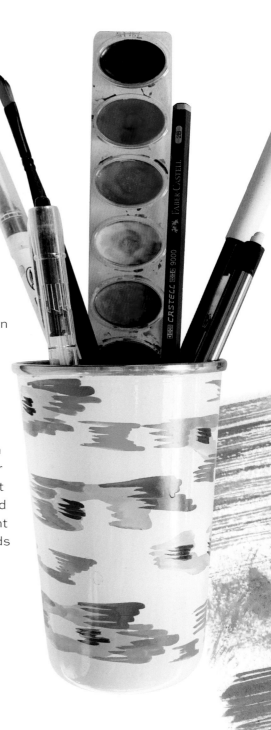

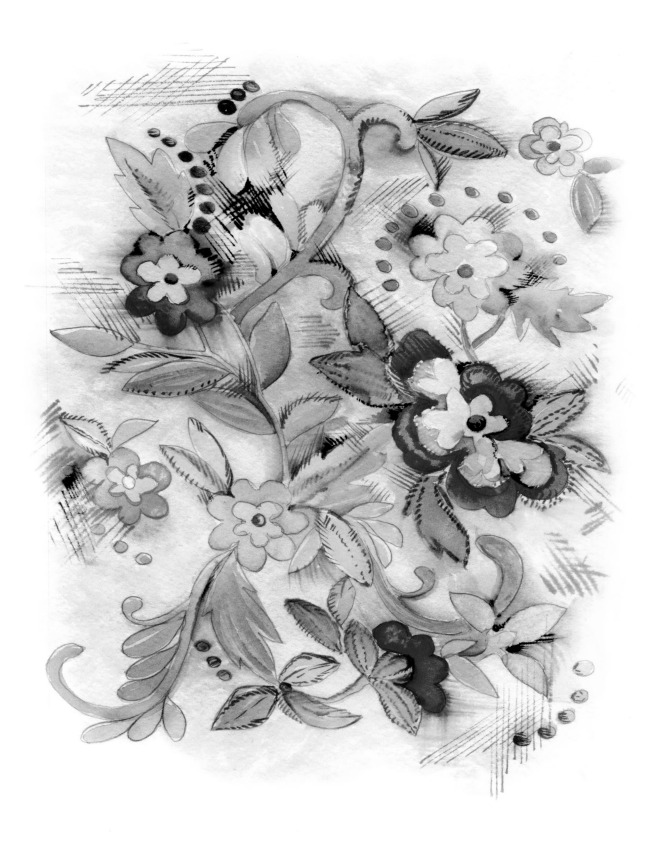

Introduction

She sat down on the short, clay-covered stool, spattered with the dried intentions of all the students who'd come before her. She was barely eight years old . . . eager, excitement mixed with a smidge of nervous. Up until then I'd been teaching retired women. I won't say they were old because there was nothing old about them. They had time and enthusiasm plus, unfortunately, a whole ton of fear under their belt when it came to trying something new.

And so I entered this lesson with this young girl. I expected a ton of questions, insatiable self-consciousness, and all the fear factors I'd experienced with my more mature students. But to my shock and awe, she sat, listened intently to minimal instruction, and watched a quick demo. Then she was off and running. She got in there, hands dirty, smile on her face, no questions asked, and within in a minute she was throwing a small cylindrical pot. A very symmetrical, skilled pot, I might add, and she'd had absolutely no experience with clay or even art for that matter.

A pattern was clear over the weeks of that summer as each new student young and not so young sat at my stool. Young artists felt a confidence in something new, because they'd never been told they should be scared. The adults were filled with self-consciousness at every turn.

So you're likely wondering why I'm telling this story. "How is pottery related to watercolor—come on, get on with it!" Fear, though, is a learned trait, my friends. Fear is built from years of making "mistakes," decades of feeling self-conscious or being told you're not good enough. By the time we reach adulthood, many of us have a sadly limited belief in our own possibility to be successful at all things new.

This story of the fearless young girl is your call to simply dive in. This is your time to leap into a seemingly scary new thing as if no self-deprecating thoughts existed. Pretend you're eight years old, with not a care, trying something new, with no one watching. I promise you that within minutes of touching that brush to paper, it won't feel nearly as terrifying.

Letter from the
AUTHOR

Calling this book a how-to is a bit uncomfortable for me. On one hand the words make complete sense, right? Of course, we're here to learn something new, but just as much as how-to seems right, the phrase for me is often anxiety inducing. You hear the words and instantly think, That's right, I don't know how to do _____. How-to can imply you are at a deficit and have so much to figure out and fail with. The phrase "how-to" doesn't quite capture our evolution as newness is absorbed, or what we bring to the experience before any learning begins. How-to is a very abrupt, specific delineation. You are here and know nothing; now follow all of these instructions and maybe you'll become proficient.

But hear this. You possess nearly everything, right at this moment, needed to find joy and satisfaction with watercolor. The foundation of "successful" is quite simply an honest curiosity. Anyone can learn techniques, how to hold a brush and mix a few colors. Listen to me: A N Y O N E. But finding joy along the way, amidst the paint smudges, ugly attempts, and awkward hands holding a brush—that takes a curious pursuit. And you, my friend, have all you need.

HOW TO USE THIS BOOK

This book is a beginning and not a means to an end. There is no end here, just beginnings. As you navigate the exercises and techniques, you'll notice my descriptions and instructions will evolve. Early in the book we'll go step by detailed step, but as we go along, my instruction will leave a bit more to the imagination. Your imagination.

As you delve deeper into the chapters, I'll encourage you to take each project in a more personal direction. My hope is that you'll confidently take more of the lead as we work together and feel free to change course rather than copy my direction exactly.

Let's call it a watercolor "choose your own adventure" book. Sound good? Okay, let's do this!

Prep

What you'll need to enjoy this book

1. ¼-inch dagger brush
2. Mechanical pencil
3. 2B pencil
4. White tube of watercolor
5. A few watercolor markers
6. A transfer pencil or watercolor pencil
7. Round and square templates
8. Watercolor paper
9. Watercolor palette

If I can teach you anything through these pages, it will be this. You are not here to compare your technique to another. You are not here to worship recipes for painting a perfect peony. You will paint a flower you love soon, I promise, but that isn't the endgame; heck, it isn't even the start or middle game. You are here to fall in love deeply with the joy that watercolor can give. But in order to fall in love with that feeling, you need to get out of your own way. You need to open yourself up to making a mess or making something ugly. Yes, you need to crave making some ugly.

If you're trying to do it "right", you're doing it wrong!

Art for Joy's Sake is made in the mess. Joy cannot come alive while striving for perfection. Joy doesn't sit comfortably in an overly critical environment. Joy flees while you're agonizing over which color or brush to use. Joy hovers just above the moment where water and pigment mingle and dance across the page in a way you couldn't have imagined. Joy surprises you when you're watching TV but randomly decide to pick up a pencil and sketch that pattern on your throw pillow. Joy is found at 2:00 a.m. when you can't remember how it all started and can't imagine stopping for anything, even sleep. Joy is knowing within a few brushstrokes that this painting is a big fat fail, but already feeling the drive to try again. You see, "doing it right" has nothing to do with joy. "Doing it right" is for someone else, somewhere else. Here it's just you and me and the page where you'll make a glorious mess finding your way through the muck and loving every minute of it.

Art for Joy's Sake is always ready. I love a good play on words, and being prepared to be in the moment is just that. Part oxymoron, part humor, but all about reminding you that we have to set ourselves up for success! We've covered materials already, so in this section we'll assume you know that paint, brushes, and water are essential.

You don't need much.
But this is my trifecta for an engaging painting experience:

1 A COMFY CHAIR

Find a chair you enjoy sitting in for more than five minutes. Seriously, a good chair that is supportive will entice you to sit and stay a while.

2 A GOOD VIEW

Natural light and something inspiring to see when you look up from the page are ideal. I much prefer to paint in daylight. Inside by a window is perfection for a more permanent setup. We'll talk more about mobile painting studios later!

3 A PRETTY SETUP

I know, I know, this isn't a decorating book, but a lovely space in which to create can be just as inspiring as what you're actually painting. Personally I'm simply not as motivated to paint if my space is cluttered with ugly stuff. You know what you find inspiring; pull it together. Take the time to create a lovely space you'll look forward to coming to again and again.

Be prepared to be in the moment

How to avoid distraction.

Art for Joy's Sake never fears a blank page. When you've painted long or often enough, you'll likely experience that phenomenon where time seems suspended. Your brain is so entirely and blissfully focused on a task that nothing else matters. Minutes fly by and you're almost in a trance. But friends, I'm here to tell you that in our modern world, this experience is becoming more and more elusive. We have entirely too many enticing distractions. Yes, we love to paint, we feel good when it's going well, we keep coming back, or we're just getting started and passionate to learn more. Regardless, though, so often, when the time comes, when the painting table is set and all is in place, distraction starts its games. There's something about the quiet of a blank page that encourages your thoughts to fly away to anything but painting. You're shaking your head in agreement right now, aren't you?

So how do we guard our precious painting time and protect it from the nothingness that these distractions produce? Here are my go-tos:

- Have someone hide your phone for a while.

- Don't feel ashamed of turning on the TV for the kiddos. Twenty minutes of your free time will do everyone wonders.

- Discover your trigger. When I sit to paint and am not feeling very focused, I know that the lure of distraction is inevitable. Soon the self-hating voice in my head starts babbling, and soon it feels like the empty page is mocking me. I swipe Instagram open and promise myself I'm just looking for an inspiration photo. Twenty minutes later the page is still empty, and I'm up tending to my son or making dinner. My trigger is Instagram. Your trigger, once engaged, is the end of painting time. Avoid your trigger.

- Keep notes. I use the notes app on my phone to keep track of painting ideas I'd like to try. Nothing invites distraction more than sitting down to paint with absolutely no idea in mind.

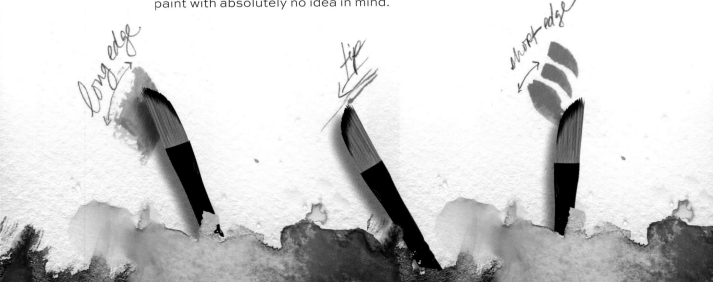

Art for Joy's Sake is a deep breath. I like to talk, and part of my work includes speaking engagements. Often I begin my workshops or talks with a simple breathing exercise. To some the practice feels odd, especially amidst a more stuffy conference vibe, but breathing—very mindful, focused breathing, anywhere, anytime—is always a good thing. Your cells start to wake up and you feel more awake instantly and, inexplicably, more clearheaded when you breathe deeply. Watercolor is like taking that first deep, deep breath. You put brush to paper and almost instantly feel a bit lighter, relieved, and encouraged. But the key to finding joy is maintaining the levity of those first few moments. You need to seek an experience that flourishes in the oxygenation of your creativity. Constantly fact-checking and second-guessing your every brushstroke will kill the high.

Materials

Dagger brush. We'll use one brush in this book—one, single brush. I know it sounds insane, but trust.

The dagger brush is . . .
incredibly versatile;
responsive, with springy bristles just like a super-expensive brush;
and everything you will need to create big, bold, delicate, and meticulous brushstrokes.

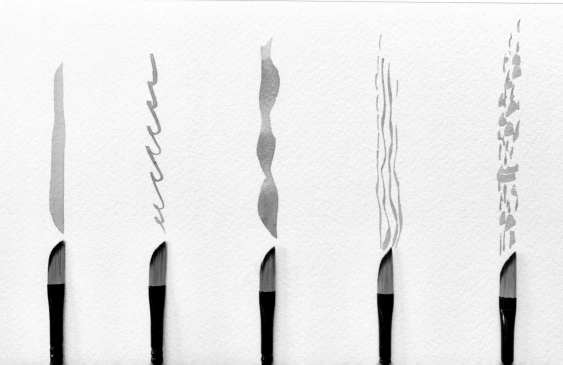

The best paper you can afford. For the last few years I've been teaching my son the very basics, using the Montessori method. Maria Montessori was a pioneer in young childhood education and encouraged a hands-on approach to learning. When it came to art, she believed providing kids with the very best materials possible was ideal. What would you rather use . . . a waxy and pigment-lacking crayon or a velvety and rich-with-pigment colored pencil? And so my approach to materials for beginners on the watercolor journey harks to the Montessori method. Arm yourself with the very best you can manage. By doing so, you avoid the many struggles that come from art supply deficiencies alone.

If you must choose between high-quality paint or paper, I always say paper! All day, every way, the best professional watercolor paper is a must-have and will make all the difference in your inaugural attempts with watercolor.

Two of my favorites:

1. Legion Paper Stonehenge cold press
2. Arches cold-press sheets cut to size

Making multiple palettes.

I'm a watercolor palette hoarder, but this isn't what I encourage you to do. Instead, I'd love for you to invest in a few amazing tubes of pigment. I recommend having a minimum of three palettes in your life. Each will contain the same pigments or not, up to you, but the point is to have these palettes stashed in places that will make painting—wherever, whenever—easy peasy.

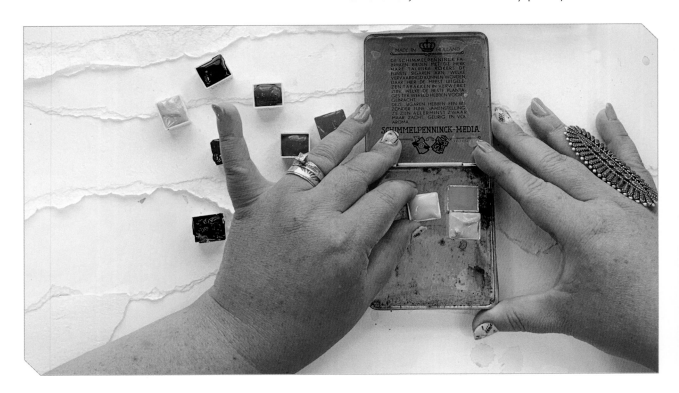

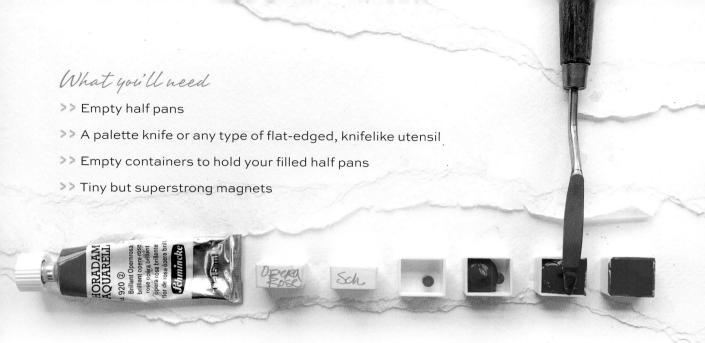

What you'll need

>> Empty half pans

>> A palette knife or any type of flat-edged, knifelike utensil

>> Empty containers to hold your filled half pans

>> Tiny but superstrong magnets

Label the half pan with permanent pen. Don't skip this step, or you'll never remember the name of the color soon to be in the pan! On one side, label the color name. On the opposite side, label the paint brand.

Place one small magnet inside.

Squeeze pigment into the pan. The ultimate goal is to level the paint with your knife, so don't overfill.

Tap the half pan on a hard surface to start leveling and to remove air bubbles. Add a bit more paint as needed, tap again, and finally level with a flat utensil.

Pans will be surface-cured in about five hours. Allow at least 24 hours before placing in your palette, closing its lid, or turning the completed palette on its side.

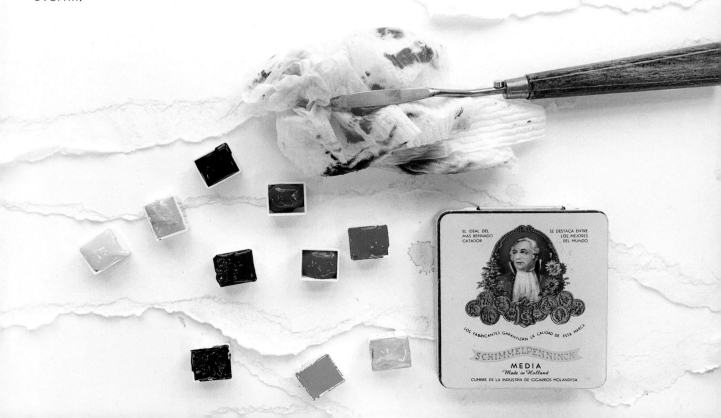

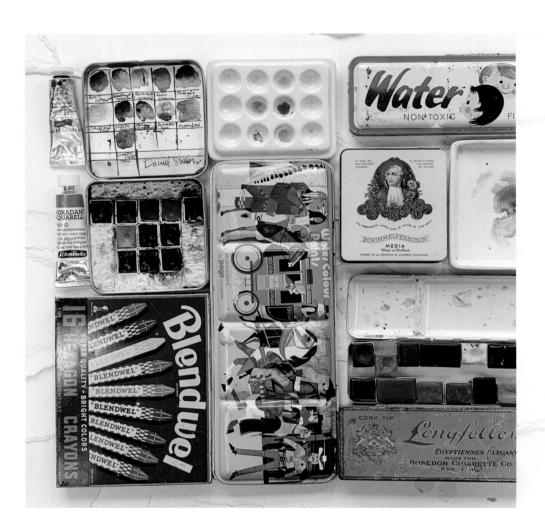

Art for Joy's Sake is a beautiful palette. Don't underestimate the power of a beautiful palette, and I'm not talking about the paints here! I've been collecting vintage tins for years. They are the perfect, most precious way to hold your newly filled half pans!

The $100 you'll never regret spending on paint.

If you've watched me teach on YouTube, you know that I rarely call out the exact name of pigments I'm using. Friends, this is by design because, quite simply, I don't want you to get hung up on the perfect palette or exact color you "should" be using. There are no "shoulds" when painting with me. Sure, I used Alizarin Crimson, but your pink and a touch of brown from the Crayola palette will do just fine in a pinch. Yes, I adore Cascade Green from Daniel Smith, but any old green of yours with a

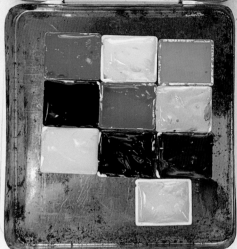

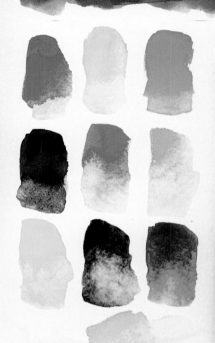

touch of blue flooded in will give a similar effect. It's all about getting something down on the page and feeling good about it. I can't have you lose your momentum and mojo during a killer painting session because you're searching for that perfect green that looks just like mine. No way. Your time is too precious, and the minutes you carve away for this painting passion should be all-in, messy-paint-on-the-page excitement, and nothing less.

Now, that being said, I do prefer professional-grade watercolor, and when I have a choice and they are at the ready, I will always choose them over a lesser quality. So if you are LOVING this watercolor adventure and want to invest in yourself, these are my absolute favorite pigments at the moment.

Below I've shared the specific brand and name of my favorites in addition to some notes about each color's personality and usefulness. You can expect these to last for an insanely long time, as such a little bit goes a very long way.

Winsor & Newton

Opera Rose
Nearly neon pink. You simply can't mix this color! Explodes like crazy!

Cobalt Turquoise
Velvety, sheer, joyful, soft teal green. Enlivens dull greens, explodes nicely on the page.

Cadmium Red
Sheer and clean. The classic red with endless saturation and explosive power!

Daniel Smith

Moonglow
This is a three-pigment blend whose true character reveals itself only when dry. You'll see hints of blue-green, red, and gray! This pigment is an experience!

Cascade Green
Similar to Moonglow, this beauty shows off countless shades of blue and green as it is brushed on and dries.

Buff Titanium
Somewhat opaque, super neutral. Buff lightens other pigments beautifully, shows off in linework like a pro, and looks earthy and sophisticated on its own.

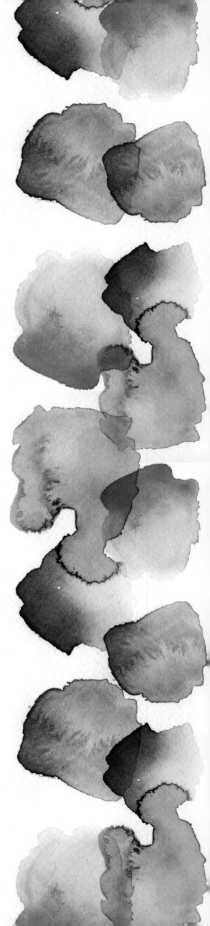

Payne's Blue Gray

This is just a really good dark blue. Killer on its own for contrast detailing or a great component when mixing my muddy color (see page 36).

Mission Gold

Shell Pink

Somewhat opaque and works a lot like the Buff described above, but it's pretty and pink!

Horizon Blue

This is always the first of the pigments to run out in my Mission Gold palette. It's sheer and clean, and I can add it to literally anything to produce a spirited lift of pigment.

Holbein

Jaune Brilliant

Somewhat opaque. This one is just a curious peach favorite that I use again and again. Mingles well with sheer watercolors and explodes like a boss!

QoR

Cadmium Yellow Medium

Sheer, extremely pigmented, and plays nicely with all brands.

ART FOR JOY'S SAKE IS THE MAGIC IN THE MUNDANE

A cup of magic.

I'm not sure whether it's a facet of my tendency to hoard art materials or just that I like to always be ready to paint and sketch, but nearly everywhere I sit at home or in my studio, there you'll find a cup of magic. So what is in my cup? My favorite dagger brush, a mechanical pencil, a 2B pencil, a random black pen, a crayon or two, a LePen, a sleeve of basic watercolors, a few half pans of favorite pigments . . . Some of my cups even have a bottle of liquid watercolor and white gel pen.

These are my favorites, my go-tos to ensure I'm always prepared to be in the moment—but please, whatever you do, don't run out and buy all the items I've listed. Take a walk around your home or office. Pick a few things that look useful and pop them in your cup. Start there.

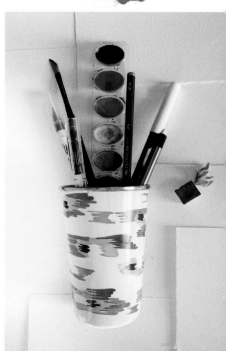

WOND

Art for Joy's Sake is about making art without feeling held back by fear. So yes, I want you to have a blast and just experiment, but at the same time there are a few essential techniques that once understood will allow you to really take flight. At this stage I do recommend practice. Messy, uninhibited practice where you get really comfortable with one brush, a few colors (I'm mostly using a pink, red, green, blue, and yellow here), your paper, water, and a paper towel or two. For now, focus on the essentials and dive deep. Learn to run before you fly with these twists on the classics.

Art for Joy's Sake

is water, wow, and wonder.

Wet on WET

Wet on wet is short for lots of water and however much color you desire dabbed onto the page. This precious technique, my friends, is the literal heart and soul of watercolor. Bursts, blends, spreading color, and all the movement that draws each of us to this magical medium is born from this simple technique. Wet on wet isn't just for backgrounds and large areas to cover. It will be used for petals, leaves, foregrounds of landscapes; anywhere you want that flowy, washy feel.

The wet-on-wet technique starts very simply, with a lot of water on the page. I like to have two water containers when I paint; one for clean water that's meant to stay clean all the time, and the other for rinsing your brush.

1 >> Start by applying a bunch of clean water on the page. You can dab it on, you can splash it on, or you can brush it on.

2 >> Then choose a color. Your brush should be quite wet and then pick up a lot of color from your palette. Now the fun starts. Just start dabbing your brush onto the page. You won't have to put much pressure at all because that color will just start to explode! If you're not seeing the color explode pretty wildly, you need more water on your paper.

3 >> Choose another color and then, same thing . . . dab the paint on and watch its color move. At this stage you can always add more water over top of an area that isn't painted yet, or you can add water into an area that already has color.

4 >> Choose a third color. I'm going with oranges, reds, and yellows, so that when things start to mix together on the page, I'm not going to get any muddy colors. So colors next to each other on the color wheel are good choices for this practice. Colors across from one another on the wheel will mix together to become a muddy, weird brown.

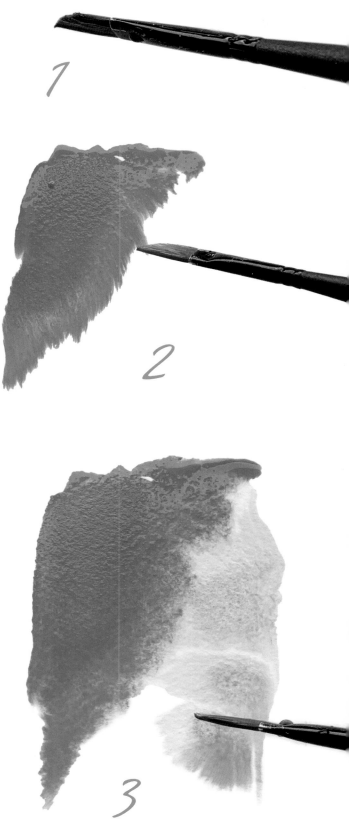

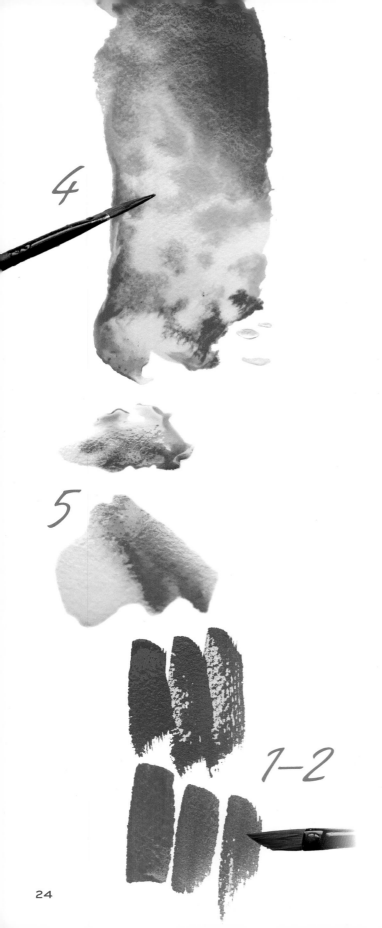

You'll start to notice as you keep dabbing on color that the water you initially laid down has time to dry, producing less intense explosions of color.

IF YOU THINK YOU'RE USING ENOUGH WATER, YOU'RE PROBABLY NOT.

5 >> This is a technique where more is better, almost always. Load that page up with water, get a brush loaded with juicy color, and start dabbing, stroking, and pushing the color around and onto the wet page with your brush. In the middle of it all, you might feel like things are wild enough . . . clean your brush and load it up with a lot of water and dab clean water into your already-begun page. Droplets will fall from the brush and splash into the color already there. And then you'll see the magic unfold.

Wet on DRY

1–2 >> Wet on dry is the slightly less wild sister of wet on wet. What you lose in splashy, juicy color on this one, you gain in interesting texture and over-the-top color saturation possibilities! Load your brush with a lot of pigment and just touches of water. Lay down some color on the dry page . . . How does it feel? . . . If you're not liking the tug of the brush on the dry paper, that dip your paint-filled brush in a touch more water.

3 >> To give you an idea of the different effects you can achieve with this technique, I've loaded one brush with a lot of juicy color, then painted a lazy rectangle and a few lines over and over. In between each, though, I dipped my paint-heavy brush into clean water. Notice how the intensity of color fades. Notice how the linear brushstrokes become less crisp but still defined. Dry paper will always give you clean, crisp brushstrokes, but

3

the amount of water and pigment on your brush will then afford you degrees of softness. So fun!

ART FOR JOY'S SAKE IS ONE REALLY INCREDIBLE BRUSH. .

4>> Now try it for yourself. Take a wet brush loaded up again with a bunch of juicy color. Don't be afraid to really dig into your palette and load up that brush. This technique is pretty straight-forward, since your page is dry but your brush is wet. Go ahead and start laying down color. You can use the broad side of your brush, or you can use the tip of your brush—it's totally up to you. But you're going to notice an immediate difference in that the pigment just stays where you add a stroke. It doesn't move around! Keep in mind as you work that the more pigment on your brush applied to a dry page, the more intensely colored the brushstroke will be.

Something you can do to get softer effects here is to dip your already paint-loaded brush into a bit of water and go back to the page and make some marks. You'll start to notice that the brushstrokes are a little more smooth. They're not picking up the paper texture like before. Pick another color and go back to the page again; you can see the pretty intense texture that happens with a wet brush full of color on a dry page.

Wet on DAMP

Okay, you caught me—I made this one up! But in all seriousness, this middle-ground technique that rests precariously between wet on wet and wet on dry can be your little secret just like it is mine. It's not one that gets paid much attention, but it is one that lights up your painting experience with the most magical effects.

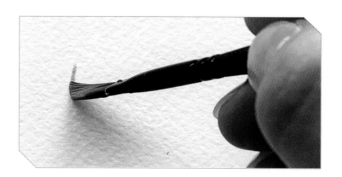

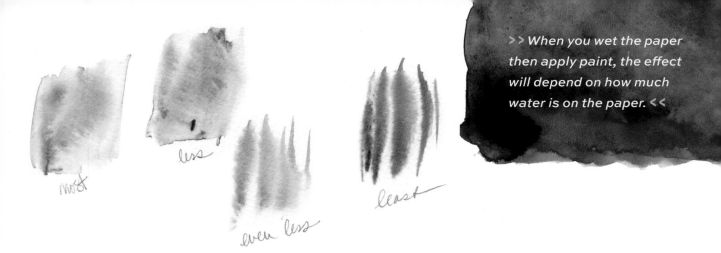

most

less

even less

least

Begin by wetting the page, but with restraint. Too much water here will make it hard for your paper to be just damp, and that's what we're after. You'll need to give this one a few tries, wet the page, wait to dry, brush on some color . . . ehh, it's too dry . . . wet the page again, don't wait quite

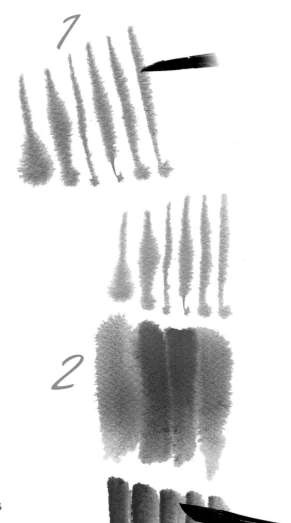

as long to dry . . . and so on. The idea is for your paper to be just wet enough that when pigment is applied, you get a subtle, soft, and barely there explosion of color, like a soft focus.

1 >> You can use linework on the damp page, lots of color on your brush applied with the broad side, or a very small, watered-down bit of color applied with the brush tip. The combinations are endless, really.

2 >> This technique might be my favorite. Start by wetting the page. You don't want the page soaked like with the wet-on-wet technique; you just want to get a nice, even coverage on the page, When you first apply the water, tilt the page to see how dry or wet the page is. When you don't have puddles of water or when you just see that the surface is damp, get ready and choose a color from your palette.

Again, the brush can be slightly wet and loaded up with lots of color. Now make a brushstroke and you're going to notice the color bleeding or exploding, but at a much-slower pace than with the wet-on-wet technique. Keep making a few brushstrokes. Pick another color and make some broad strokes.

If you're noticing that your page is completely dry, you may want to consider upgrading your watercolor paper. Even a midrange watercolor paper should have a reasonably slow dry time. Watercolor paper keeps the page wet for longer, so the artist has time to work with a wet page.

The Details

Now you're energized . . . right? Excited to put these techniques into action . . . yup, that's how you should feel. No fear here, right? But next comes the real fun. These techniques are derived from your core WOWD arsenal, but with interesting twists and intentions specific to your future painting passions. These techniques are the building blocks for painting flowers, mountains, fruits, and clouds. Please take some time to practice, play, and experience the wonder of these techniques. Practice can be joyful too; it doesn't have to be repetitive and boring. You might be wondering . . . Kristy, aren't we supposed to be having all the fun, playing around with paint without a care in the world? Yes! But a little practice never hurt anyone!

Art for Joy's Sake is practice making imperfect.

Flood

Force clean water into wet color and watch the movement! This technique is a version of wet on wet, but here I'm using water and my brush as leverage to push around color I've already put on the page. So first lay down some color like you would for wet-on-dry technique, then rinse your brush. Directly next to the color you just painted, dab in a lot of water. Rewet your brush and continue to dab, essentially forcing clean water into the painted area. Soon the clean water and paint will start to mingle and mix. Feel free to tilt the page to force a more extreme mingling of paint and water.

Dry Brush

This technique is an extreme version of wet on dry. You approach the dry page with a brush loaded with only enough paint to make a mark. The marks can vary in their intensity and coverage, depending on how much water + pigment is on the brush. Try the dry-brush technique with both the broad side and tip of your brush. Also try scrubbing the paint on while hold your brush perpendicular to the page. Apply pressure and movement, allowing the bristles to fan out as you work.

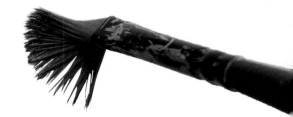

>> The dry-brush technique is key when painting tree leaves, pebbles, or leaf veins. <<

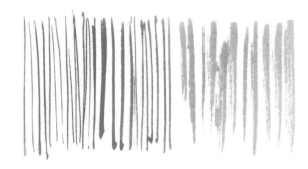

Linework

For this technique I typically use just the tip of my brush, but with very little pressure. Load up your brush with a lot of juicy color. Lightly begin making marks. Try to make similar, very thin lines side by side. Then try making thicker lines side by side. Add a bit more water or pigment to your brush as you feel fit. Then try your hand at curved marks, figure eights, and swooshes.

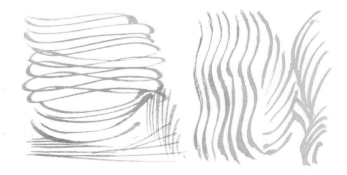

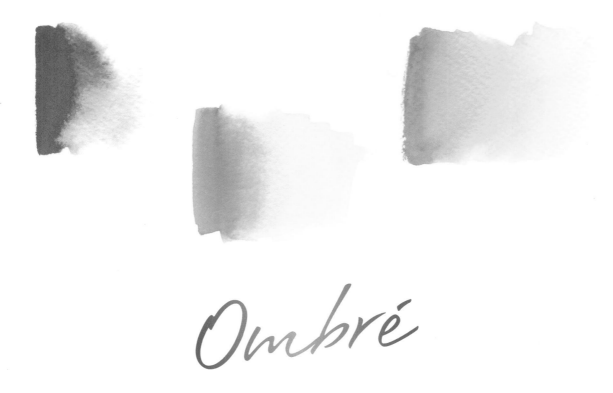

Ombré

This technique is a mindful hybrid of wet on wet and flooding. Be mindful, mostly because here the brushstrokes are slower, more tentative, and extremely deliberate. First you lay down some rich color, then you clean your brush and load it with clean water. Brush the water next to the rich color just painted. A bit of dabbing or swirling with a light touch will begin the water-and-pigment mingle. Clean your brush and reload it with clean water. Brush water onto the page again, just next to where you most recently painted. Continue until the color fades to nearly nothing.

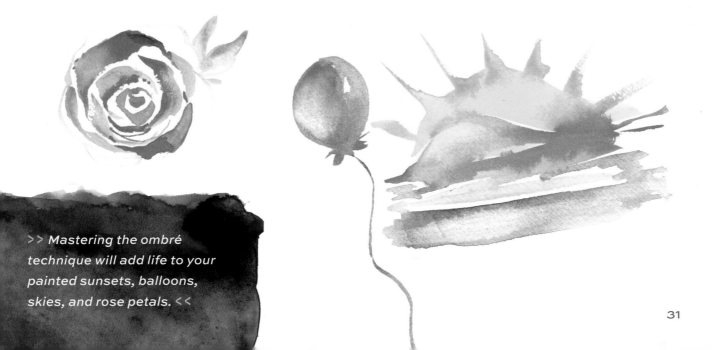

>> *Mastering the ombré technique will add life to your painted sunsets, balloons, skies, and rose petals.* <<

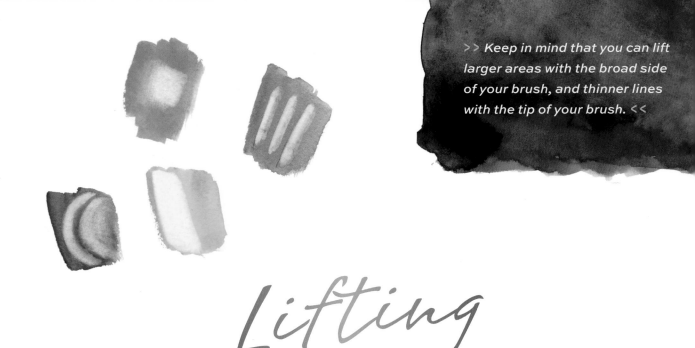

>> Keep in mind that you can lift larger areas with the broad side of your brush, and thinner lines with the tip of your brush. <<

Lifting

Feeling like some areas you've painted so far are too heavy? You CAN remove dried paint or "lift" it from the page! Using a clean brush loaded with clean water, scrub the area of the painting you wish to lighten. As you scrub lightly with the short side of your brush, blot on a paper towel, rinse, and reload the brush with clean water. Continue this process until you have the level of lift you're after. If things don't look as smooth on the page after the lifting, add a drop of clean water to the area, and watch the natural smoothing happen! Be sure to use very little pressure, since a rough scrub could eventually damage your paper.

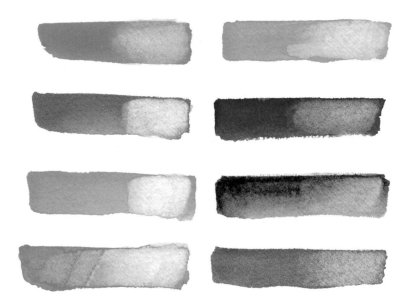

Contrast Detailing

This is the depth maker, the drama technique! Contrast detailing can be used in any painting situation imaginable. Wildlife, landscapes, flowers and leaves, and on and on. Start by painting a single flower petal.

LET'S TRY THIS TECHNIQUE BY PAINTING A SIMPLE BLOOM.

1–2 >> Paint a light wash of pigment over the entire petal.

3 >> Rinse your brush. Load the very tip of your brush with a contrasting color, meaning, in this case, a brighter or darker pink compared to the first wash painted on the petal. While the petal is still wet, start to touch the very tip of the brush to the wet edge of the petal. Use very light pressure.

 The idea is to delicately outline parts of the petal with this contrasting color. I would avoid a total outline here, but you do you. Rinse and dry the brush and go back to the wet petal to dab and lightly blend the area where the contrasting line meets the wet petal.

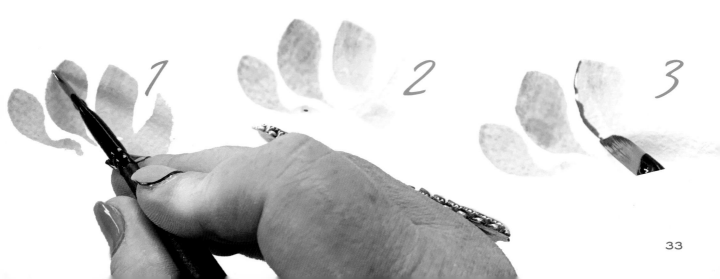

4 >> Soon the outline will bleed into the petal and take on the look of a pretty shading effect.

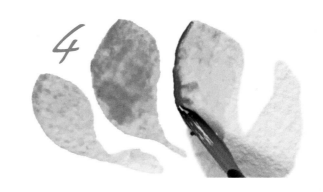

5 >> The more water you use in the first wash, the more obvious mingling of water and pigment you'll get when adding the contrasting detail later on.

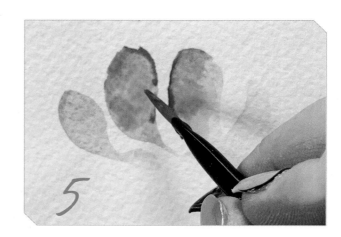

6 >> If your petal is dry by the time you start to add the contrasting brushstrokes, you can add another clean-water wash to the petal before continuing.

>> Spatter is messy, so think about the surfaces nearby. Use scrap paper to cover areas you want to keep clean during the process. <<

Spatter

Spatter can be a boring painting's saving grace. It can be magic when organic texture is needed. Spatter added early in a painting can keep you motivated and energized! Start with two brushes. Use your dagger brush and whatever other brush you have; even a pencil will do. Load your dagger brush with juicy color, lots of water, lots of pigment. Gently tap the loaded brush against the other brush or pencil while hovering over the area you wish the spatter to land on.

ART FOR JOY'S SAKE IS PAINT-SPLATTERED CLOTHES

The Muddy Color

It's rare that I use black watercolor. So rare. What feels a bit lacking with straight-up black is a certain richness. So when I'm after a super-dark, intense color, I most often mix up what I call "muddy" color. The process of mixing this color is nearly as fun as painting with its magic. Throughout these pages, I'll ask you to mix a muddy color, and now you'll know exactly how to get it done!

Take a sampling from your palette. A bit of green, yellow, red, purple, blue, and even pink. Start mixing. Soon you'll have a deep-gray color appear before your eyes.

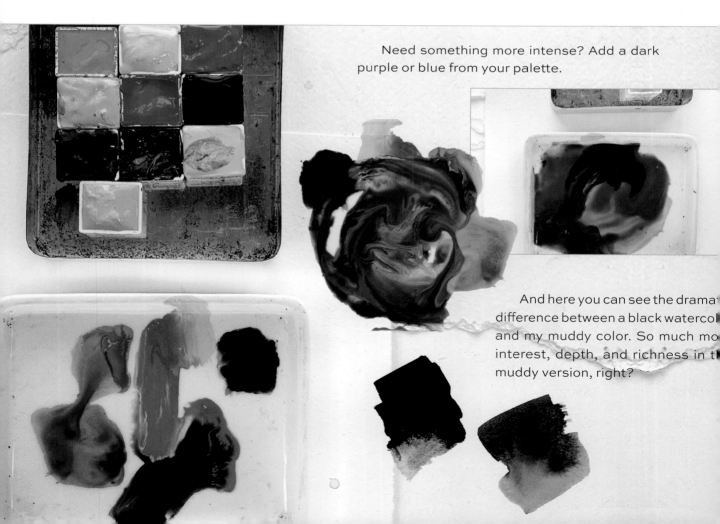

Need something more intense? Add a dark purple or blue from your palette.

And here you can see the drama difference between a black watercol and my muddy color. So much mo interest, depth, and richness in t muddy version, right?

Forget Rules
Forget Right

Rules:

How, when, and why to break them.

We're not supposed to be overt pleasure-seekers in just about every aspect of life. We're taught to get enough sleep, eat the right foods, drink enough water, keep a tidy home. These rules of life leave so many of us looking for rules to follow in all aspects of our existence. Not here, folks. We learn the basics and then we have a blast. We do whatever it is in the moment of splashing paint that makes us feel good and motivated to keep going.

Art for Joy's Sake is breaking the rules.

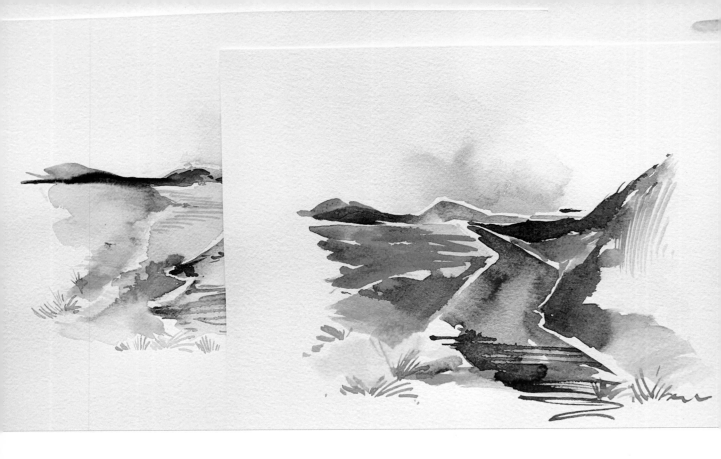

Rule #1—

Light colors first. River scene.

ART FOR JOY'S SAKE IS COULD, NOT SHOULD

We're going to paint a simple river scene two times, using an inspiration photo. First I'm going to go by the rules of watercolor, which dictate that we paint the lightest colors first, building up to dark and bold. Afterward I'm going to break all those rules and paint a version my way. You don't always need to break the rules, but I simply want you to know that you can when you want to.

1 >> Starting with a bit of blue on my brush and a lot of water, paint kind of an off-center zigzag shape to represent the river. The river will be very thin at the top and wider at the bottom. This will create the perspective needed for this to be a convincing scene. Use the wet on dry technique.

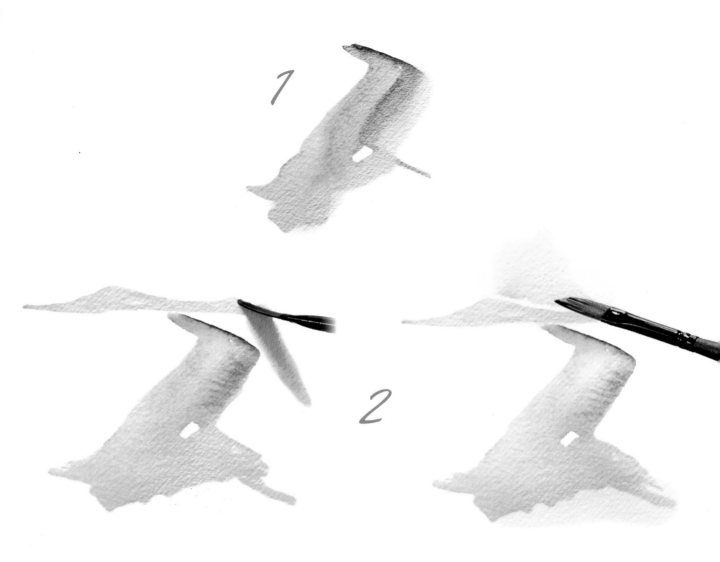

1

2

2 >> Choose a soft peach to paint the horizon line. Add a bit of green, but again, keep all the colors really soft and light.

Now add a touch of soft yellow in the sky. Starting with light colors first allows time to build up color intensity and detail slowly with greater planning. Continue using wet on dry here.

3 >> Now add more intense color. Using the tip of the brush, paint more color and moments of contrasting detail here and there.

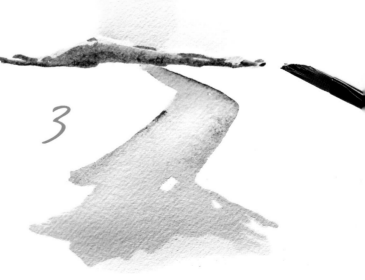

3

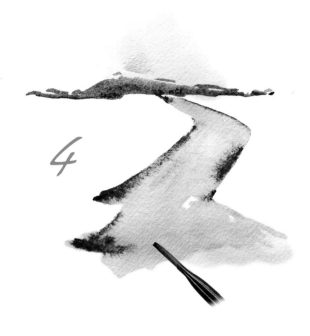

4 >> Go back into the water and accent there with intense areas of blue. Continue to layer in light to dark.

5 >> Add soft greens on either side of the river. Start light and gradually build up intensity.

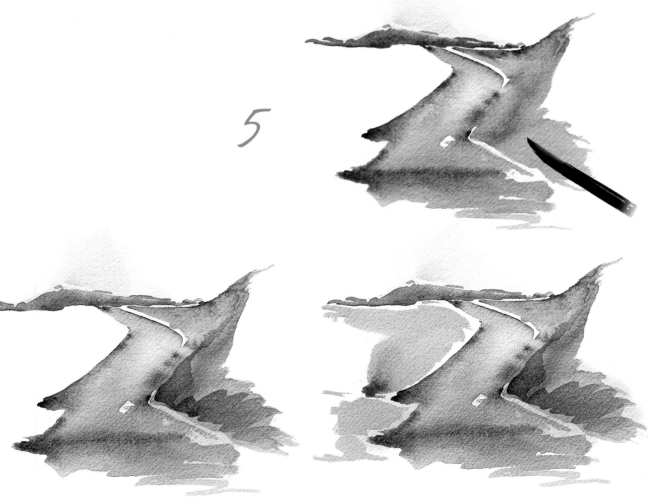

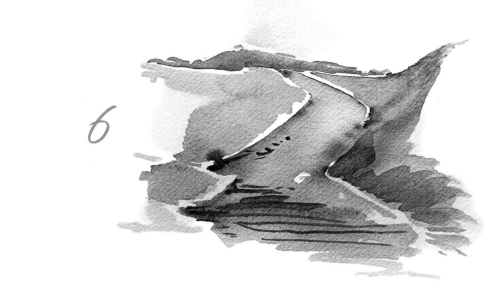

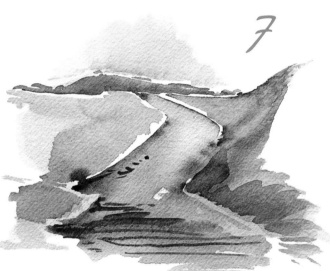

6 >> I began adding detail in the river only near the end of the painting.

7 >> As you continue in your painting, add increasingly more intense color and more detail. For this exercise the buildup from light to dark should be more gradual; you should be restraining yourself a bit.

8 >> You're probably feeling and thinking, "I want to get in these colors, these details!!" But according to the rules, take your time and add color and detail slowly, and only when you have a good solid foundation of light washes painted first.

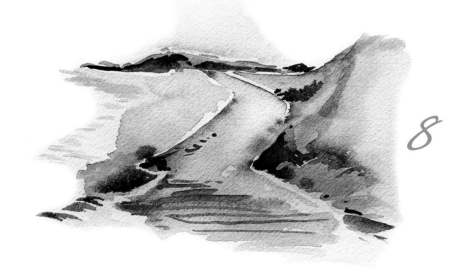

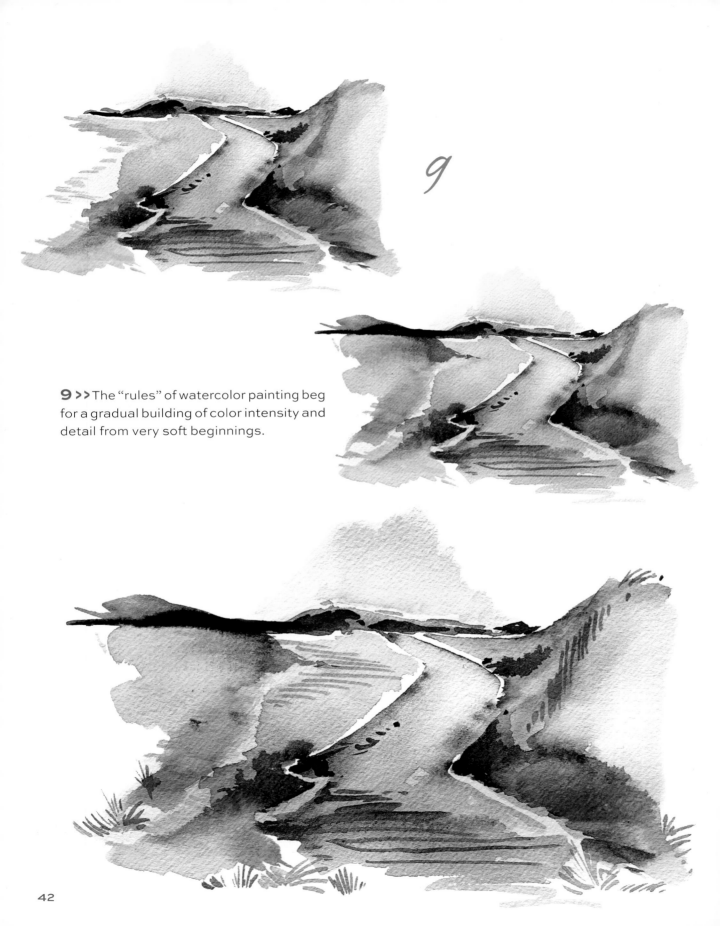

9

9 >> The "rules" of watercolor painting beg for a gradual building of color intensity and detail from very soft beginnings.

Now let's re-create the scene, but this time we'll use our joyful instincts to determine what color to use and when. Let's cast off the rule here and dive right in with strong color!

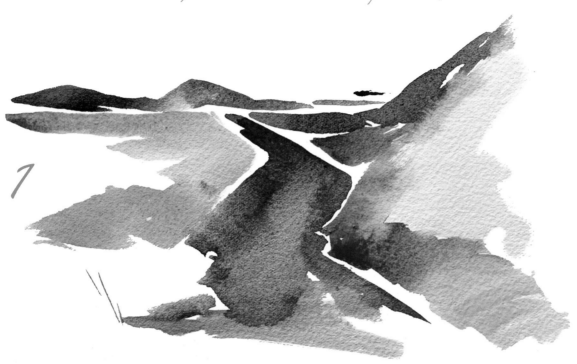

1 >> Using the short side of your brush and a bit of purple, start at the horizon by adding few mountainous marks. Rinse your brush and continue with various shades of green on the right side. Using broad strokes, add in a suggestion of tall hills here. Don't be afraid to go bold and intense with color right away.

2 >> Use wet on dry initially, but soon you'll add more intense color into the wet areas: wet on wet.

Continue adding bold green on the left side. Dive right in with boldness, detail, and color intensity.

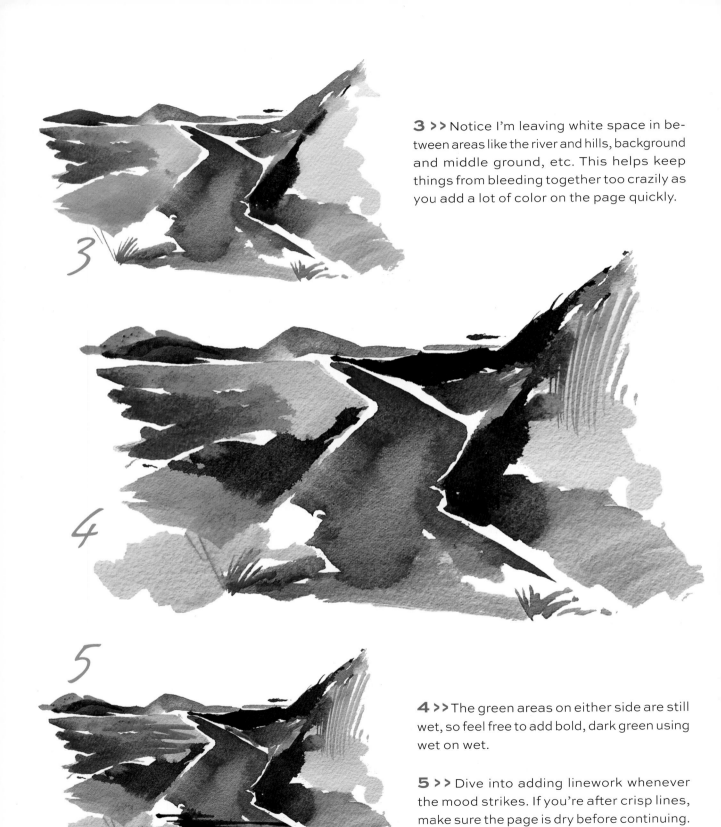

3 >> Notice I'm leaving white space in between areas like the river and hills, background and middle ground, etc. This helps keep things from bleeding together too crazily as you add a lot of color on the page quickly.

4 >> The green areas on either side are still wet, so feel free to add bold, dark green using wet on wet.

5 >> Dive into adding linework whenever the mood strikes. If you're after crisp lines, make sure the page is dry before continuing.

6 >> Add a simple wet-on-dry suggestion of sky with a bit of yellow orange, using the short side of your brush and upward strokes.

7 >> Come back with a water-loaded clean brush to smooth and blend your sky.

Add some expressive linework with the tip of your brush to suggest grasses in the foreground.

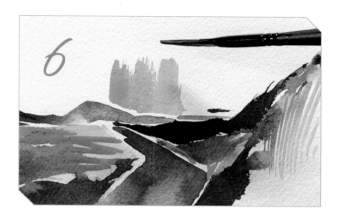

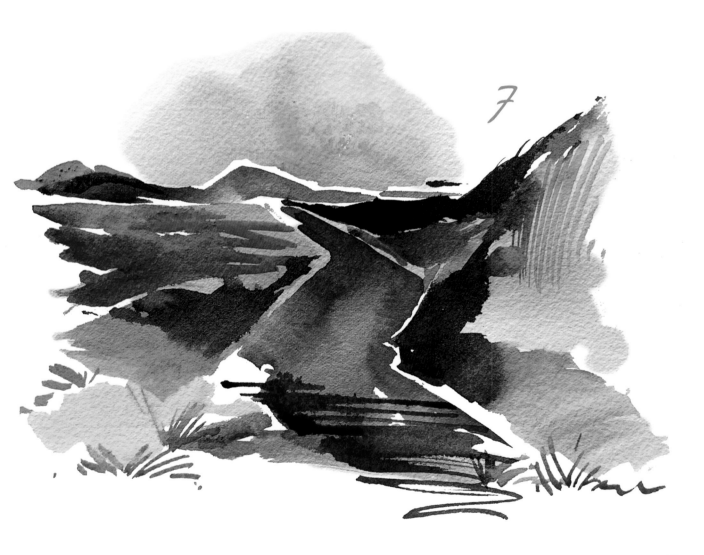

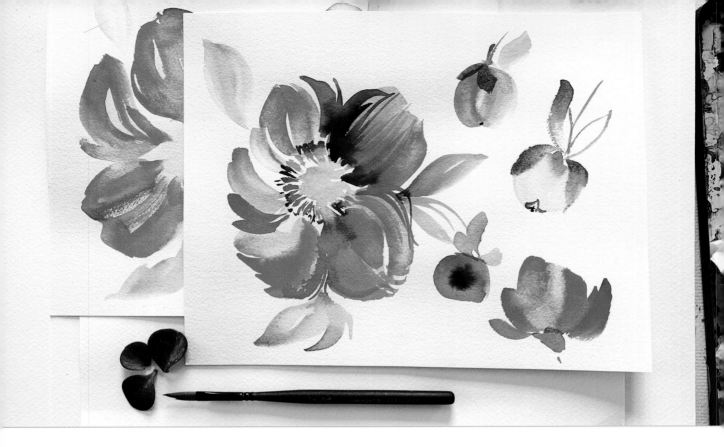

Rule #2—

Big washes first. Floral composition.

Another hard-and-fast rule I'd like to dispel is about only starting your painting with big washes all over the page. I was taught from an early age that starting with big, light washes of color was the best way to map your composition confidently. Well, this is a wonderful way to begin a painting, but it definitely isn't the only way in painting. Rules aside, I believe we should paint in a way that satisfies and maintains our creative momentum. And many years ago I started breaking the "painting rules" to keep myself motivated to keep painting!

So let's start by following the rules. I'm going to paint a flower composition, working from my imagination. If you feel more comfortable working from a photo that you love, then go for it. Starting with your favorite pink, load lots of water and a bit of color onto the brush.

1 >> Let's start with a peony-like flower, rather large on the page. Using the long edge of your brush, press down and paint a wide petal. You may need to paint two strokes side by side. Continue painting petals, but pressing on the brush as you paint and lifting up. Peony petals are often large, wide, and floppy, so be sure to add a few drooping petals. The rule of light washes first also goes hand in hand with keeping your eye and your brush moving around the page at all times, so as not to get stuck in one area for too long.

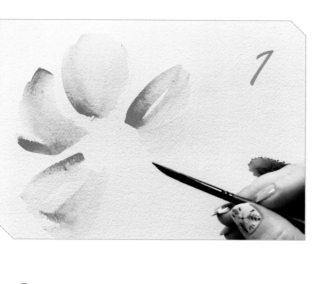

2 >> Now add a few buds. Paint a quarter-size lazy pink circle. Rinse your brush and reload with a favorite green. Add a few dots of green on the edge of the pink bud. The idea here is also to work quickly.

3 >> Continue working throughout the composition, adding leaves, buds, and petals by using light washes.

4 >> Now start to use a bit more color intensity and detail throughout.

You could continue this painting, slowly adding more color intensity and detail. But watch on the next page how to get the intensity and wow factor quickly by breaking the rules!

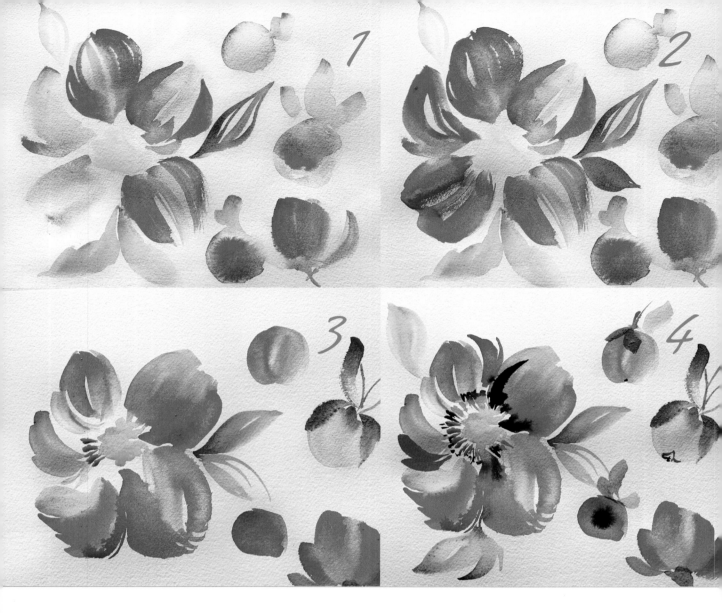

Let's re-create the same painting, but by ignoring the rules adhered to in the first one. We'll simply paint with as much detail and as much color as desired.

What you'll notice most when examining the two paintings is that my second approach gives more detail and wow factor in the same amount of time it took to paint the first. If I had continued on with the first painting, slowly building up more detail and continuing to paint bigger washes around the whole page and slowly adding in stronger color and detail, the result would be a much more realistic painting. My second painting, however, fed my immediate need to see progress and personality quickly.

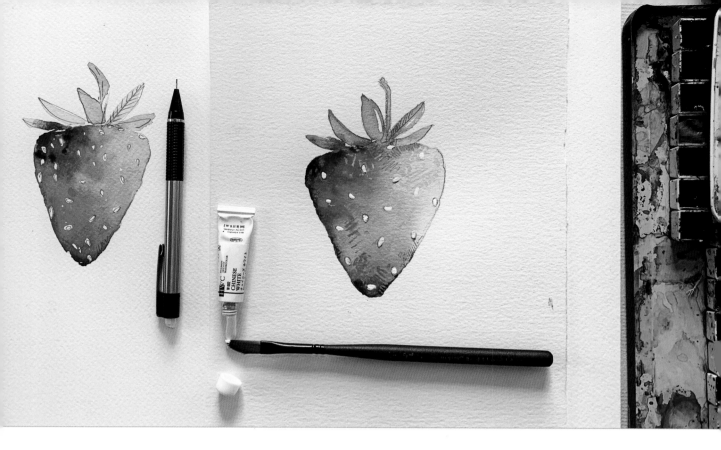

Rule #3—

Never use white. Strawberries.

Preserving your whites is a long-standing watercolor tradition, or rule, if you will. Purist watercolorists avoid white paint of any kind at all costs. So let's test the theory and practice here.

1 >> We'll start by sketching a simple strawberry. Make this beauty larger than life so you have room to move here. Strawberries are similar in shape to acorns, so use that understanding to feed your sketch. As your pencil moves, wiggle a bit to make sure the fruit's edge is a bit uneven. Add a stem and a few leaves. Then let's sketch in the strawberry seeds. As we paint this version, it's important to preserve the white of our seeds.

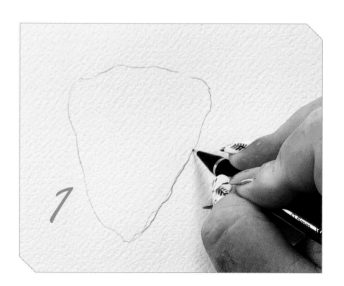

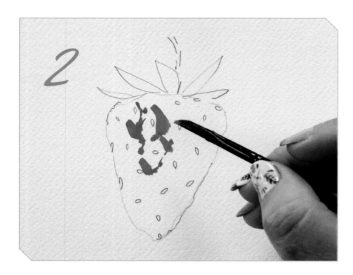

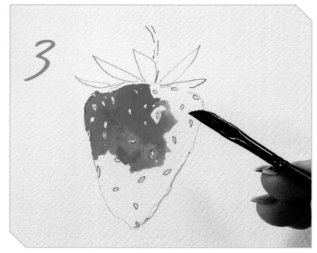

2 >> Load your brush with a bright red. Using wet on dry plus the tip and short side of the brush, dab in color.

3 >> Quickly rinse your brush and start spreading this color throughout the strawberry using a wet brush.

4 >> Now load your brush with a darker red and dab in areas to suggest shadows. Be careful NOT to paint over the seeds. Leave these completely white.

5 >> Finish painting the strawberry. Add additional colors, some pink or touches of yellow and green even. Add greens to the leaves and stem.

6–7 >> Now repeat all steps above, but purposely paint over the strawberry seeds. We'll be adding them back in later with white watercolor. Once your strawberry is completely dry, moisten your brush slightly. With the very tip, dip directly into a tube of white watercolor. This will give you a very saturated white versus pulling from a cured pan of white watercolor. Add your seeds!

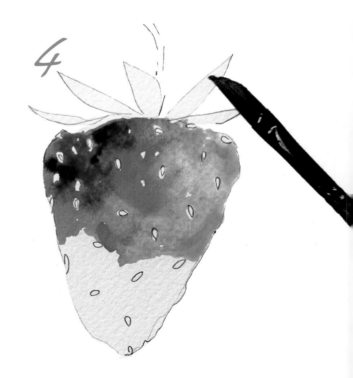

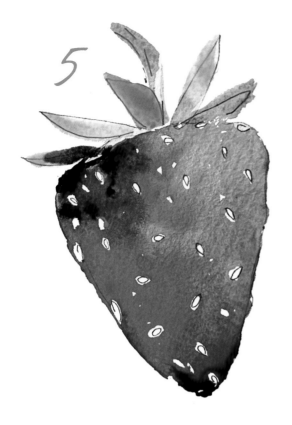

5

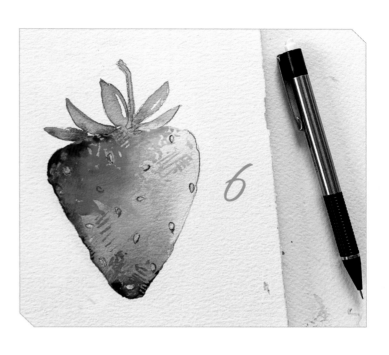

6

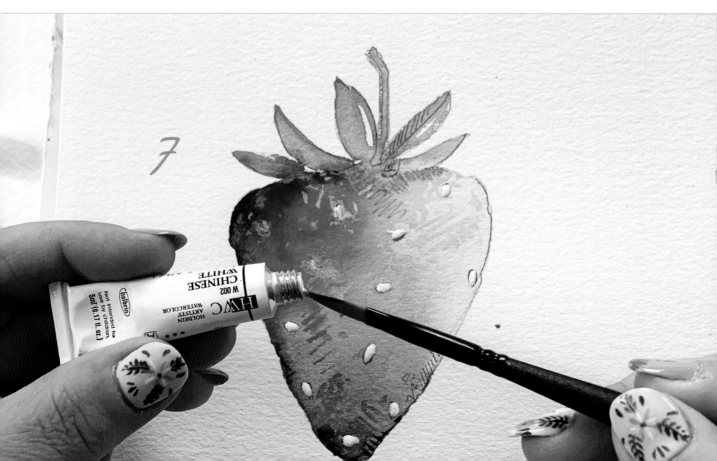

7

Rule #4—
Use only professional, best-quality paints.
Sennelier vs. Crayola.

What I'm about to share isn't technique based. I'm here to dispel a myth about watercolor palettes. If I told you that Crayola watercolors were worth your time, you'd never believe me. But start believing. And so I've decided to paint identical compositions, one with a Crayola palette and one with a Sennelier palette.

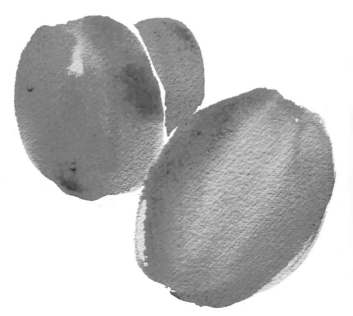

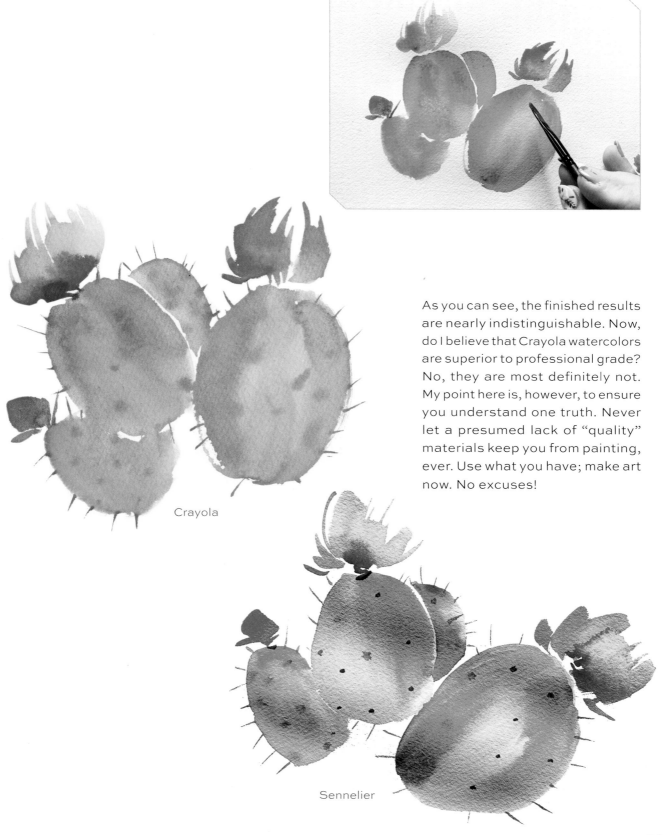

As you can see, the finished results are nearly indistinguishable. Now, do I believe that Crayola watercolors are superior to professional grade? No, they are most definitely not. My point here is, however, to ensure you understand one truth. Never let a presumed lack of "quality" materials keep you from painting, ever. Use what you have; make art now. No excuses!

Crayola

Sennelier

BEST PRACTICES FOR A JOYFUL PAINTING EXPERIENCE.

All the water

You can almost never use too much water in watercolor painting. Seriously. When folks come to me with issues, not enough water on the page is nine times out of ten the problem.

Stand up / Sit down

Get away from your painting! If all of the sudden your face is almost touching the paper and fingers are cramping from too tight a grip on the brush, it's time to take a break. Nothing kills a painting session like hyper focus or boredom. So take breaks!

On hand and in place

Readiness is the #1 roadblock to painting on a regular basis. We're creatures of habit and ease. We often take the path of least resistance, especially in our downtime. Set yourself up for success by having painting supplies conveniently stashed and ready to go!

Remember Joy

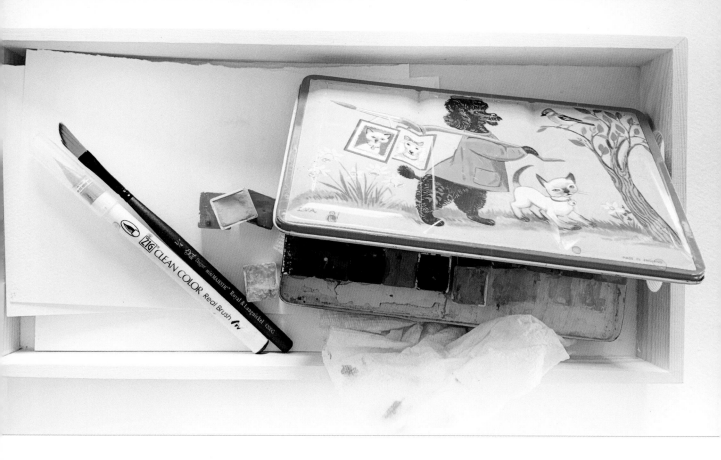

The Mobile Studio

If you're never ready, you'll never get to where you're going. **Art for Joy's Sake is ready to go.** Yes and amen! Half the creative battles we experience have to do only with not having what you need at the ready. And so in my home you will find art supplies tucked, literally everywhere. Pretty glasses full of colorful pens. Watercolor notebooks tucked in between books I'm reading, watercolor markers in drawers, pencils and scrap paper on the kitchen table. I even stash a palette and notebook in my car. I literally have no excuse for not creating art. It surrounds me.

I realize you may not want to go to my extremes, but anyone can create this small tray of art-making treasures. Store this tray where you are often when the art-making should-haves/could-haves happen. For me, it's by my favorite chair in our living room. Let a well-placed treasure trove of art supplies be just the motivation you need to forgo a night of Netflix bingeing!

ART FOR JOY'S SAKE IS READY TO GO.

Exercises

A little exercise never hurt anyone.

I think it's important for me to say here that as we dive into more technical aspects of watercolor painting, your passion for joyful painting shouldn't be overshadowed. I'm here to teach you some simple basics in a curious way that you've probably never been taught before. Let's think about it this way. These techniques are a launchpad. Here you'll gain strength and confidence for liftoff.

Creating a Linework Chart

As you work through these exercises, don't get too lost in the minutia of learning the technique. Don't get lost in the search of the perfect brushstroke or choosing the best color. So as you work through this part of the book, I want you to hover just above it all. Keep your joy buoyant and inspired. Let that initial drive that pushed you to open this book in the first place remain the most important as you work through this book.

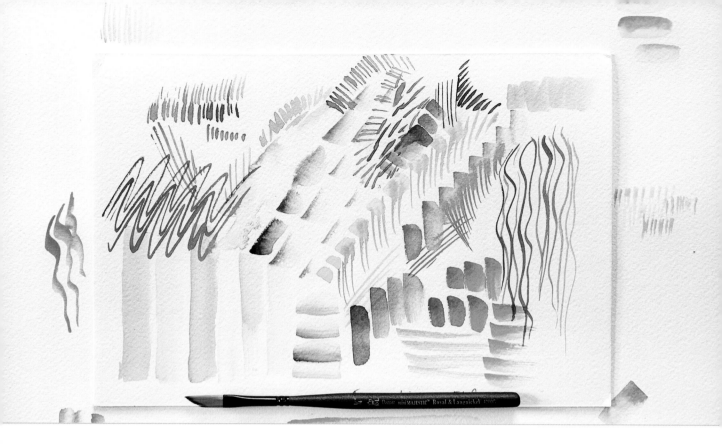

Brush Handling

Linework is a simple term for creating thin, linear marks on the page. You'll get a delicate thin line if you use very little pressure on the brush. You'll get a thicker line if you use more pressure. For this exercise, we're going to eventually fill a page with various lines.

This linework chart is meant to help you understand how varying amounts of pigment and water on a dry or damp page can affect the look and feel of your brushstroke. I definitely encourage you to create your own pigment line work chart.

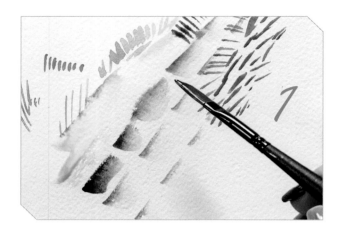

1 >> To start filling the page, you really just want to think about how you're holding your brush, how much pressure you are adding to the brush, and how much water versus pigment you have on your brush. This pattern isn't necessarily meant to be anything you would ever hang on the wall. It's just meant to be fun, freeing, and explorative.

2 >> Pay attention to the angle that you're holding your brush in context of the paper lying flat on your table. As you paint your lines, think about making the most variety on this page. It's not just about filling the page but about variety of brushstrokes. This is a training exercise to get comfortable with and aware of just how much this one magical brush can do for you.

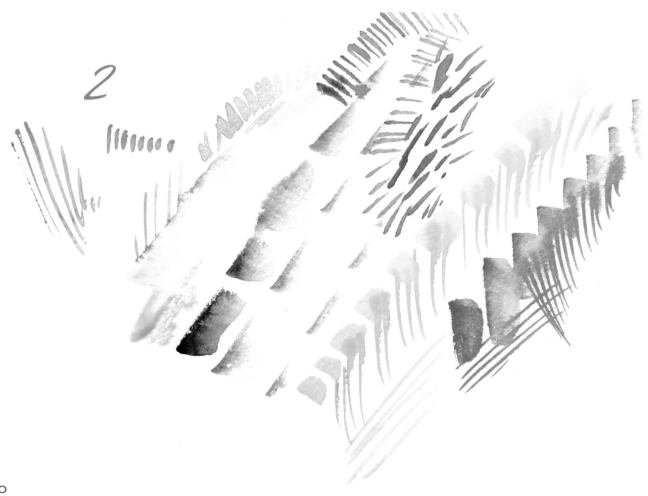

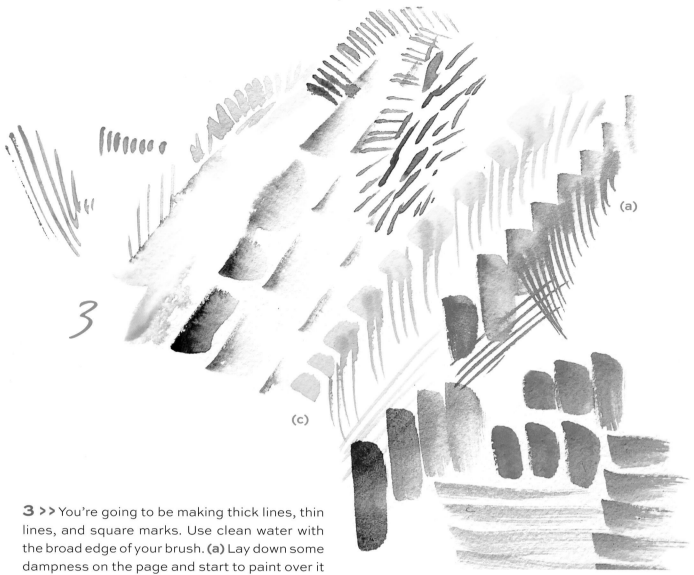

3 >> You're going to be making thick lines, thin lines, and square marks. Use clean water with the broad edge of your brush. **(a)** Lay down some dampness on the page and start to paint over it with a variety of lines. See what happens as you proceed, but try to avoid making anything recognizable. Feel free to paint over areas where you just laid down color, and see how the lines interact with one another.

4 >> **(b)** Experiment with making vertical and horizontal marks. Try to make thin lines very close to one another again and again and again without touching. What a challenge! **(c)** Using the short side of your brush, trying to make vertical lines next to one another with a touch of white space in between, it's a bit more difficult than it sounds. Same goes for horizontal lines . . . make these lines without moving your page but only adjusting the angle of your hand and brush.

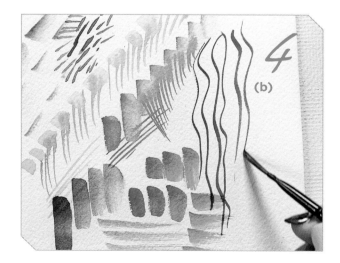

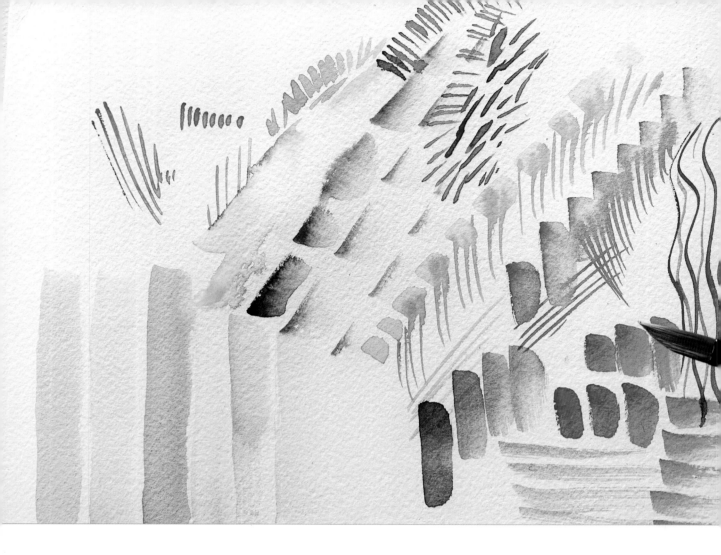

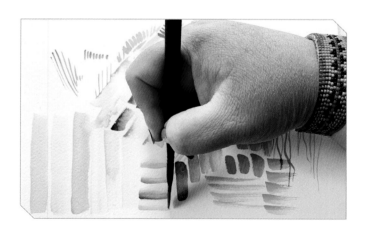

Linework is so integral to what you'll do with watercolor. It's a way to add movement and interesting textures. Linework can help you develop a signature style, depending on exactly how you place the mark on the page. Linework can also be a creative reverie when you're feeling uninspired or going through a dry spell with your painting journey. Take time to just sit down with the brush, palette, and paper to repeat this exercise. It can be a great way to come back to yourself, to reenergize yourself.

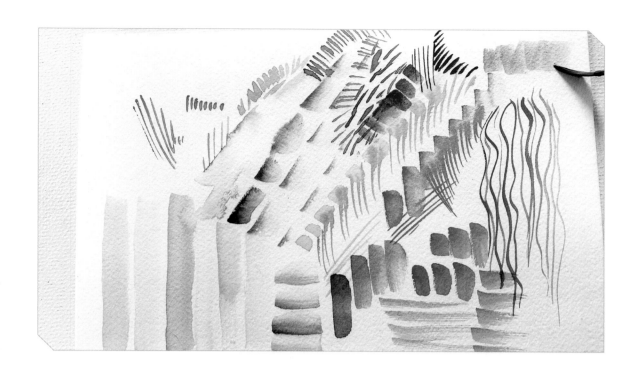

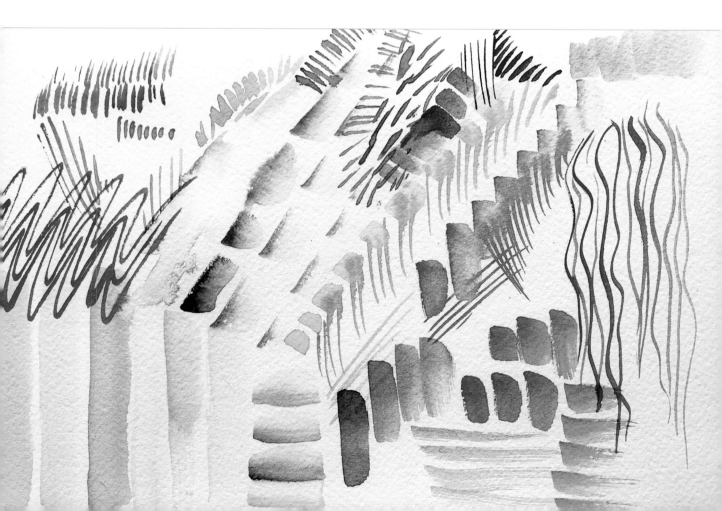

Muscle Memory

Muscle memory is another way of saying exercise. So to build muscle memory in your hand, you need to exercise your hand. A great way to do that is to paint the same element over and over and over again. And so that's what we'll do here. You can decide what elements to paint again and again. Choose something you don't tire of easily . . . for me, it's flowers, leaves, and berries.

Building muscle memory is also more about the brushstroke itself rather than the technique. So in this exercise, we're really just repeating a brushstroke or a collection of brushstrokes again and again to attempt to produce the same result repeatedly. Repetition will train the muscles in your hand, sharpen your eye-hand coordination, and make painting feel increasingly natural every time you sit down to paint.

As you work, take notice of how your element is changing. I started with leaves, and I can definitely see how the leaves have changed in shape and angle as I painted, despite my best attempts to keep them identical. Create another row of the same element and try to get a more consistent result.

>> *If you really like to challenge yourself, add a second color to each element that you're painting. Continue to add additional details with added colors in order to make your muscle memory exercise even more challenging.* <<

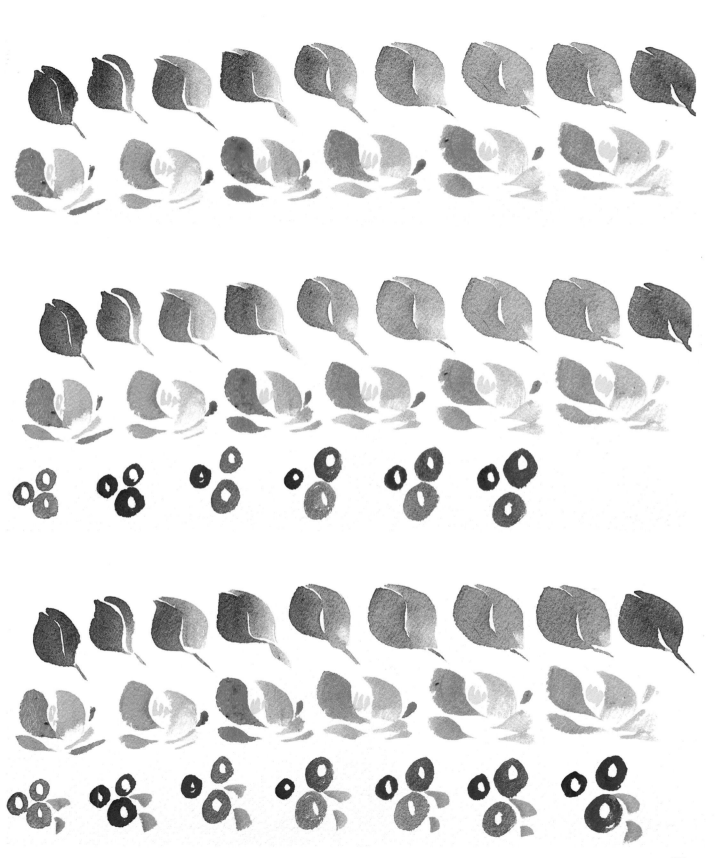

65

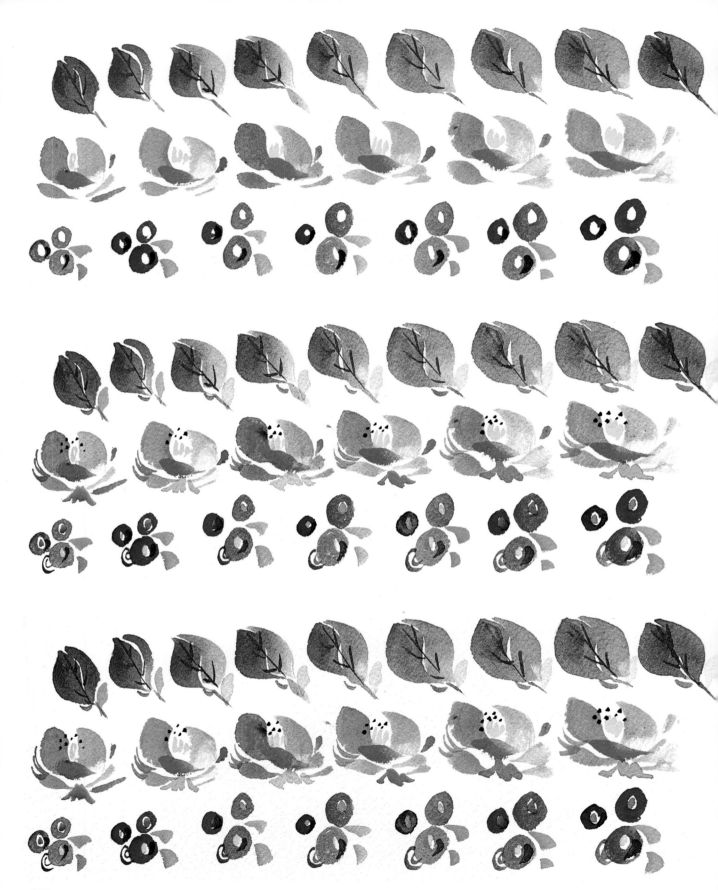

66

Color Mixing or Not!

I am not a huge fan of mixing colors obsessively on a palette. Letting colors mingle with water on the page and allowing the mixing to happen without much force is, for me, more often than not, the way to go. Don't get me wrong; there are many times and many places where mixing on a palette makes sense, but learning to let yourself go and enjoy the freedom of less color mixing and more painting, simply put, can be quite the freeing experience.

1 >> So let's get warmed up a bit now. Start with a wet, clean brush. Load your brush with a yellow paint, start at one end of the paper, and make a few marks about 2 inches long.

2–3

2 >> Clean your brush and load with a new color. Important: Don't think about what color comes next. Choose whatever comes to mind. Repeat this step again and again, creating a trail of color over the page.

3 >> Simply lay marks down next to one another. Don't force them to mix; just let them mingle naturally. As you work, watch and absorb what is happening. Discover interesting mixtures of color on the page.

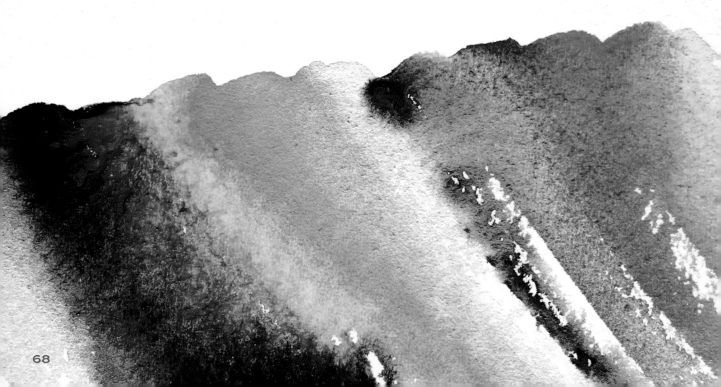

The Circles

The circle exercise is another great way to learn how colors can blend on the page with little more than a bit of gravity and water.

1 >> Start by tracing smallish circles on a piece of watercolor paper; use anything you have on hand as a template. I'd recommend the circle being no smaller than 2 inches and no larger than 4 inches. Fill the page with circles or just begin with three to five. Whatever makes you comfortable. Start thinking ahead of time what colors you may want to use. I would choose three or four colors that you love most.

2 >> With a very clean brush and clean water, start painting water into the circles. Paint one or two circles at a time, and don't feel like you must add a water layer to every single circle.

ART FOR JOY'S SAKE IS KNOWING WHAT COLORS MAKE YOU HAPPY.

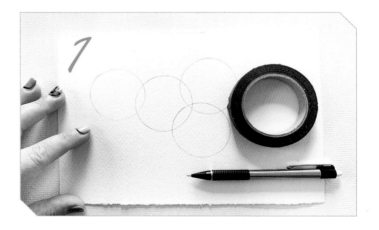

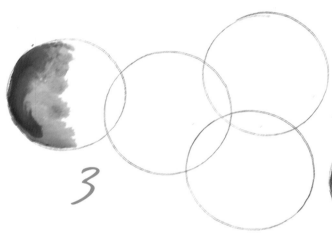

3 >> While wet on wet is an exciting way to fill the circles, wet on dry or damp can be invigorating too! Now choose your first color. Start to dab the color into the wet page.

4 >> Choose another color, and dab nearby the first color. Rinse and load up your brush with clean water and dab some clean water between the two colors. Watch the mixing naturally unfold.

5 >> Continue filling circles with the WOWD technique, and try not to get addicted to seeing the colors come alive!

You may start to see color mixing or combinations that you're not loving so much. Don't stress about it! This is just an exercise; you can always start again!

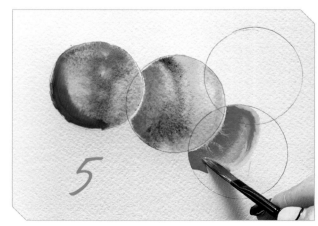

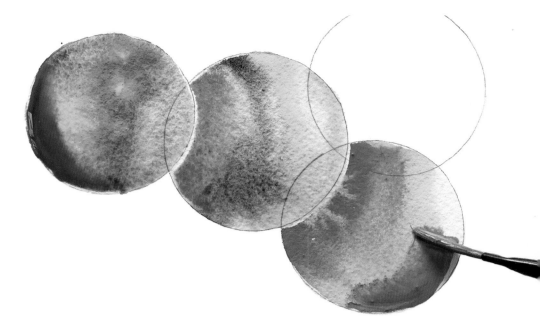

Consider trying a wet-on-dry technique for one or two of your circles. See how this technique changes the way that the colors mix together. Consider that you might have to add more water in between.

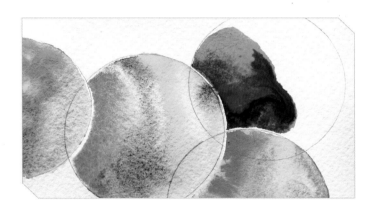

You will most certainly have to take more care to stay inside the lines of your circle, but most importantly, notice how the colors are mixing and mingling together almost effortlessly on their own. Think about how you can use this technique when painting a flower or a mountainous landscape. Think about how you can rely less on a palette and more on the natural way the colors want to combine themselves.

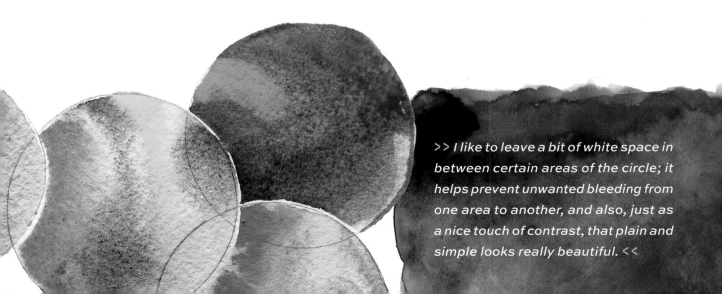

>> I like to leave a bit of white space in between certain areas of the circle; it helps prevent unwanted bleeding from one area to another, and also, just as a nice touch of contrast, that plain and simple looks really beautiful. <<

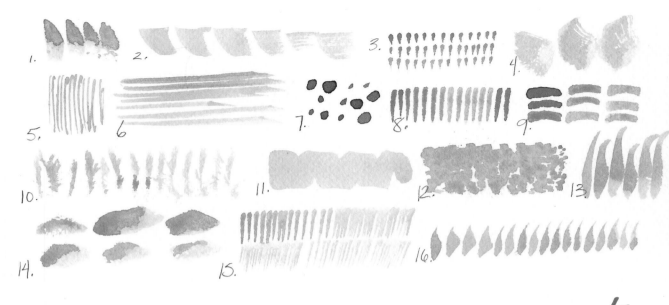

Texture Development

There are countless ways to makeh this dagger brush. Mastering all of the many techniques isn't really necessary, but knowing the capacity of your brush is. Being willing to experiment just for fun, with various angles, pressures, and amounts of paint of the brush, is where it's at!

I'm taking you on a deep dive here into the specifics of creating each brushstroke pictured. Now, please stay loose. Don't get nervous and filled with worry about making these marks perfectly! Sink it to the process, yes; obsess and fuss, no!

1 >> Holding your brush between your thumb and index finger, hovering parallel above the page, make slow and steady marks next to one another. Make sure your brush is loaded with a good saturation of color and plenty of water.

2 >> Hold your brush in a horizontal direction. Using the short edge of the brush, drag and press lightly for about a half inch. Lift up, leave a little space, and then repeat. This can become a great dry-brush technique if you don't have as much water and pigment on your brush.

3 >> Holding your brush perpendicular to the page, start dabbing. You'll be using just the brush's tip plus a little more. Depending on the pressure, you will get a longer or shorter mark.

4 >> Again holding the brush nearly perpendicular to the page, press down and let the bristles fan out. Pulse the brush a few times, lifting up straight as you go. Repeat. You may have to wiggle the brush a bit to get the bristles to fan out farther.

5 >> Using just the tip of your brush, make vertical lines by using very little pressure, one right next to another. The amount of pressure used here is key to creating a very delicate line.

6 >> Holding your brush vertically, drag the tip with a good amount of pressure across the page. Continue to make the same mark underneath until you have your desired texture. Again, as with this technique and all the others, the more wet your brush is when painting, the more full and voluminous your brushstrokes will be. When the brush is drier, you will see a lot more texture in the finished mark.

>> Make sure to reload your brush in between exercises. <<

7 >> Load up your brush with a tremendous amount of water and pigment, almost to the point of dripping. Repeat this in between each stroke. With the very tip of your brush, touch the page to paint very dimensional and wet water droplets on the page. Ultimately the droplets will dry to produce a very interesting texture.

8 >> Holding your brush at an angle to the page and using the short edge of the brush, press down and lift up straight to make vertical marks side by side.

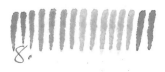

9 >> Repeat steps in number 8. Instead, though, hold the brush horizontal. Before you lift up after the first stroke, drag down just a bit. Feel free to reload your brush at any time or see what happens when you let the pigment run out.

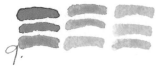

10 >> Hold the brush perpendicular to the page and just bounce the brush off the page in a bit more haphazard fashion; this action should be quick and bouncy.

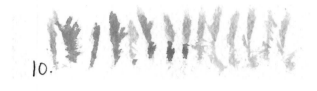

11 >> Using the short edge of the brush, press down on the page and, without lifting off the page, make a snakelike curve for as long as you'd like. Try to keep even pressure as you move, being careful not to lift off the page and interrupt your brushstroke.

12 >> Using the tip of your brush, bounce up and down on the page's surface. Don't go easy on the paper! If your brush is holding more water, the texture will be a lot softer. If your brush is quite dry, the texture will be more detailed and scratchy in appearance.

13 >> Using the tip of your brush, start at the bottom of your stroke and lift upward and let go. Your stroke will resemble elongated flames. Repeat.

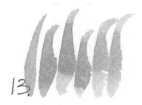

14 >> Holding your brush horizontal and using the long edge, press down on the paper with some pressure. Wiggle and lift up quickly. Repeat as necessary: wiggle, lift up, wiggle, lift up.

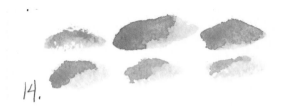

15 >> Holding your brush at a slight angle to the page and using the short edge, press down and bounce along the page, creating marks right next to one another with just a bit of space in between. Make some of the marks far apart; make some of the marks very close together. Let the paint start to run out and see how it changes your mark. In some areas you'll almost be dragging your brush very slightly, which creates an incredible continuous texture.

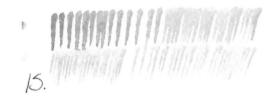

16 >> Holding your brush at an angle, put some pressure on the short edge of your brush and lift up while keeping the brush angled. Varying the pressure as you hold the brush at this angle will change the type of mark you make. The shape and color saturation will vary also.

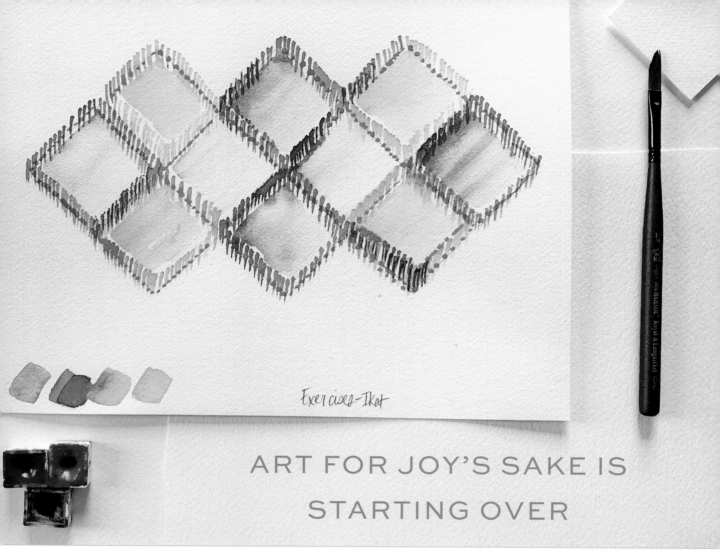

Exercises-Ikat

ART FOR JOY'S SAKE IS STARTING OVER

Ikat Pattern

Let's put these brushstrokes to use and create an ikat pattern! I like to have some sense of symmetry as I work, so I would recommend creating a template to trace a variety of diamonds on your page. You certainly don't have to fill up the entire page though. Remember that these painting experiences are always designed to be joyful. And let's be honest; if the project is too long and too laborious, you're probably going to lose interest, right? :-)

So fill the whole page, half page, quarter page . . . however much you have the gumption for?!

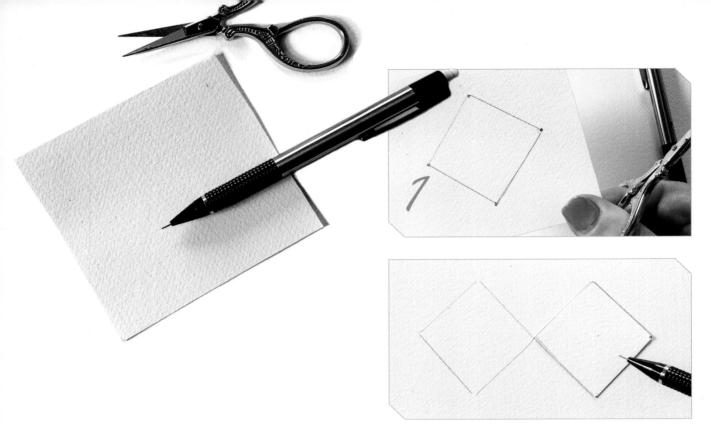

1 >> Start by cutting a square template out of a scrap of watercolor paper. Draw a pattern.

2 >> You'll be making marks similar to texture 15 on the chart earlier in this book. Hold your brush at an angle, using the short side, and just dab along the pencil edges in the color of your choice. The marks you're making should be about a quarter of an inch tall. Don't stress too much about making the marks equidistant from one another; it's really okay if they aren't perfectly spaced. Unevenly spaced marks here are more interesting. I even enjoy it when the marks overlap each other in certain places. Variety really is the spice here. You'll likely need to reload your brush a few times or maybe even once per diamond, depending on how much texture you want (wet brush = less texture; dry brush = more texture). Feel free to switch up your color at any point. These marks should not be labored over; they should be quick and spontaneous—your brush should essentially be bouncing along the page.

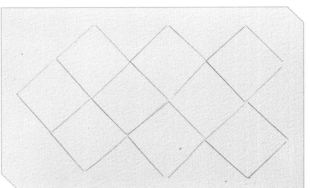

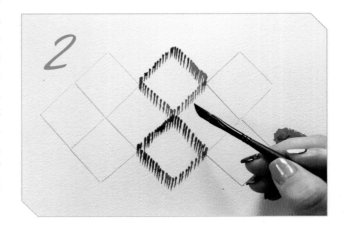

3 >> Next, load your brush with a 40/60 ratio of pigment to water, so more water than pigment. Using the broad side of your brush and moderate pressure (brush should fan just slightly), create three-plus strokes to fill each diamond. Be totally okay with the fact that some of your original color will start to bleed a bit.

4 >> If choosing a color palette has you stressed . . . you're just not sure how they will ultimately look together? Okay, then—make a swatch sample in the corner of the paper you're working on. Just paint a small square of each color you've chosen next to one another. This will give you a great opportunity to see how the colors you plan on using work with one another.

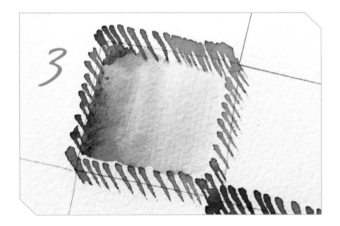

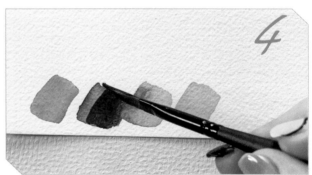

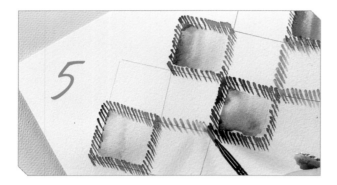

5 >> Continue making vertical marks along your diamond template. Feel free to change the thickness of the lines with added pressure.

6 >> For those of you who really don't like to see pencil lines, there are many different ways to cover up pencil. Simple dots painted close to one another are an easy option.

7 >> Next, choose a color that is a darker shade of one you've used before in this pattern. Using the same technique to create your original diamonds, add some shadow here, there, and throughout. Don't overuse the shadow but add touches in certain places that feel right, to add a bit of depth and interest.

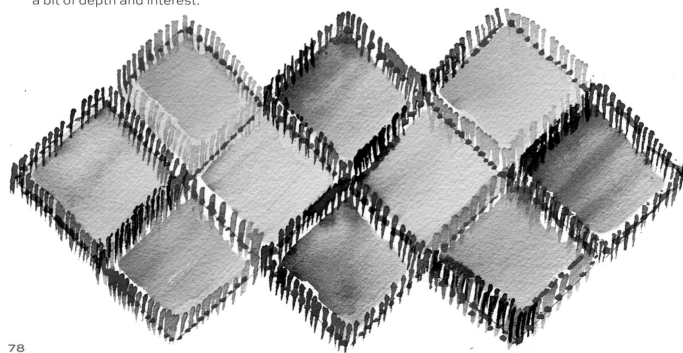

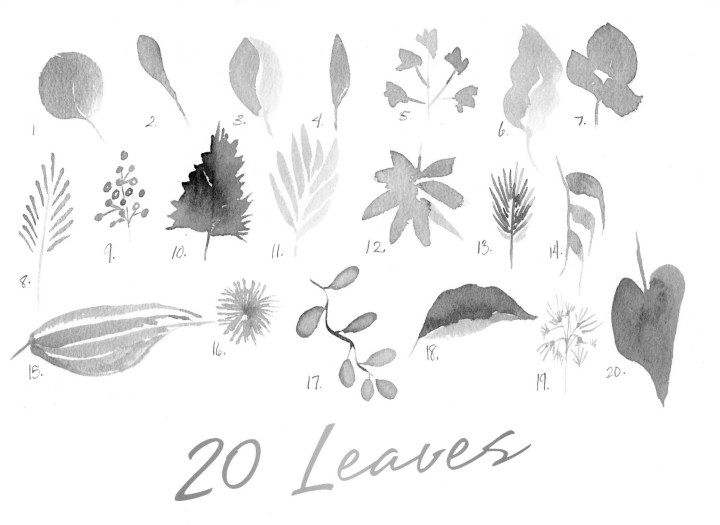

20 Leaves

Before beginning to deep-dive into the 20 Leaf chart, promise me one thing: promise you will just grab a piece of watercolor paper and experiment with some leaf making. You've already worked through the linework and brush-handling concepts from earlier in this book and so are perfectly capable of painting some killer leaves without further instruction. My hope is that you don't get so tangled up in my ways of painting leaves that you ignore your own abilities. SO, start this section with some play and then dig deeper, okay?

This chart is designed to acquaint you with just some of the ways to paint convincing leaves. I recommend reading through the entire section before creating your own chart.

1 >> Using the broad side of your brush, make a "C" curve. Directly next to your first curve, create a backward C curve. Using almost no pressure from the very tip of your brush, create a wispy stem. This technique creates a lovely silver dollar eucalyptus.

2 >> Starting with the short side of your brush, press down and drag your brush as long as you'd like the leaf to be. Gradually lift up and end with a very wispy stem.

3 >> Create a new leaf, using the same technique as seen in leaf #2. Create a second leaf directly to the right of your first leaf, ending with a short, wispy stem uniting the two. Fill more color into the center as needed.

3.

4 >> This version is also similar to leaf #2, but instead we start with the tip of our brush and add pressure as we drag down the page. Remember: how far you drag your brush will dictate the length of your leaf. Gradually lift up, leaving a short leaf stem. This, as with any leaf we create, can be painted in proximity to one another many times over to give the appearance of a branch full of leaves.

4.

5 >> With the very tip of your brush, using almost no pressure, paint a single straight line. Again with the tip of your brush, create very thin and wispy lines radiating from the center of the first line you painted. Now add small, sketchy-style leaves to the end of each stem. For this, I like to use the tip of my brush but with more pressure, scratching up and down. The scratchy brushstrokes should be only about ¼ inch tall. This technique creates maidenhair fern or ginkgo biloba leaf very convincingly.

5.

6 >> Starting with the short side of your brush, begin to add pressure while dragging down the page. While dragging, wiggle your brush slowly. Repeat this action again right next to the first mark you made, and end by lifting up gradually to create a leaf stem.

6.

7 >> Start with the long edge of your brush and make a lazy circle. Using the short side of your brush, make a shorter leaf mark directly under the circle to the left and right. Create a short stem by using just the tip of your brush and very little pressure.

7.

8 >> This leaf or collection of leaves will use the very tip of your brush exclusively. We will be painting very wispy, short marks for the leaves themselves and a long, thin, wispy center stem to tie everything together.

8.

9 >> Similar to leaf #5, paint a thin leaf stem, using just the tip of your brush and very little pressure. Add radiating thin lines from the center line only about ¼ inch long. Add as many as you would like at varying angles. At the ends of each line, add a small dot or circle.

9.

10 >> Begin by holding your brush nearly perpendicular to the paper. You'll be using the short side of the brush, but without much sustained pressure. Start by creating repetitive dabbing marks with the short side of your brush. All the while, keep the brush perpendicular to the paper. You'll be creating one side of the leaf and then mirroring the technique for the other side of the leaf.

10.

11 >> Using the tip of your brush, drag to create a skinny leaf about one inch long. We're making a very skinny leaf, so not too much pressure as you drag. Lift up before you create a stem. You don't necessarily need stems here. Repeat that again and again around the initial leaf made until you have an interesting collection of leaves.

11.

12 >> Using the short side of your brush, which is lying almost flat to the page, make a few marks connecting with one another on only one side. Continue making these marks, letting them connect in the middle and radiating out from there. Add a short, thicker stem that connects the grouping of leaves.

12.

13 >> Using the very tip of your brush, begin making small wispy lines that are directed at the center of a single stem. Feel free to add a contrasting color while painting shorter stems around the center. Note: if you add a second color when the first is still wet, they will bleed together. Be okay with it and let the magic happen!

14 >> We're going to create a bent leaf. Start with the short side of your brush and make an even-pressured mark about half an inch long. On one end of your first mark, make a thin, downward pointing stroke by using the tip of your brush, gradually lifting up to end in a very fine point. Repeat this technique a few times and connect with an organic-shaped stem, using almost no pressure from your brush.

15 >> Using the short side of your brush, drag with even pressure horizontally across the page about 3 inches. Curve your stroke as you paint. Repeat this step, starting at the base of your first stroke. Remember to lift up toward the end of each stroke to make the leaf point. Keep repeating these steps until your leaf is fully formed. Add a short stem.

16 >> Using the short edge of your brush, create quick, small lines radiating from the center around in a circle. Notice you're creating a kind of starburst effect in green. Feel free to add a dab of contrasting color in the center, which should blend a bit into your radiating strokes if they are still damp .

17 >> Using the very tip of your brush, create a very thin but curving vine. Also paint a few small stems radiating out from the vine. On the ends, create a teardrop-shaped leaf. You can create an outline first and quickly add water to blend color out into the leaf from your outline. Finish all leaves on the vine. Now get a bit of water on your brush and fill in the leaf outline shape with water, which will pull color inward from the outlines previously painted.

18 >> We'll be creating a leaf with a curled-up edge. Using the short side of your brush, create an arching stroke, starting with a good amount of pressure and slowly lifting up as you drag along the length of the paper. Lift up and lessen pressure to create the leaf's tip. Feel free to make the edges of the leaf a bit uneven or a bit wavy. Load your brush with a touch of yellow and, again using the short side of your brush directly next to the first stroke made, create another mark, although much thinner. Add a very contrasting color at the base of the leaf where the stem and the leaf connect and follow along with that contrasting color a bit up the middle of your leaf.

19 >> Start with the very tip of your brush barely touching down and create a variety of small marks in clusters that are separate from one another. Each cluster should be about ⅜ of an inch long. Continue by creating a central stem, again very, very fine and wispy. Now connect your wispy clusters to that central stem with smaller stems. Finish by making a small dot at the base of each cluster, where the stem connects. The dot can be the same color you've been using all along or something more contrasting.

20 >> Starting with the short side of your brush, make a mark that is about ⅜ of an inch tall at an angle. Begin pushing up with the short edge of your brush and then drag down. The mark you'll be making will be about ½ inch wide. Keep dragging down and slowly lessen your pressure, coming to a nice thin point. Repeat this exact motion on the other side. You're essentially making a heart outline. Finish by filling in with whatever color you would like, and add a stem at the top. The stem can be a bit thicker where it connects with the leaf.

The Techniques

How-To? How Fun!

It's only when you're brave enough to experiment that you truly feel the joy in painting.

Art for Joy's Sake throws precision and perfect to the wind.

Perhaps you've already had that moment . . . where the brush in your hand feels more part of you than separate, where the marks on the page are so beautiful that your heartbeat quickens. I want this for you! If you haven't felt THE moment, you are nearly there. Stay with me, be bold, throw care and precision to the wind. March ahead bravely here on the promise that watercolor holds—a promise to connect your heart, mind, and eyes inexplicably.

Flowers

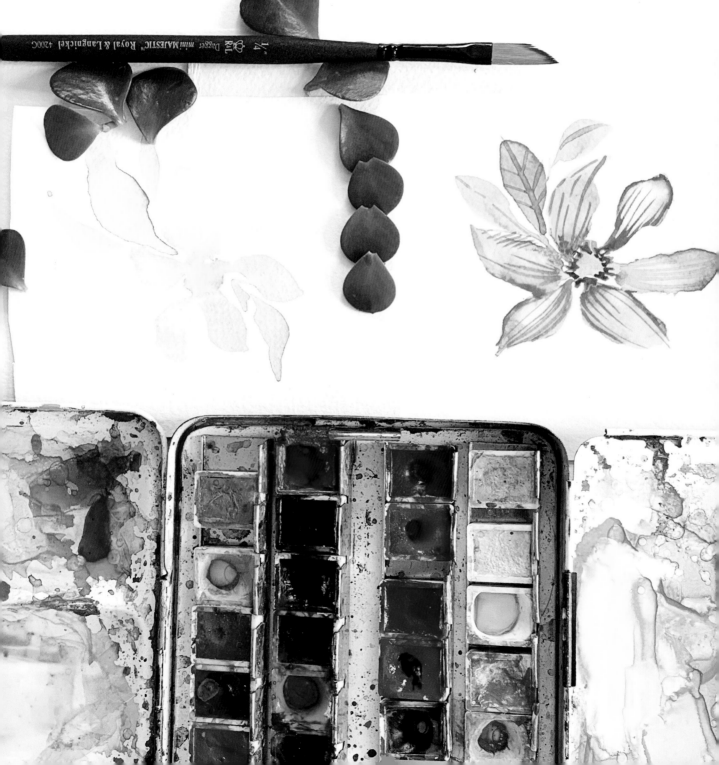

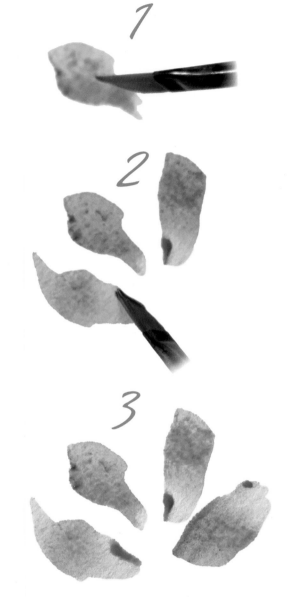

We'll be creating a five-petaled flower that is more transitional in appearance. Meaning, this flower could be a daisy or cosmos or even perhaps a peony or dahlia. Transitional flowers are well formed and beautiful but don't necessarily need to represent a single type of flower. I say this only so you don't get caught up in the idea that "oh my goodness, my flower has to look like a _____." I encourage you to actually stay away from Google and any type of inspiration image for this exercise. Just follow along with my flower here. I promise there will be so many opportunities later in the book to select your favorite inspiration image!

1 >> Start with the short side of your brush loaded with a soft pink. Press down, wiggle, and lift up fairly quickly. Continue similar strokes around an imaginary center, which will eventually become the center of your flower.

2–3 >> As you work, change the angle of your brush or the paper. Do what feels natural for your hand and comfort level.

4 >> Even though my petals are still wet, I feel the desire to go in and paint the center of the flower. If you're worried about things bleeding together, you may want to wait for your petals to dry.

While the petals are still wet, add in some bold red. Don't completely cover the petals with the second color; just dab into certain places.

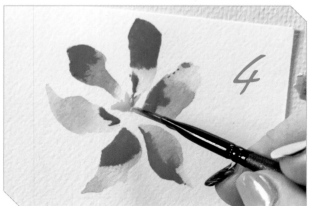

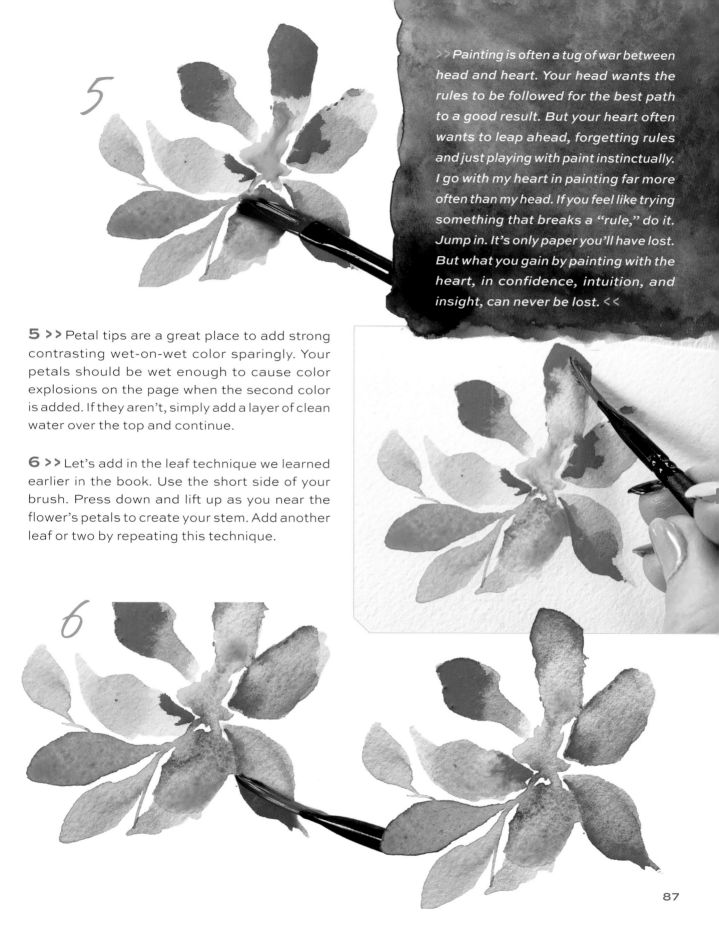

5

5 >> Petal tips are a great place to add strong contrasting wet-on-wet color sparingly. Your petals should be wet enough to cause color explosions on the page when the second color is added. If they aren't, simply add a layer of clean water over the top and continue.

6 >> Let's add in the leaf technique we learned earlier in the book. Use the short side of your brush. Press down and lift up as you near the flower's petals to create your stem. Add another leaf or two by repeating this technique.

6

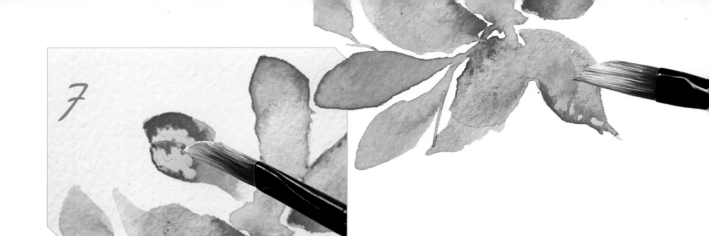

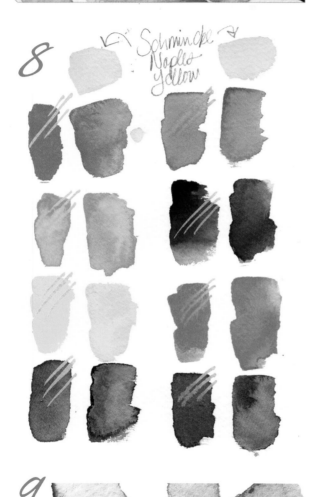

7 >> I like to add a little bit of unexpected opaque watercolor in places from time to time. Most watercolor sets come with a few more opaque options: white, peach, or often Naples yellow. When you have a wet area on your page rich with pigment, dab in a bit of an opaque color. You'll see an interesting swirling texture. If you look closely, it almost looks like a marbling effect. Don't be shy about letting colors really mix together on the page at this stage. It will likely feel a little messy, but trust me. When we begin adding more of the fine details with just the tip of our brush, things will really start to pull together.

8 >> This chart should help inspire a bit more experimentation with opaque accents over sheer watercolor.

I adore mingling opaque watercolor with a more traditional sheer watercolor. Take some time to experiment with the way that opaque and sheer watercolors function together. The results can be quite magical, offering truly unexpected textures. This chart will help you understand how opaque watercolor can affect the sheer, and ultimately how the combination of the two might inform your work.

9 >> Feel free to add the contrast-detailing technique (see page 33) in places for added definition. I'm adding the really bright red into some of the areas where two petals meet.

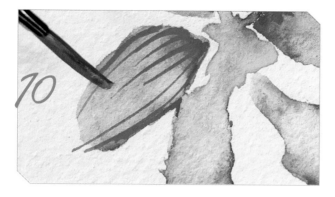

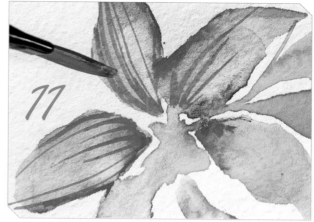

10 >> Now it's time for linework. We'll be using the very tip of your brush. I'm going to start with a bright pink by loading up my brush with about 50% pigment and 50% water. In the direction of the flower petal, following its contours, add some very light and thin linear strokes. You want to make sure that your flower petals are nearly dry, or you will have more of a bleeding effect happening.

11 >> Think about how some of your lines can be much closer together in an effort to create shadows. Feel free to change the color of your linear brushstrokes now; I'm switching to an orange with pink undertones.

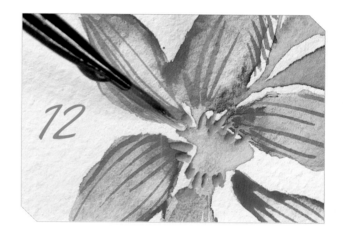

12 >> You'll definitely want to vary the way you create these linear marks on the page, so that each petal doesn't look the same. Not every line needs to go the whole length of the petal. These lines don't always need to start from the center of the flower.

13 >> They can start at the edge of a petal or the tip of a petal. Moving on now, apply these techniques to heighten definition at the center of the flower with thin, short strokes. You can also add similar detailing to your leaves.

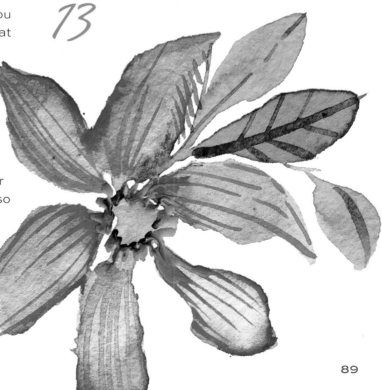

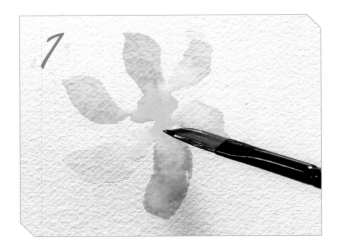

Now let's try the same flower, but with really loose wet-on-wet washes of color. We won't get into too much detail at all here. The effect we're going for is very soft and ethereal.

1 >> Using the short side of your brush, start to create your petals. The petals radiate around an imaginary center. I'm using the same color as with our previous flower, but keeping it more watered down, so it appears as a soft pink. Add a touch of color to the center.

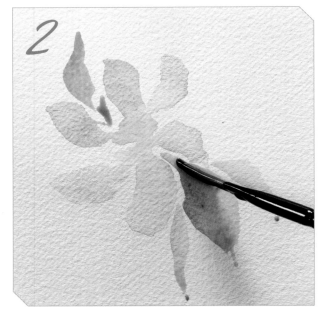

2 >> This version of the flower is definitely quicker, and a perfect style to use when you don't have much time to devote to painting on a particular day. Let's now add in the leaves, using the short side of the brush. Just have fun with this! Make the leaf and petal shapes that feel most comfortable to you.

ART FOR JOY'S SAKE IS BEING OKAY WITH OUT OF CONTROL

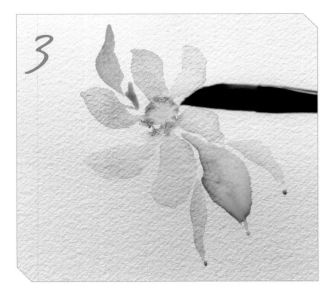

3 >> At this stage, your flower and leaves are still pretty wet; if you'd like to go in and add some interesting definition, just at the center perhaps, know that everything is going to bleed and spread and become very fuzzy.

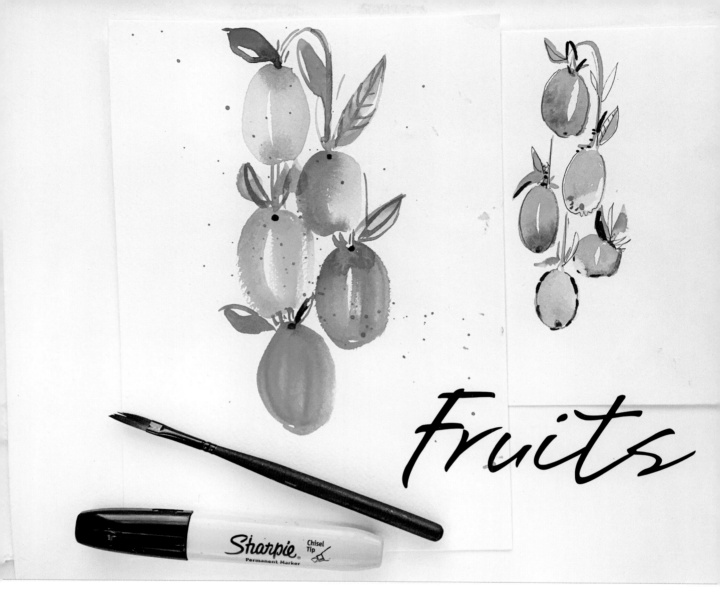

Fruit is most definitely one of my favorite things to paint. The shapes, the contours, the textures, and the colors all light my fire! We're going to experiment with two different techniques for painting fruit. First will be a watercolor technique that's finished with black ink, and the next will be a bold wash technique.

I'm painting from my imagination. I would still recommend avoiding any type of reference image, but if that's what makes you feel comfortable, don't let me stop you.

>> If you'd like to practice some ink and pen mark making for diving right into the kumquat exercise, head to page 94 now to see the chart I've created to guide you along. <<

>> *When just starting out with this more washy and bold style of painting, try holding your brush near the end of the handle. This will force you to give up some control. It can loosen you up in a beautiful way, inspiring more fluid movement and freedom in your strokes.* <<

Watercolor Then Ink

1 >> Let's paint some kumquats! Start with the long edge of your brush; lift up and twist the brush until you land on the brush's tip. A grouping of five small kumquats will be lovely and balanced. Kumquats hang on a vine, so they usually appear to drag down toward the ground.

2 >> I'm purposely not using a very detailed style because I want to add more detail with my ink pen as we move along in the painting. This would be a great time to add some unexpected color into the fruit.

3 >> With the very tip of my brush, I add in some greenery and leaves looping and draping from one kumquat to the next. Feel free to practice these looping stem marks a few times to loosen up.

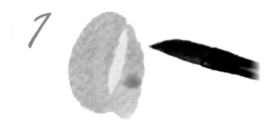

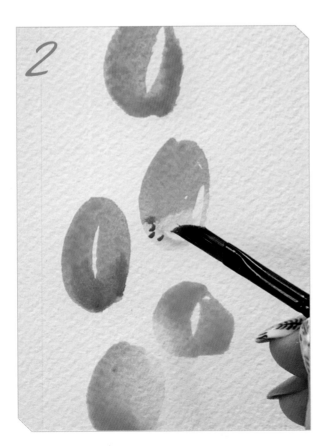

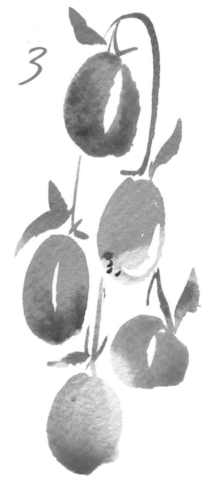

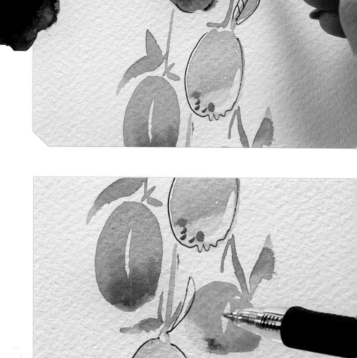

Next, find a few black pens. Literally any old pen will do. I'm using a thick Sharpie and a random black ballpoint ink pen.

I'll start by outlining the kumquats, but not with a consistent, continuous outline.

4 >> Experiment with adding scratching marks here and there, where two parts meet or where it just feels right. Feel free to add veins to your leaves or even add additional leaves not already painted in.

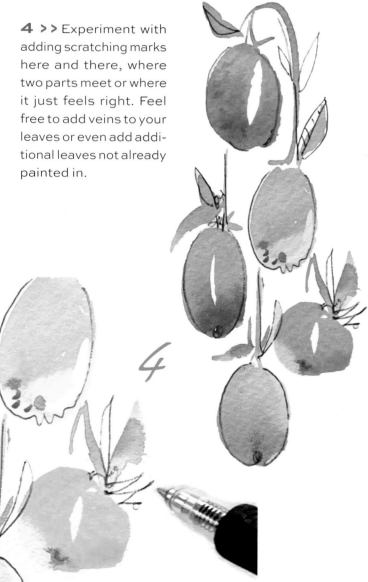

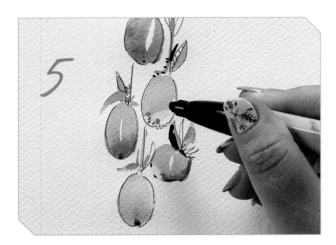

5–6 >> Now I'm going to play with my monster Sharpie, which I know may seem scary. The point is thick, and we all know it makes a bold, PERMANENT mark. Just dive in, though. You can always paint another bunch of kumquats! If you want a bit of "creative insurance," practice making some Sharpie marks on a piece of scrap paper. Start by making a few marks—dots, dashes, curves, and so on. See how the marker feels, and if you're happy, keep going, using varying pressure. If not, try a different type of marker.

Feel free to finish up by adding in a few more color details with your brush. That could mean adding in additional leaves or painting atop existing stems with unexpected color accents, or you may choose to say, "I'm done; this looks good."

Ink Texture Chart

Take about ten minutes to create your very own ink texture chart. This will help you familiarize yourself with the way that different types of ink interact and look with watercolor.

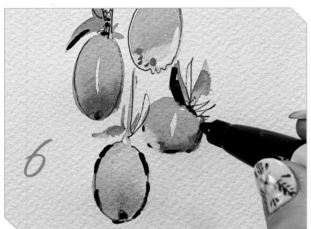

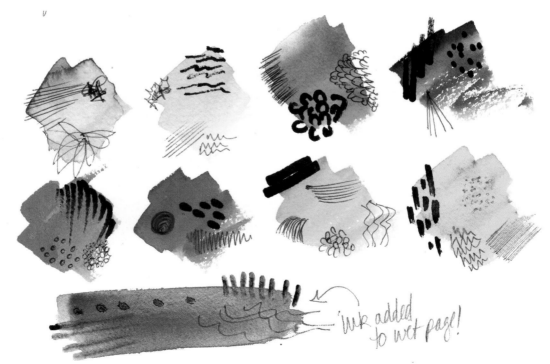

ink added to wet page!

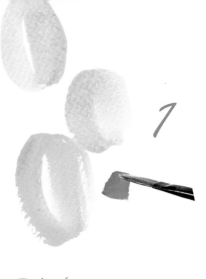

Bold Washes

Let's paint the same kumquats, but with a bold watercolor wash technique. I'll stick to the same colors for consistency's sake. This technique can be really fun if you increase the scale, making things a bit larger than in real life.

1 >> Let's paint another grouping of five kumquats, but this time exaggerate their size, taking up more of the page. The same brushstrokes used in the last exercise still apply, but just bigger and BETTER!

2 >> Introduce contrasting colors quickly and early on, using splashier strokes (more water).

3 >> Think about highly unexpected colors you could bring in. I'm adding pink as the main color of my greenery instead of green. Wild, right? Trust me, so fun! Think back to our "20 Leaves" (page 79) to choose leaves to add here.

ART FOR JOY'S SAKE IS A RUN TO THE MARKET JUST TO ADMIRE FRUIT.

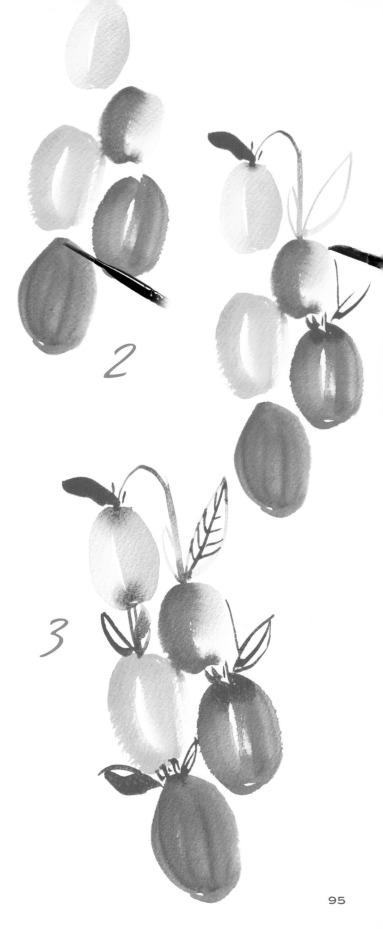

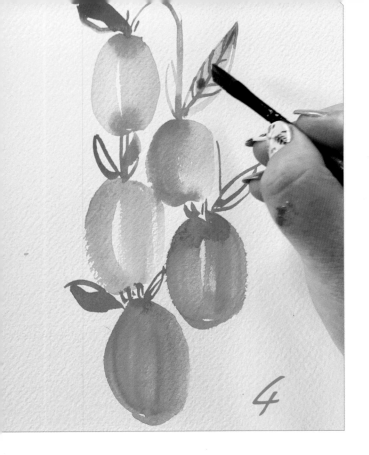

4 >> A bit of opaque color in areas is super exciting right now. Try either bold brushstrokes or dabbing in some dots. Think about what other unexpected colors you could bring in. If all of this unique color application is just a little too much for you, no worries; go ahead and pull in some greens. The point is for you to feel good about this painting! I want you to experiment, yes, but in a way that you are happy with the results and joyful along the way.

5 >> Add some spatter now, a detail I often reserve for the end of the painting, and watch the small color explosions happen where spatter hits damp paper.

The painting up until this point took me about three minutes, so obviously the idea is to move quickly and instinctively. To not get too bogged down in the idea of exactly how to perfectly place this brushstroke and that.

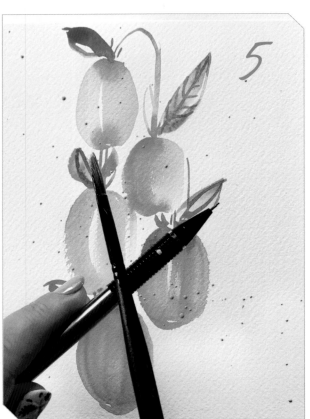

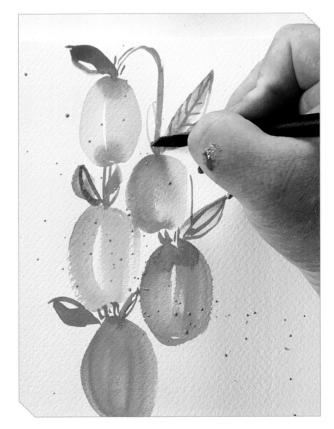

Your goal is to take the knowledge that you've gathered up to this point, mix it all up, and use it to your own advantage for the fulfillment of your own joy. So don't even feel like you have to copy exactly what I'm doing here. Or perhaps copy first and then follow up right away with something completely different, using similar techniques.

I talk a lot about shrugging off mistakes, but please know I make them too, all the time! In fact, when painting the kumquats for this book the first time around, I was unthrilled with the result. And so I repainted them! (See below.) Friends, own your discontent when painting AND resist the urge to walk away, possibly never to return. So many share stories of becoming frustrated with a painting, feeling ill equipped to continue,

and essentially giving up. Nope. Not here. Some of my most beloved work has been on the coattails of a seemingly epic failure.

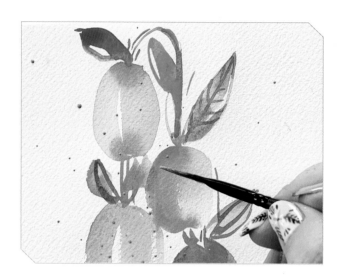

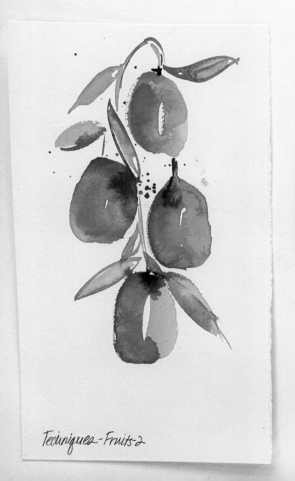

Techniques-Fruits-2

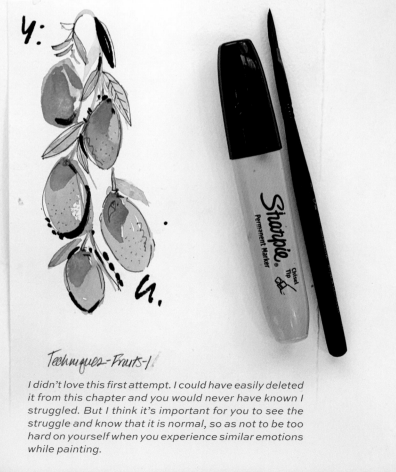

Techniques-Fruits-1

I didn't love this first attempt. I could have easily deleted it from this chapter and you would never have known I struggled. But I think it's important for you to see the struggle and know that it is normal, so as not to be too hard on yourself when you experience similar emotions while painting.

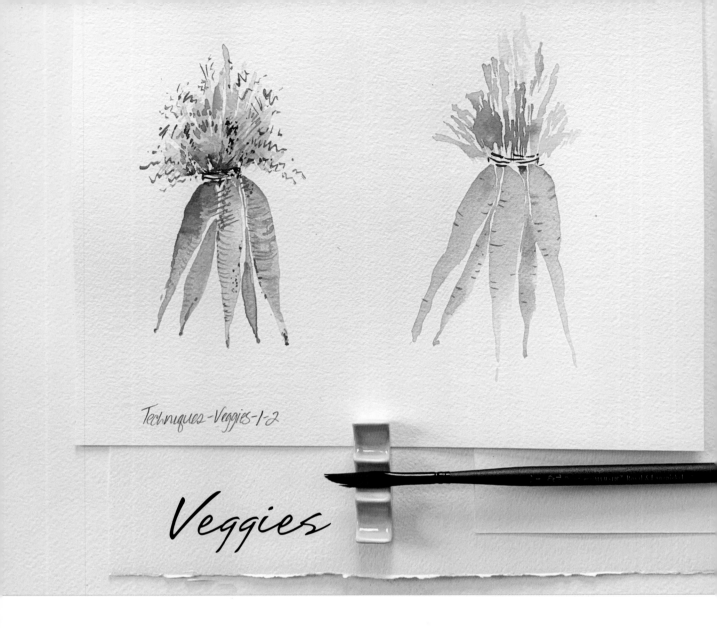

Techniques-Veggies-1-2

Veggies

You can apply this particular technique to any vegetable, really. I'm going for a bunch of carrots, but feel free to try carrots first and then quickly move on to other vegetables you may be more excited about painting.

Art for Joy's Sake is a hand-painted shopping list

Smooth, Subtle Silhouettes

This technique creates a smooth appearance on the page without too much fuss.

1 >> Start creating your bunch of carrot using the short side of the brush, pressing d⊂ and then slowly lifting up as you reach the bᵃ of the carrot. I have a bit of yellow and oran on my brush.

You'll be placing several marks like this or the page: some angled, some straight down to resemble a bunch of carrots.

2 >> Place a few similar strokes in between each that you've just made. We want to make sure our carrot bunch is quite full.

3 >> Start adding in the greens by using the short side of your brush, held almost perpendicular to the paper. Make marks that bounce along the page up and down, leaving short strokes of color. Feel free to add in a second green color for some contrast and depth. Rinse your brush in between colors.

4 >> Let everything dry for about one minute. We'll now add linework, very minimal, to express details throughout the bunch. Mix a muddy color. You can certainly use black as well, but in a lot of cases a rich, dark color that is the combination of many colors looks more interesting than a straight-up black.

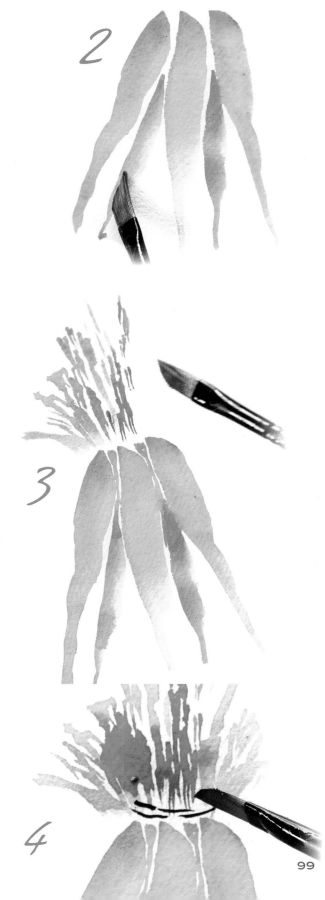

Using the tip of your brush, add some horizontal strokes where the greens meet the carrots. The point is to subtly suggest a tie at the base of the greens.

5 >> Blot your brush lightly. Now add delicate strokes to the carrots. These will be very subtle lines since you didn't reload paint on your brush. Keep in mind that you should be barely touching the page.

Detailed

For this next step, paint another bunch of carrots in the same way as the first. We're basically picking up where we left off with the previous exercise. We'll start by using brushstrokes just like you did for the previous technique. The true difference will be the level of detail that we add. Will be using the tip of our brush and continuing to add and layer in detail.

6 >> Load your brush with an equal amount of pigment and water. Using the tip of your brush, add in some very short and quick marks into the carrot greens. Add hints of dark green as you work, but make sure your brush isn't too heavy with moisture or the pigment could puddle on the page.

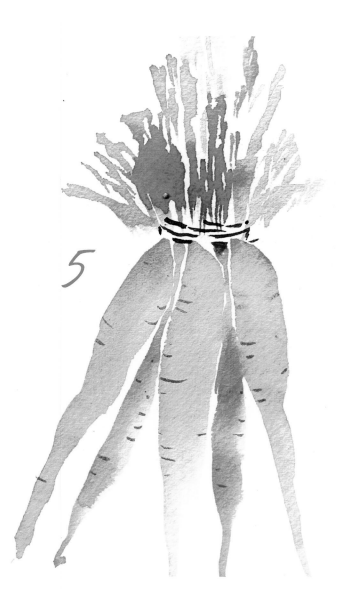

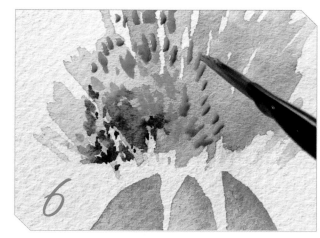

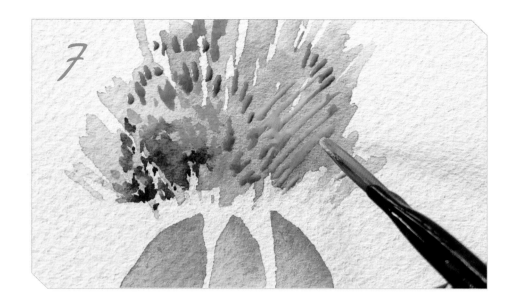

7 >> Rinse your brush in between color changes to ensure the colors stay clean as you paint. Feel free to make some longer strokes with the tip of your brush. When adding texture like this, for me it's less about what looks real and what I'm supposed to paint, and more about what feels fun, what feels different, and what looks exciting.

8 >> Now add some curved, horizontal strokes along your carrots in select places. If you haven't already completed the linework exercise earlier in the book, now would be a good time!

9 >> Continue adding various marks with the tip or short side of your brush. Consider experimenting with the addition of texture, using the broad side of the brush. Be sure to vary your color choices as you go with a quick rinse in between. I'm using different shades of orange, a bit of yellow, and even a rusty orange in areas.

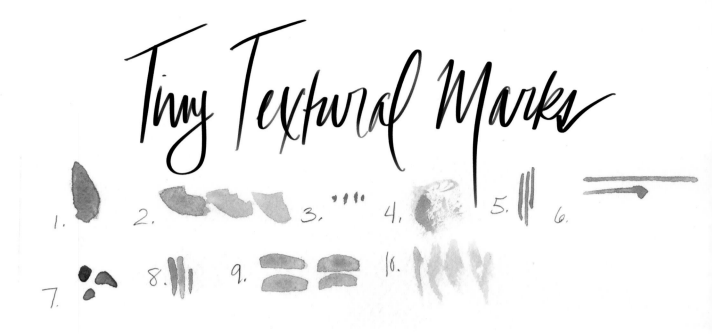

Tiny Textural Marks

1. 2. 3. 4. 5. 6.

7. 8. 9. 10.

Above are a few marks I find myself using over and over again, with step-by-step instructions for making them happen on paper!

1. Using the tip of your brush, and keeping your hand and arm loose, create a mark by using a back-and-forth motion of your whole hand. Remember that you're barely touching the page with your brush, keeping an even, light pressure.

2. Again using the tip of your brush, create similar movements to #1, but moving in a more horizontal direction. Experiment with the very end of the stroke, letting it flourish out in different ways, different lengths.

3. Using the tip of your brush, create a more bouncy, cloudlike mark. Compared to the previous two marks, your hand will be moving in more of a half-circle motion over and over again. Don't forget to experiment with the way you make your mark.

4. This mark is very similar to #1 and #2, but a bit more curvaceous and free flowing. The real point of this chart is to encourage you to experiment

a bit more in depth with making your own variety of expressive marks.

5–6. I adore these types of marks where we start more tight and like an ocean wave, but then toward the end of the mark we really let go and finish with an elongated stroke.

7. These marks are a hybrid of vertically placed brushstrokes, but with a more curved character. You'll again use the tip of your brush; with very little pressure, start from the bottom of where you want the stroke to be working upward, of course giving a bit of finesse to the end of the stroke.

8–10. This type of mark is created within a more elongated stroke that stays connected as you work. Your hand as it moves will bounce up and down along the surface of the paper, but keeping the strokes close to one another and connected edge to edge.

10 >> Contrast detailing can be a blast to add at any stage of your painting. Contrast detailing can be that wow factor that you need to wrap things up and feel really good about what you've created. Contrast detailing early in a painting can give you the bold courage needed to create a painting that really steps outside your comfort zone.

11 >> Continue by adding small asymmetrical dots throughout in a contrasting darker color, doing this both in the orange areas and in the greens. This is a much more controlled alternative to spatter. And of course don't forget to add in your vegetable ties between the green and the top of the carrot.

A fun little trick of mine that I've been using for years is unexpected expressive lines, as I call them. I'm sure there's a better name for these marks, but oh well. The point here isn't the name, but the energy and excitement they can add to your painting!

Use the tip of your brush loaded with a bit of paint and water. Not enough that the brush is dripping, but sufficient to make a mark that glides easily along the page. Use very little pressure as you go. Make a few curvy S or snakelike lines emanating wherever it makes sense to you. These lines add life and excitement to the carrot greens. You likely made similar marks during your linework exercise, and now you understand how they work in real-life paintings.

Creating expressive lines is just another way of using linework to your advantage. Expressive lines can be used toward the end of the painting to add that dynamic movement and interest needed to call the painting finished. (Of course, I'm all about breaking the rules to experiment with them at the beginning of a painting, too!)

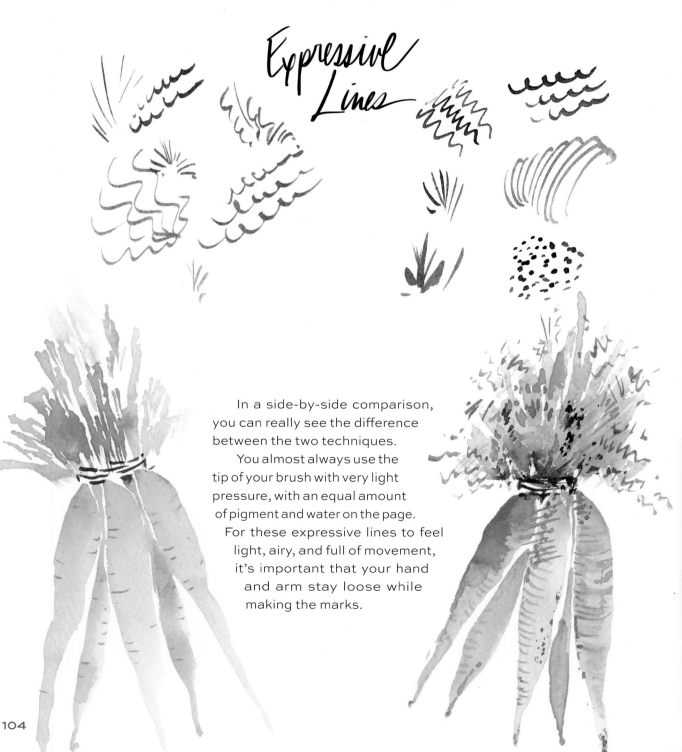

In a side-by-side comparison, you can really see the difference between the two techniques. You almost always use the tip of your brush with very light pressure, with an equal amount of pigment and water on the page. For these expressive lines to feel light, airy, and full of movement, it's important that your hand and arm stay loose while making the marks.

Landscapes

For this exercise we'll be creating a very simple mountainous landscape. Inspiration images or reference images can sometimes squash your creativity, but in this case I recommend grabbing an image that you'd like to work from.

I'm using a snapshot from one of my travels to the southern part of Utah. Feel free to follow along with me, using my photo, or start with a photo of your own choosing.

a few horizontal marks to resemble a southwestern butte (red-rock mountain).

2 >> Choose a blue and create an uneven horizon line under the mountain.

3 >> Add a few more thin wavy strokes horizontally under the first blue stroke.

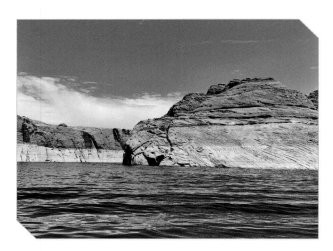

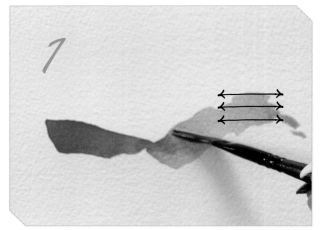

Expressive Minimal Brushstrokes

The idea behind this technique is to keep things extremely simple, quick, and full of personality. To get yourself into the swing of things, so to speak, start with a bit of scrap paper and practice a few ways to create this landscape with minimal brushstrokes. If you're brave and feeling lucky :-), dive right in!

1 >> Load your brush with an orangey-red color. Start with the short side of your brush and drag it backward (left to right) horizontally along the page for about an inch and a half. As you finish the brushstroke, lift up slightly. Rinse. Now choose a creamy peach color. Using the short side of your brush, make a mark starting where the last ended. Notice we're creating a more mountainous shape rising up along the surface of the paper. Now create

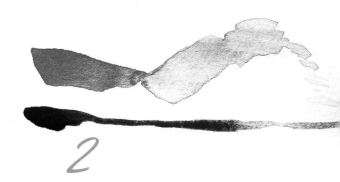

>> *Avoid the need to fill every bit of white paper with paint. Letting your painted landscape sort of hover amidst white spaces on the page gives an effortless and fresh feel overall.* <<

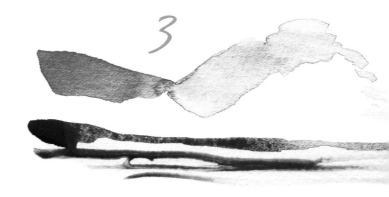

4 >> Add a layer of clean water over these lines with a soft touch to blend.

5 >> Next mix a peachy watercolor with a rusty red color. Load your brush and, using the very tip, create horizontal linework to add some detail in the mountainous areas previously left white.

6 >> Now load your brush with clean water and begin painting the sky. No pigment should be on your brush here. I like to leave a bit of white space between the wet in the sky and the mountains.

7 >> Once the color is flooded into the wet, you'll see the lovely character this thin white separation creates. Don't feel the need to paint the entire sky; leave some white surrounding so your landscape can breath. Load your brush with a favorite blue, lots of pigment here, and begin dabbing in color with the tip of your brush. Depending on the paint brand you're using, you may get a lot or a little color explosion.

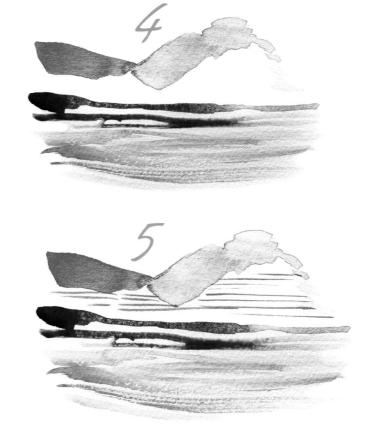

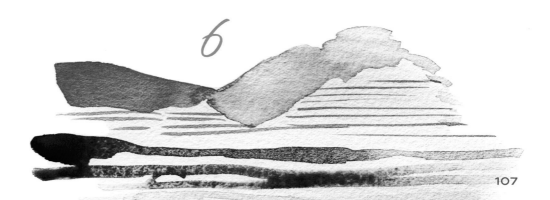

8 >> Continue to dab blue and clean water. Go back in with a brush loaded with clean water, and make a broad brushstroke right next to the blue you just painted. You will see the blue really starting to spread now. Feel free to angle your page a bit to spread things around, but for the most part you are done!

Detailed Robust Linework

For this version of the landscape, you'll want to repaint the first version. We'll start where we left off by adding a good amount of linework and detailing.

Adding linework and detailing is really about using your instincts. There isn't one right or wrong way to do this. You'll definitely want to use just the tip of your brush and lighter pressure, but beyond the techniques, listen to your heart. Now would be an awesome time to take a look back at the linework exercise we completed (see page 59).

1 >> I enjoy using a variety of colors throughout. For example, I started by adding rusty-color linework to define the mountainous shapes in the foreground. Feel free to vary the thickness of the lines as well and change the color. Move freely around the page or complete one area before moving on to another. Do what feels good and right as you paint.

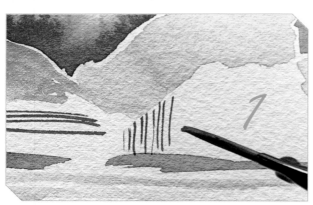

2 >> A dry-brush technique can be a fun and interesting addition here. Using the short side of your brush, load it with a lot of pigment and not so much water. Just above the mountain on the left, add a few brushstrokes in an upward motion. You'll feel the brush drag a bit and the color fade, but go with it . . . This technique, when you trust it, makes for some killer marks.

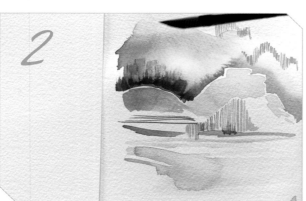

For this version of the painting, I'm almost exclusively using very linear vertical marks throughout. Sticking to one type of mark for detailing can be a really interesting and somewhat challenging exercise. But feel free to change the direction of your marks if the mood strikes.

1 >> Using the short side of your brush, held horizontally, add some thicker lines at the top of the butte.

2 >> For the water, long horizontal strokes back and forth with varying pressure can add a lot of interest. A few thoughtful vertical marks in the water can create a sense of reflection.

3 >> Continue on as you'd like. Remember to take a step back for some perspective on what to do next. Trust yourself here. You no longer need me dictating every step to make the wow happen!

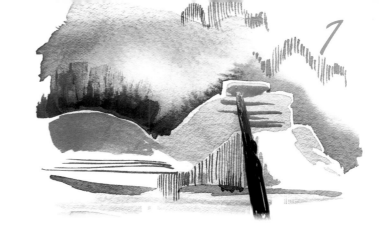

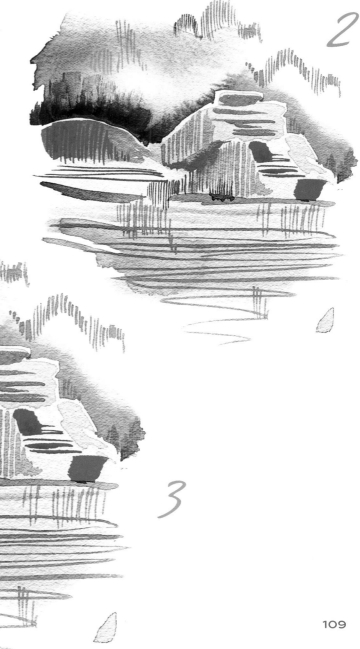

ART FOR JOY'S SAKE IS USING WHATEVER YOU FIND.

A few years ago while visiting Rome, I stumbled upon an old stationery shop. They carried a treasure trove of vintage pencils, papers, markers, pens, and I discovered a box of vintage pencils. A perfect dozen blue pencils with stripes and gold detailing sat untouched in the box. I thought they were just well-preserved graphite pencils, but soon learned that these transfer pencils held a little magic of their own. Once used by architects before any type of reliable image copying was available, they are now simply relics of a bygone era. These create some of the most interesting marks I have ever seen in my art-making career. And while modern versions of the transfer pencil are made, they're not quite like their vintage counterparts.

When water is applied to marks made with the transfer pencil, the ink present in the graphite pencil is water soluble and therefore starts to blend and bleed like watercolor would. You might be thinking, "Well, that sounds an awful lot like a watercolor pencil." True, but only to a point. When you first sketch with a transfer pencil, what you see is a typical graphite . . . gray and dull. It's only when the water touches this mark that it completely transforms.

So for those of you looking to invest in a little something new to add to your magic cup, I'd highly recommend searching out this particular transfer pencil. You can find them on kristyrice.com or eBay. If you're not quite looking to spend a couple of dollars on a pencil, give the watercolor pencil a try.

Re-create a chart like this for a fast warm-up!

1 >> I've created a third version of this south-western painting to demonstrate how the transfer pencil works directly on the wet page. I'm working with less linear details and more wet on dry, so that my page is quite saturated when I come into it with the transfer pencil. Be okay with colors bleeding together here!

2 >> Go ahead and start adding marks to your landscape, using the transfer pencil into the wet areas just like you might with a brush.

3 >> Use the tip of your pencil, the side of your pencil; think about different angles at which you can hold your pencil. Marks are awesome, with dots, dashes, outlines here and there, but also think about shading with the transfer pencil. Use a light pressure on the side of the pencil, moving back and forth slowly to create soft marks one right next to another. Then with a brush, add more water over the top.

4 >> Enjoy watching the pigment float and swirl on the wet page.

>> *I adore these quick paintings because you know going into them that they're not meant to take up a lot of your time. They leave your heart and your creative spirit to just enjoy the process and not worry too much about making mistakes. In the beginning, committing yourself to more lengthy painting projects can really work up your creative anxiety. Quick paintings like these aren't a huge time investment, so starting over because you're not too thrilled with the first results is really no big deal!* <<

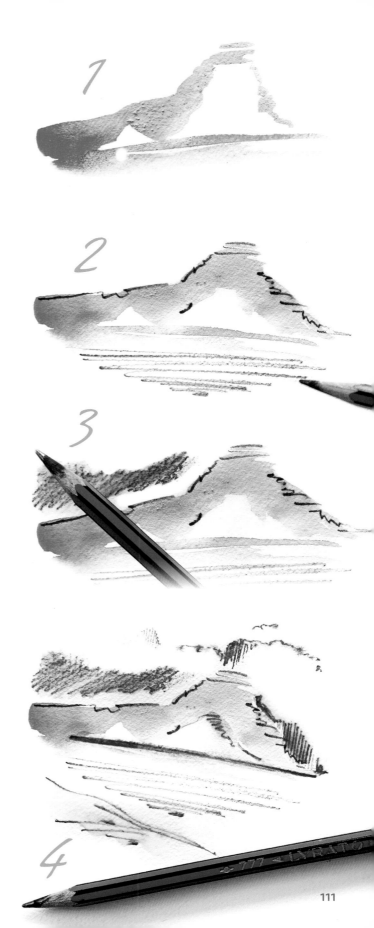

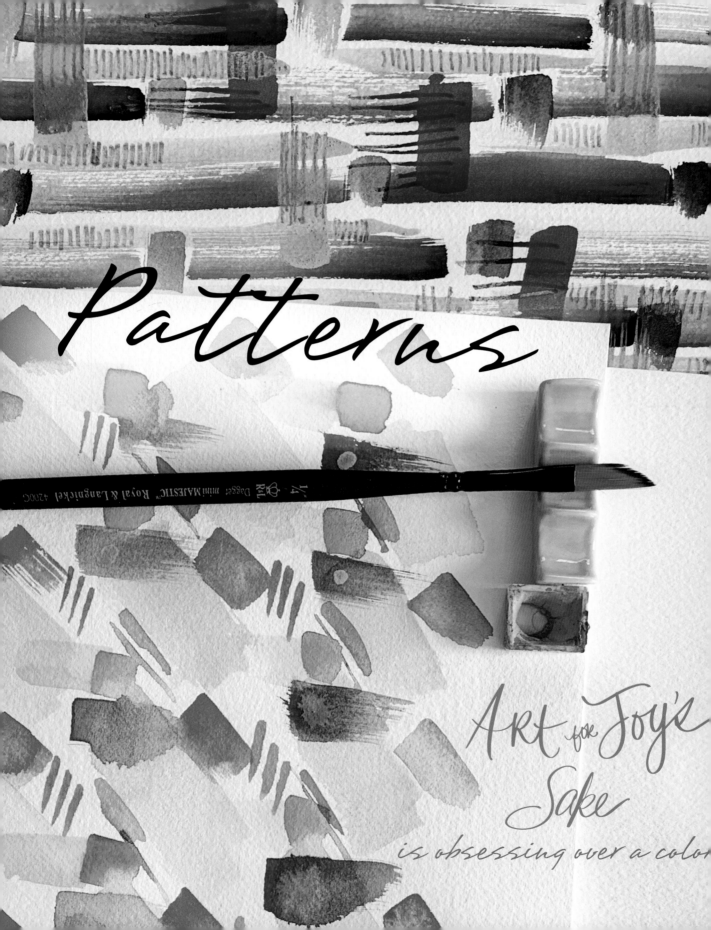

Patterns

Art for Joy's Sake

is obsessing over a color

Bold Pattern

There are so many ways to create a watercolor pattern, but one of my favorite methods is to just have at it. Of course you could be inspired by a piece of fabric, a magazine graphic, or the way leaves glisten on a tree in your front yard, but ultimately it's just about you, some brushstrokes on the page, and paint.

I encourage you to use just your favorite colors here. Don't worry about picking THE combination… just choose what you're attracted to and what strikes you in the moment.

When you're thinking about the types of shapes and the types of brushstrokes to use, remember the linework and brush-handling exercises earlier in this book. Of course you can paint shapes like hearts, stars, and moons, but for a super-chill painting session where you don't have to think too much, go back to the basic brushstrokes.

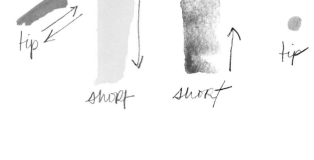

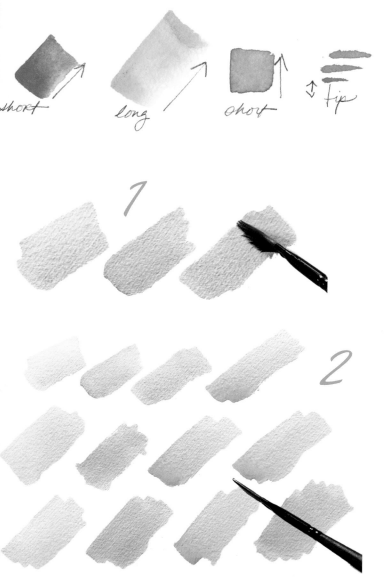

ABOVE IS A CATALOG OF SORTS, BREAKING DOWN THE LOOK OF EACH STROKE I'LL USE IN THIS PATTERN. The arrows indicate how I moved my brush for each.

1 >> Load your brush with a soft peach color. Then, with the long edge of your brush, press down to create bold and wide marks at an angle adjacent to one another. You'll need to apply strong pressure to get that wide stroke. Your bristles should fan out with each stroke.

2 >> After completing one row, paint another just underneath the first, but shifted like brick courses. Repeat until the page is full enough for you!

3 >> Next, load your brush with a pink color. Using the tip of your brush, add thin lines in between each of those bold brushstrokes.

4 >> Load your brush with a green. Add small, square strokes in front of each of those bold, large marks first painted on the paper. Be okay as colors start to bleed together.

5 >> Load your brush with an orange color. Paint three thin brushstrokes stacked atop one another. Use the short side of the brush, held nearly perpendicular to the page, and wiggle back and forth slightly to create each mark. Repeat to fill the page.

6 >> Choose a blue color. Using the short side of the brush in an upward motion, make a stroke about 1½ inches tall. Your page likely has some wet areas, so some bleeding together of colors is possible.

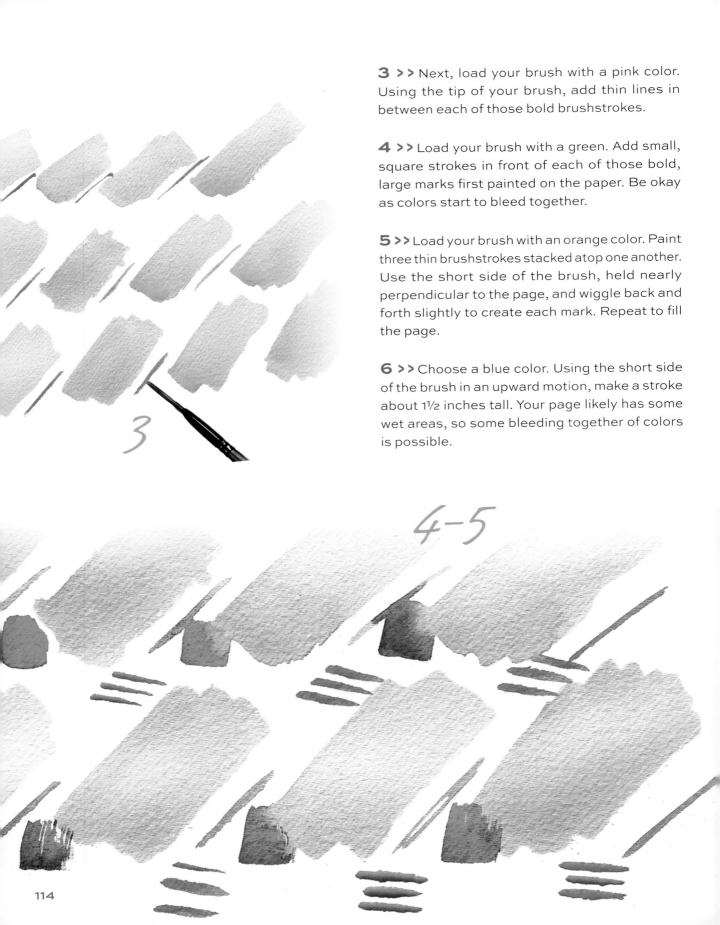

Of course I would be remiss not to talk about symmetry, being that we're creating patterns, but I also don't want you to get too tangled up in the idea of perfect symmetry. So as you're painting new marks and new shapes, pay attention to repeating each mark in essentially the same spot. You can use the corners of previous brushstrokes as a guideline. For example, you might place a green square underneath each bottom-right corner of your previous mark and so on.

7 >> Choose a pink color. With the short side of the brush in an angled stroke, to the right of each green square, paint an elongated rectangle. Repeat.

8 >> Continue to layer in brushstrokes, varying shapes in a repetitive fashion until you're pleased with your pattern overall. I chose to add a final round of strokes in a yellow.

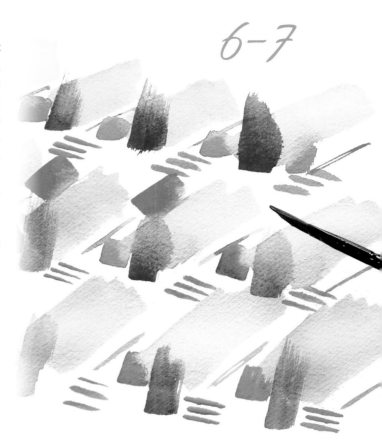

6-7

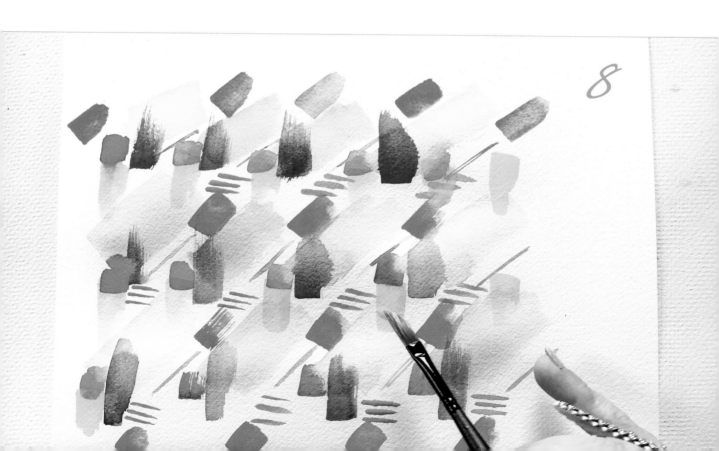

8

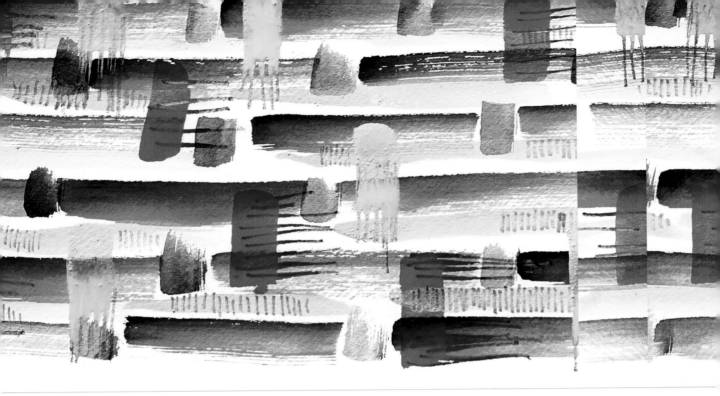

Dual-Stroke Pattern

This is a fun technique that is easy to execute and always produces a surprisingly refreshing result.

1 >> Load up your brush with a lot of pink pigment and a little bit of water. The brush should feel very juicy with color. Blot the tip of the brush, then load the very tip with a purple. With the short side of your brush, make a few horizontal strokes. Rinse your brush and repeat the step.

ART FOR JOY'S SAKE ISN'T ALWAYS INSTAGRAMMABLE.

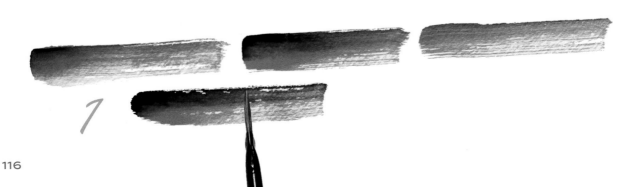

1

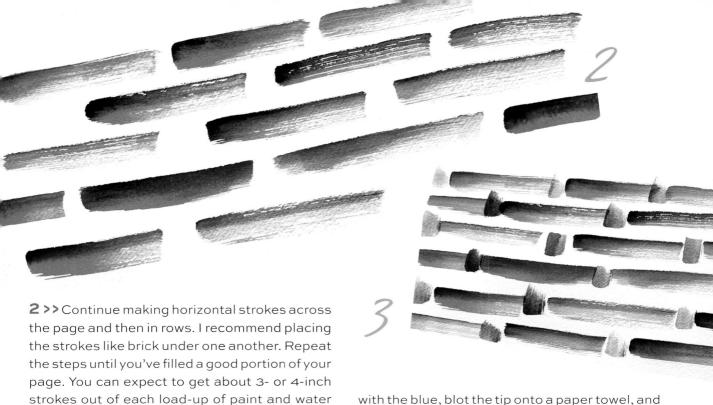

2

3

2 >> Continue making horizontal strokes across the page and then in rows. I recommend placing the strokes like brick under one another. Repeat the steps until you've filled a good portion of your page. You can expect to get about 3- or 4-inch strokes out of each load-up of paint and water on the brush.

Don't worry if the strokes aren't perfectly even or if the spaces between them are uneven. The point is to enjoy the process, to enjoy experiencing a new way of placing brushstrokes on the paper.

3 >> Now choose a new color combination. I'm going with a blue and a green. Load up your brush with the blue, blot the tip onto a paper towel, and then load up with green. This time start making small, square marks in between your purple and pink marks. Reload the brush as needed.

4 >> Load your brush with the yellow. Blot the tip and load the tip with a creamy, peachy color and make some long horizontal marks with the long edge of your brush in between the marks you've just painted.

4

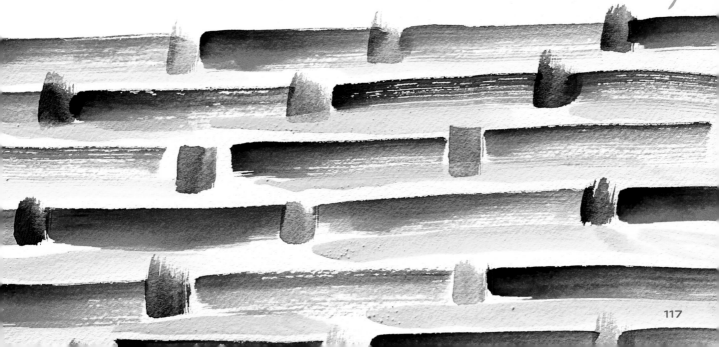

5 >> Using a 2B pencil or any you have, make some short vertical marks in the yellow- and peach-painted areas of the page. The point is to apply these marks into wet areas to essentially soften the darkness of their effect. Using materials in unusual ways is my jam. It pushes me and excites like little else. You will get some of the most interesting results by not being afraid to push the material in a new way.

NOTE: You'll want to work fast at this stage. You'll be working a new material into the wet paint! Load your brush with a strong red and start making vertical rectangles in choice places throughout your pattern. Make sure to use a lot of pigment, about 70% pigment and 30% water.

6 >> While your brushstrokes are still wet, make horizontal pencil marks from the wet red paint into the drier areas. You're literally pulling the pigment out of the wet area with your pencil mark. When this dries, you'll see a beautiful ombré from red to graphite on your page. Incredible!

7 >> Load your brush with a peachy color, same ratio as in the last step. Add a vertical rectangle, making sure your marks stay very wet. Go back into the wet marks with pencil and make vertical

marks, dragging the wet paint into the dry area of your page. If you have red residue on the pencil and that bothers you, wipe it off before using the pencil. If it doesn't bother you, let the happy accidents flow.

How we paint the forms and textures of one item informs the next piece we create. What do I mean? Well, watercolor painting is all about making connections, being able to recognize similarities, and trusting that what you learned painting that peony will make your next landscape more satisfying. It's kind of like algebra, and oh my goodness, no one tell my husband I'm talking about math! But truly, we learn the basics, the very minimal basics, and soon we have the tools needed to grow and evolve into more complex solutions. Painting is very much the same. We've learned the essentials. You're standing, maybe still a bit wobbly, but aren't you feeling a bit like taking that leap?

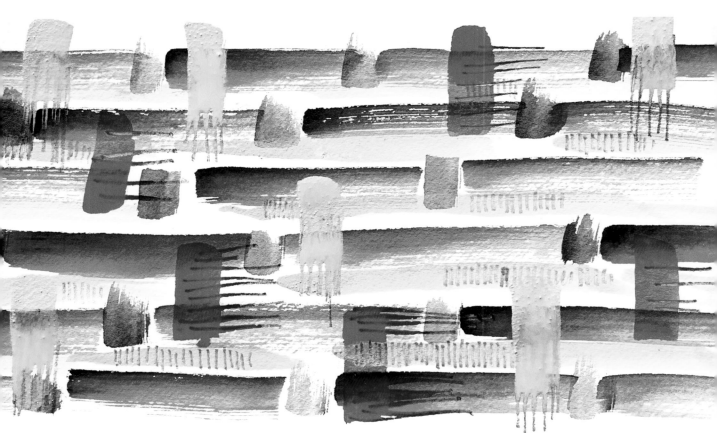

MAKE YOUR OWN GRAPHITE AND WATERCOLOR CHART TO INFORM FUTURE EXPERIMENTS WITH THESE TWO MEDIUMS.

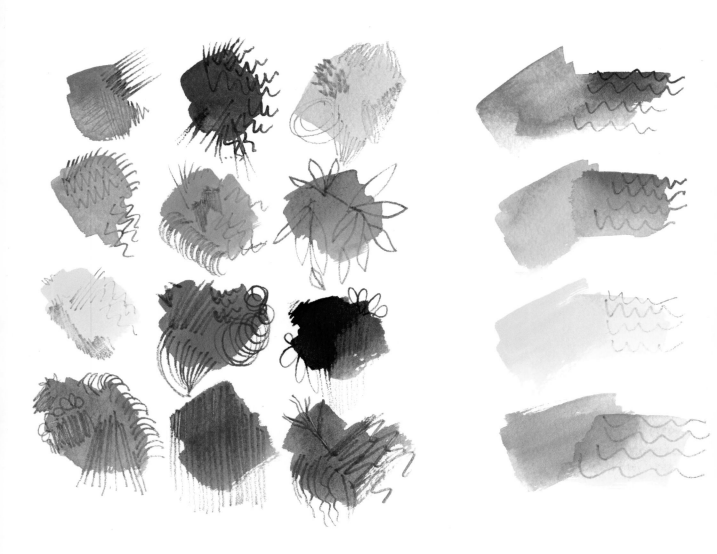

Create swatches of your favorite colors one at a time. While the swatch is quite wet make a variety of graphite marks radiating from the paint swatch. Notice how the graphite carries the paint color, and how the graphite mark changes as the paint dries.

Projects— Ready to Fly?

I'D SUGGEST WORKING THROUGH THESE PROJECTS IN ORDER. EACH FOCUSES ON SKILLS AND TECHNIQUES THAT BUILD UPON ONE ANOTHER.

Art for Joy's Sake

is leaf collecting instead of raking

Leaves and Greens

We're going to create a leaf pattern with one brush—the famed dagger brush! You'll notice me using a variety of techniques that we covered in earlier chapters, so keep an eye out for WOWD especially. The key to creating a variety of leaf shapes with one brush is pressure. It's all about how much pressure or force you apply to the brush. The more pressure you use, the larger the stroke you create, while the less pressure you use, the more delicate the stroke you'll make. Don't forget about our 20 Leaves chart on page 79!

I started my pattern at the upper left of the page. You do you. This first photo isn't a mistake, friends . . . Remember that this chapter is all about leaping. So I want you to rely on your knowledge and sense of adventure to create the pattern to this point without too much technical help from me.

ART FOR
JOY'S SAKE
IS RELYING
ON YOUR
ENTHUSIASM
MORE THAN
YOUR SKILL.

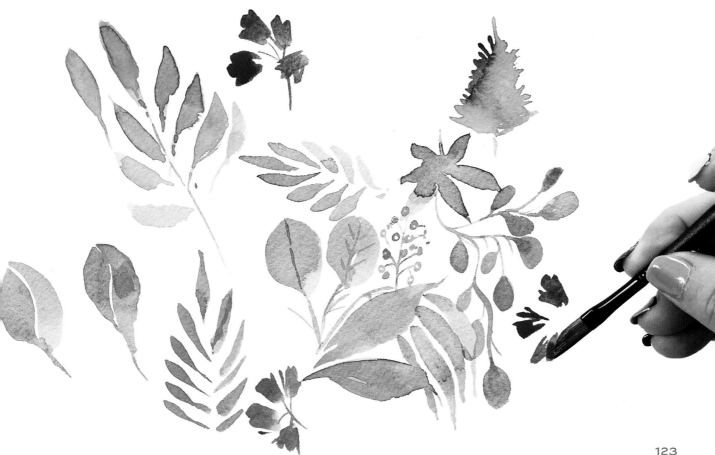

123

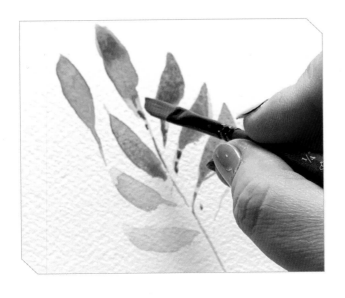

I'll get you started: Start with about 50% water and 50% pigment on your brush. We're going to make a very simple leaf. Start by pressing down fairly hard and then slowly lifting up as you drag the brush. Drag for as long as you'd like your leaf to be. Continue making these press-and-lift-style marks, holding your brush at a variety of angles.

SOME POINTS TO CONSIDER AS YOU WORK:

Refer to the 20 Leaves project if you feel stuck about what leaves to add.

Change your pressure as you paint: lift for thin lines, press for wide.

Add touches of unexpected color while certain leaves are still wet.

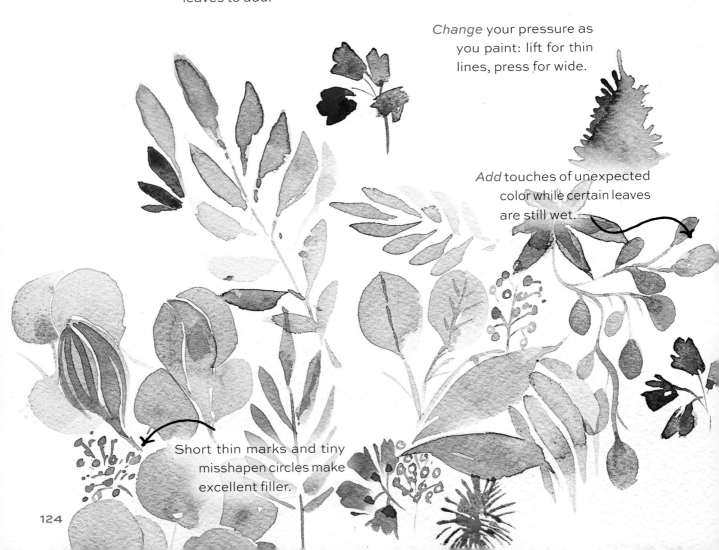

Short thin marks and tiny misshapen circles make excellent filler.

Change the angle of the brush to create fernlike plants made up of a collection of thin leaves.

>> See page 129 for an exercise that will really help you with this particular project! Create a mixing chart of greens, to see how many versions you can mix using your palette. Don't just think about traditional mixtures of color like green and blue, green and yellow, green and brown. But start to think of the unexpected color combinations, like green and a little bit of pink, or green and a bit of turquoise, or green and a bit of orange. See what happens. <<

Wispy, thin details can add immense interest to a painting.

Light pressure is key when creating these wispy lines.

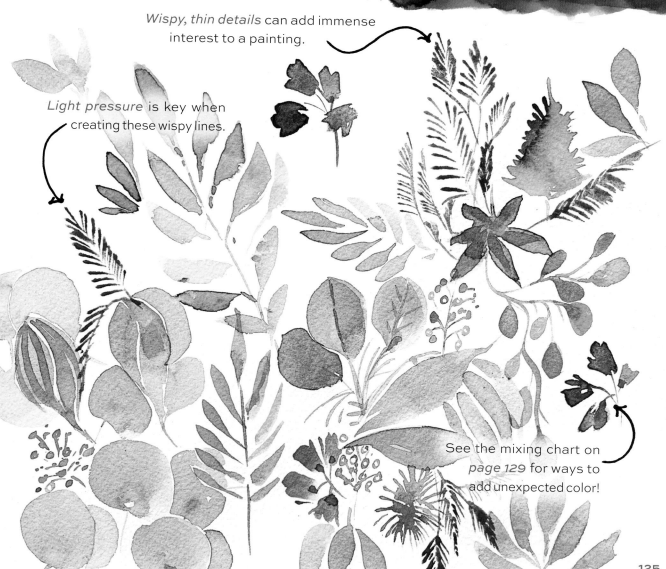

See the mixing chart on page 129 for ways to add unexpected color!

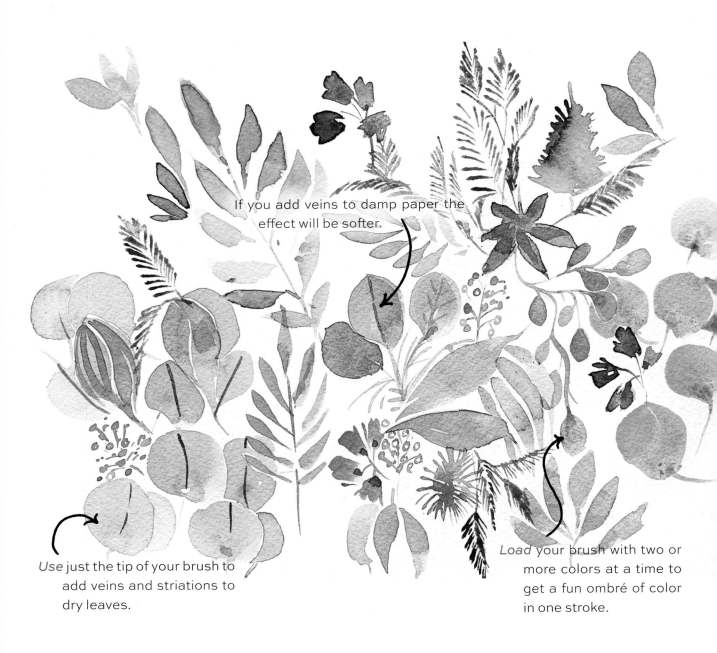

If you add veins to damp paper the effect will be softer.

Use just the tip of your brush to add veins and striations to dry leaves.

Load your brush with two or more colors at a time to get a fun ombré of color in one stroke.

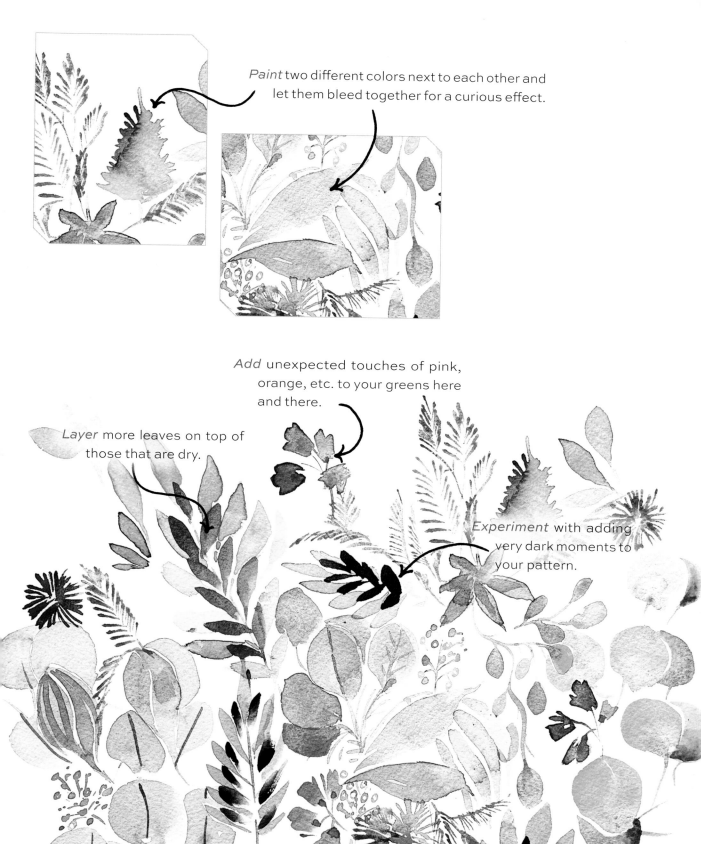

Paint two different colors next to each other and let them bleed together for a curious effect.

Add unexpected touches of pink, orange, etc. to your greens here and there.

Layer more leaves on top of those that are dry.

Experiment with adding very dark moments to your pattern.

127

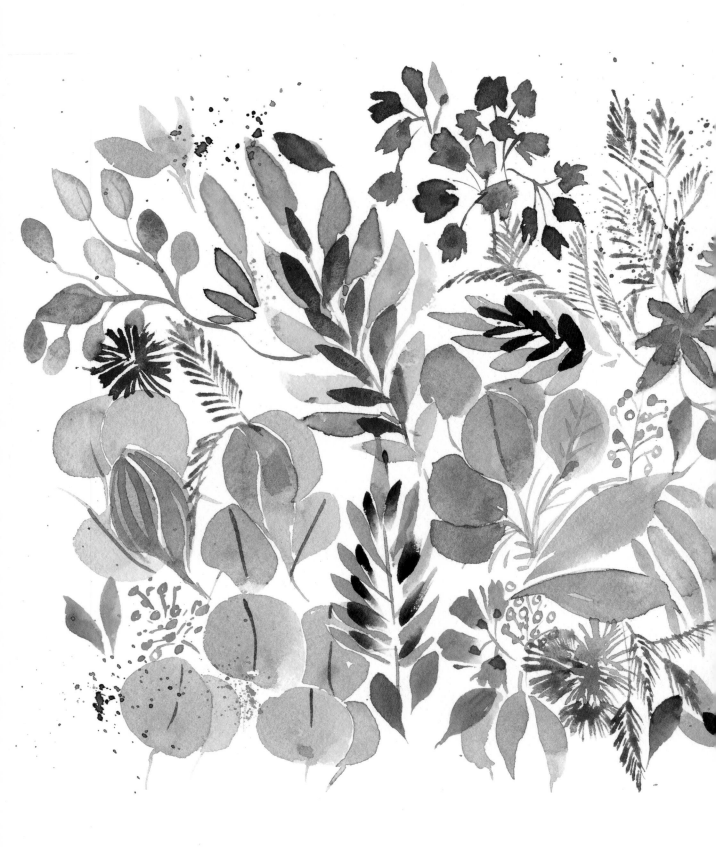

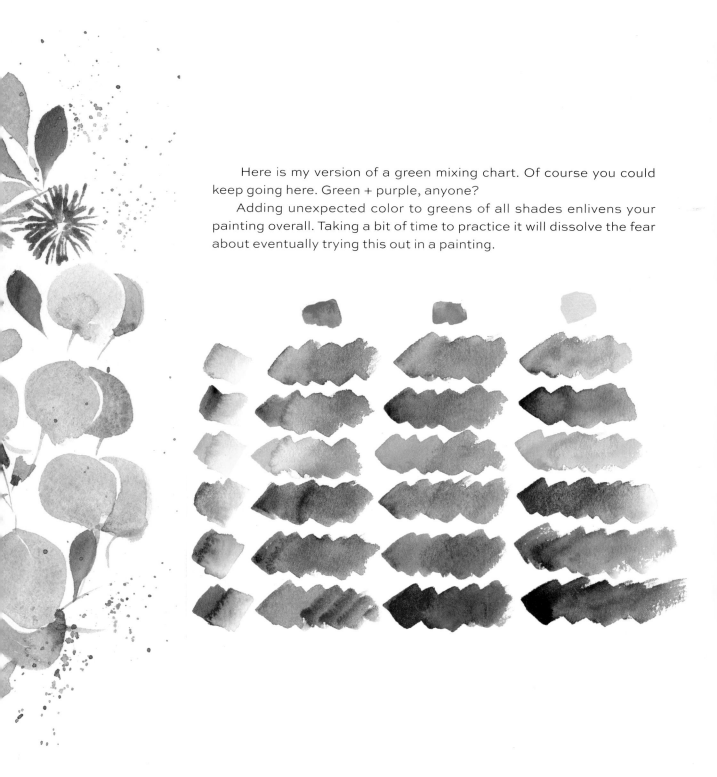

Here is my version of a green mixing chart. Of course you could keep going here. Green + purple, anyone?

Adding unexpected color to greens of all shades enlivens your painting overall. Taking a bit of time to practice it will dissolve the fear about eventually trying this out in a painting.

Take-a-Walk
Pattern

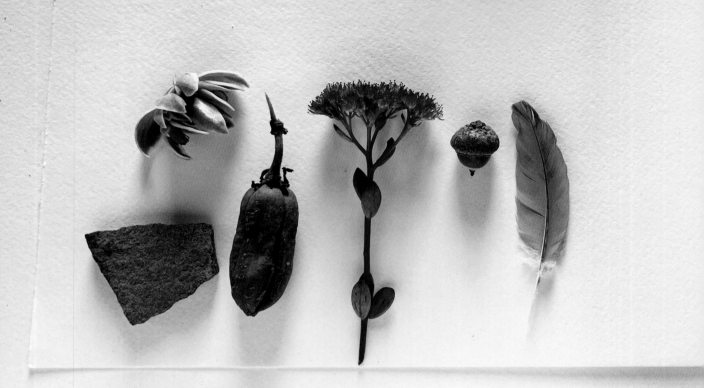

Pattern developed from items foraged during a ten-minute walk.

This project is all about experience and speed, but don't let that scare you! Effortless brushstrokes are fueled first by trust in yourself and second by fearlessness. Do you know how long it takes to use up a watercolor palette? Years. And that is for a professional artist. Why do I bring this up? Never let the waste of materials prevent your art making, or should I say art experimenting! Never!

So let's get our creative blood flowing a bit. Go outside! Take a five-minute walk and pick up five to seven items that you find along the way. It can be a beautiful plant, rock, feather, piece of interesting wood. Grab anything that interests you, and bring them back to the painting table.

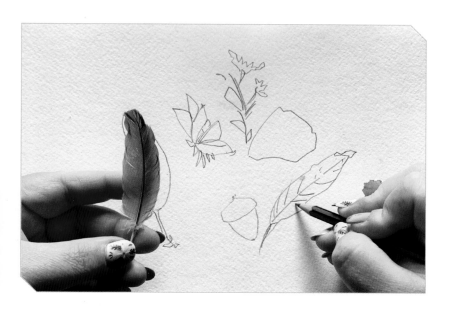

I'm using my transfer pencil, but remember that if you don't have one, you can use a watercolor pencil. A feather, a few plant clippings, and a rock are my discoveries. Nothing too out of the ordinary, but the way in which they'll be painted will make them extraordinary.

Art for Joy's Sake is fast and loose. (Funny or gross, LOL?) Using a very loose and quick sketch style with the transfer pencil, pick up each item and very quickly sketch the item. I don't care if you've never sketched before; I want you to give it a try. Remember it's key to hold the item in your hand and look back and forth at the item as you sketch. Don't obsess over getting the sketch just so. This is all about instincts and trusting what you see in front of you, trusting your hand to capture what is seen in front of you.

Certain elements can be sketched multiple times on the page, since the idea is to create a very relaxed pattern. Move quickly to ensure you're sketching instinctually, not too literally. We're looking to capture what we see: shapes, curves, distances, etc. that define an object. We're not looking to sketch what we think an object looks like.

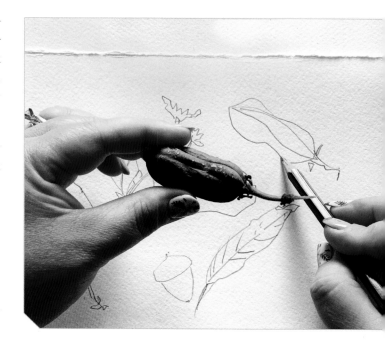

While sketching, ask yourself questions. What does this item remind you of? For example, this little pod reminds me of a peanut, and recognizing similarities like these can help you decide what adjustments to make as you work. Sketch parts of the object. No need to sketch the entire object each time it appears in the pattern. Now add a few leaves here and there.

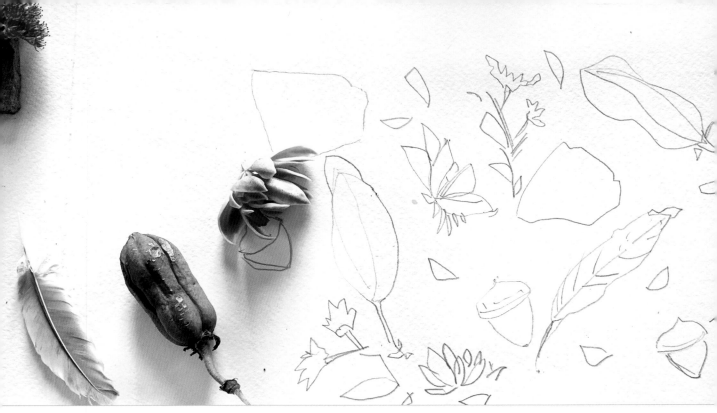

Okay, we're about done with this sketch, and we are going to start splashing around with watercolor. Start with the short side or the broad side of your brush. Choose a color palette and, using big strokes and little detail, start painting in strokes. Things could get messy; painting outside the lines a bit here is okay!

I'm using soft grays, greens, and berry tones.

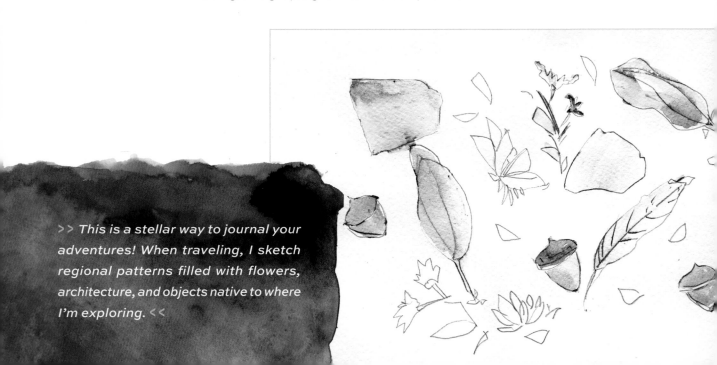

>> *This is a stellar way to journal your adventures! When traveling, I sketch regional patterns filled with flowers, architecture, and objects native to where I'm exploring.* <<

This is also a perfect exercise to jump into if you've been experiencing a bit of a creative block lately; it will really shake you up and get the blood pumping—simple, delicate, invigorating.

I stopped here, resisting the urge to add more detail. There is much to learn through the act of restraint.

>> *Using color mixed and existing on your palette is an awesome way to be more instinctual in choosing color as you paint. As an alternative to choosing a specific color palette before beginning, commit to using colors only from the corners of your palette. You know, the grungy corners with just hints of the original color left.* <<

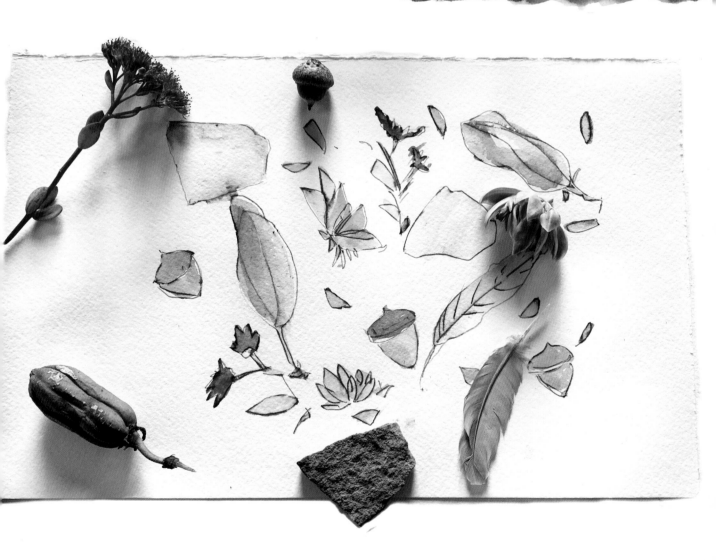

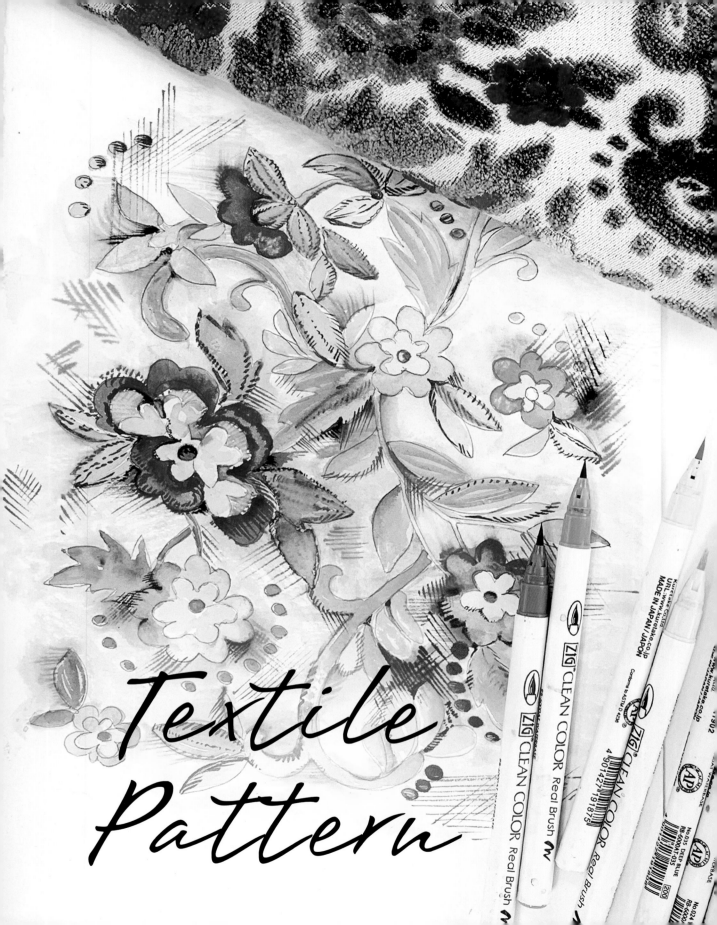

Textile Pattern

Create a detailed pattern inspired
by a real piece of fabric.

Using Mission Gold watercolors and
Kuretake Zig Clean Color Real Brush Pens.

I always have a side project going on, meaning a painting I'm working on but never seem to finish; it's always in some stage of undone.

This is a longer project, but one worth inviting challenge! There are a few layers: sketching, painting, watercolor markers, and a lot of dry-brush texture. You will likely get bored with this one as you go, but don't beat yourself up for the feeling. It's natural to visually and emotionally tire of a painting. Put it away and revisit later.

For this project we'll be using a scrap of your favorite fabric to inspire a watercolor pattern. Feel free to follow along, using my fabric as your muse. I won't be copying the pattern necessarily, just using it as a general reference.

There are some key flower elements that I'll replicate with simple sketching techniques. Mechanical pencils are my go-to, because with them I'm guaranteed a forever-sharpened point.

We'll be sketching a series of leaves, flowers, buds, and swirls. If you'd like to practice some of these shapes ahead of time, feel free! Just a reminder before we begin: don't get caught up in the idea of copying your inspiration fabric exactly.

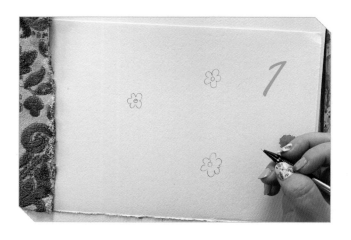

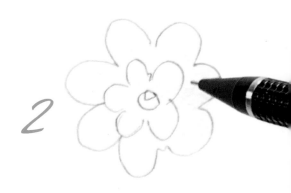

1 >> Start with light pencil lines, creating a very rudimentary, cloudlike flower silhouette. Sketch a few cloud flowers across the page. (Odd numbers look best in a composition, so try 3, 5, or 7 flowers.) Add a small circle in the middle of each.

2 >> Now sketch another slightly larger cloud flower surrounding the very first drawn here.

3 >> Now create a zigzag line on a curve. Repeat just under the first. Re-create the zigzag leaf in several spots on your page.

ART FOR
JOY'S
SAKE IS
UNDONE

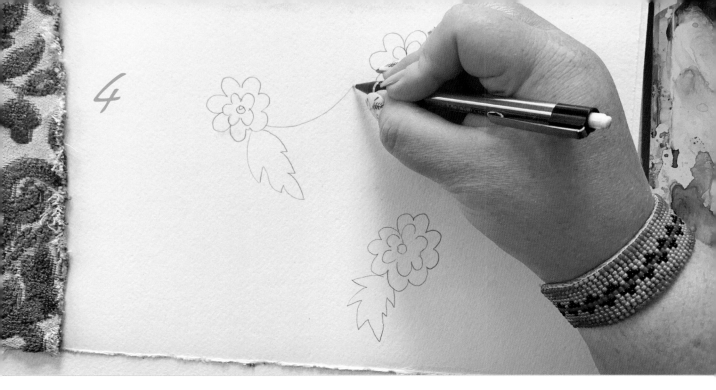

4 >> Next, draw a lazy U curve and another just ⅛ inch below. Now you have the beginnings of a stem. Create a few more U curves radiating from the original as a way to connect one flower to another.

5 >> Let's start sketching a larger flower. Draw two petal shapes side by side.

6 >> Sketch a few upside-down hearts radiating from the center, and then cloudlike silhouettes around the inverted hearts.

7 >> Repeat a cloudlike silhouette about a quarter of an inch above the one you just drew.

8 >> And to finish, another cloudlike shape with three bumps on top. Feel free to erase some of the connecting lines to give this flower shape a more seamless feel; also go ahead and add a small, round center.

9 >> Add a few leaves radiating out from your new flower. Consider deviating from the teardrop shape a bit, adding in a few dots, zigzags, and curves as you sketch. When I'm creating a pattern, I like to keep all of my marks away from the edges. So, in other words, I don't sketch any elements that just disappear off the edge of the page. If you ever get into creating repeat patterns, you will thank me.

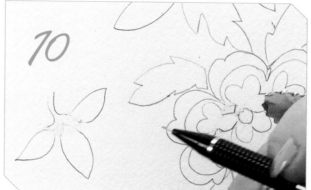

10 >> In the bottom left-hand corner of the pattern, let's create a side-view flower. Start by sketching a teardrop shape in the middle, with two on either side. Sketch a small stem at the base, connecting the three teardrops.

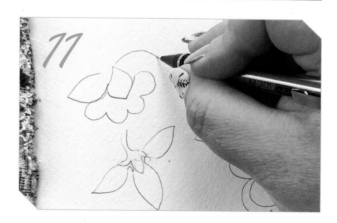

11 >> Sketch another cloudlike flower with two large bumps and two small bumps, and three teardrop leaves underneath. Add a small stem to finish, plus a few curving leaves that will start to connect these seemingly random flowers on the page.

12 >> Add a few more cloudlike flowers to the composition, very much like the first three we sketched at the beginning. Add more dots if you see fit. Add vines to connect one flower to another and start adding additional smaller flower silhouettes.

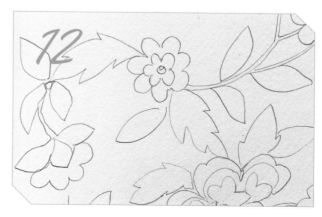

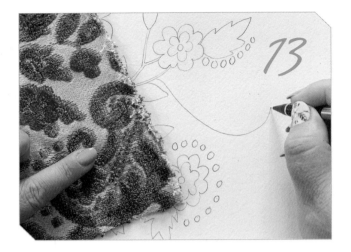

NOW IS A GOOD TIME TO STEP BACK AND EVALUATE. DECIDE WHAT'S NEEDED NEXT.

13–15 >> We definitely need some work in the upper right-hand corner. I'm going to add a big curve that I see in this fabric here. Add three or four teardrop shapes to the tip of your curve, descending ever so slightly in size. Add a small accent curve angling away. Feel free to add additional teardrop shapes and accent curves as you see fit.

Let's add another curve in the upper left-hand corner; also add some teardrop shapes and accent curves wherever you would like. Creating these flourished curve sketches is incredibly relaxing and enjoyable. I invite you to explore your creative license here.

I've said it before and I'll never stop saying it: don't feel compelled to fill the entire page; don't overwhelm yourself! I'll add one last curve in here among the flowers and leaves, but scaling everything down to suit the surrounding elements.

16 >> Add a few more leaves at the top middle, then a few more dots. Last, at the bottom right, one last small cloud flower.

I'll start the painting portion of this with a wet-on-wet technique. Start adding clean water to the page atop the pencil marks, using the broad side of your brush. Use a lot of pressure; you really want to fan those bristles! Perfect coverage on the page at this point isn't needed, so leave some dry areas if you wish.

17 >> Load your brush with a very soft peach and a lot of water. Let's paint into the background very softly while the page is still wet. Add a touch of yellow if you like, and keep moving around the page. Use the long edge of your brush with pressure to cover a lot of area quickly.

18 >> Load up a muted green onto your brush. Mix any old green with a bit of purple or touch of brown to produce a

muted green. Start dabbing green on the page. Allow bleeding to happen. Continue to work with the same green throughout. I'm trying to somewhat replicate the look of a piece of fabric that has limited colors of thread, but if you would like to introduce more color here, feel free at this stage. Now that the first washy layer is done, let things dry a bit.

Using the same green to fill the leaves and vines, I try to stay inside the lines for a more neat appearance overall, but moments of expression that lead to a few marks outside the lines never hurt anyone.

The look you're going for here at this stage is soft and dreamy, nothing too detailed or specific yet.

>> As you work, be careful of where your hand rests, so that you don't transfer paint from your hands to the page. <<

The painting looks really interesting right now. I think to myself, "Gosh, I could stop here and be happy." If you're feeling that, then stop and enjoy that moment and call your painting done. Don't ever lose sight of the good that's right in front of you in anticipation of what might be better in the future.

19 >> My fabric has golden yellow, a reddish burgundy, and a beautiful muted blue. Let's start with the blue. Mix any blue with a touch of peach or orange. You'll suddenly have the perfect muted blue. Now your page is dry, so we're using the wet-on-dry technique. After you have your first cloud flower painted, while the flower is wet load

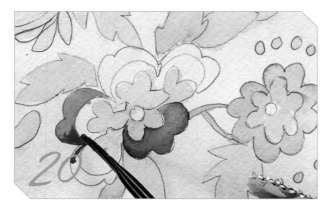

a contrasting blue and dab into certain areas throughout the flower. If any areas feel too heavy, use a dry, clean brush to lift out any splotchy or dark moments. Or drop some clean water over the top and watch everything smooth out naturally. Add more shades of blue or even a peach for a bit of fun!

20 >> Now let's move on to the burgundy. You may have something already in your palette, or just mix a good amount of red with a bit of green. We'll again paint wet on dry and drop in unexpected color or clean water here and there for interest.

Continue to add the burgundy color on any flowers you would like.

21 >> Mix a golden color and paint a few flowers wet on dry. Add touches of brown or purple to the bright yellow, wet on wet. Don't panic if paint goes outside the lines. We'll be adding texture soon with small, detailed strokes, and all of those "imperfections" will disappear.

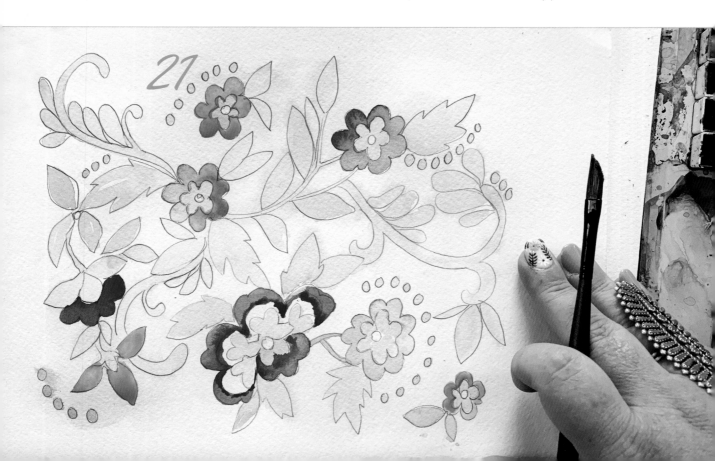

Go back into the green and start adding additional layers with the short side of your brush. Add an olive green as you work in areas with simple, haphazard strokes. The ultimate goal is to casually replicate the texture of this fabric, so we don't need these strokes to be perfect.

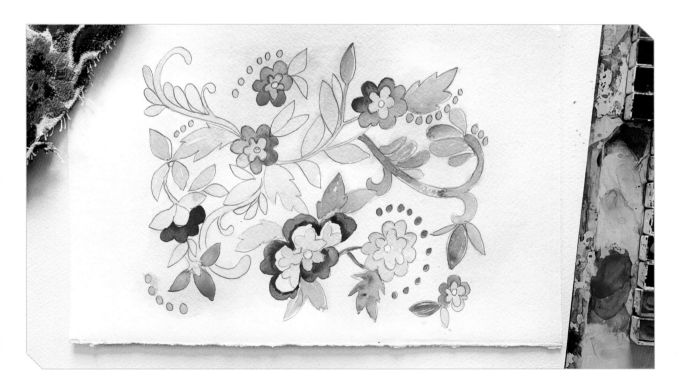

Now it's time to add fine detail. This is where we create the feel of textured fabric. We're not after a photorealistic finish, but the end result will be super interesting and definitely convincing.

I've chosen colors from my collection of Zig Clean Color Real Brush Markers. There are many sellers online where you can buy individual markers, so investing in a set isn't necessary, and so I'll list the ones I'm using below in case you want to pick them up. If you don't want to invest, try a sharp watercolor pencil, colored pencil, or even graphite.

Zig Clean Color Real Brush Markers used:

No. 35 Deep Blue
No. 24 Wine Red
No. 43 Olive Green
No. 67 Mustard

No. 71 Flesh Colour
No. 41 Light Green
No. 63 Ochre
No. 45 Pale Green

1 >> Start with the olive-green marker and create a variety of small dots and dashes along a leaf. My marker is essentially bouncing along the page, with varying pressure. These markers function very much like watercolor on a brush but with more precision in many cases.

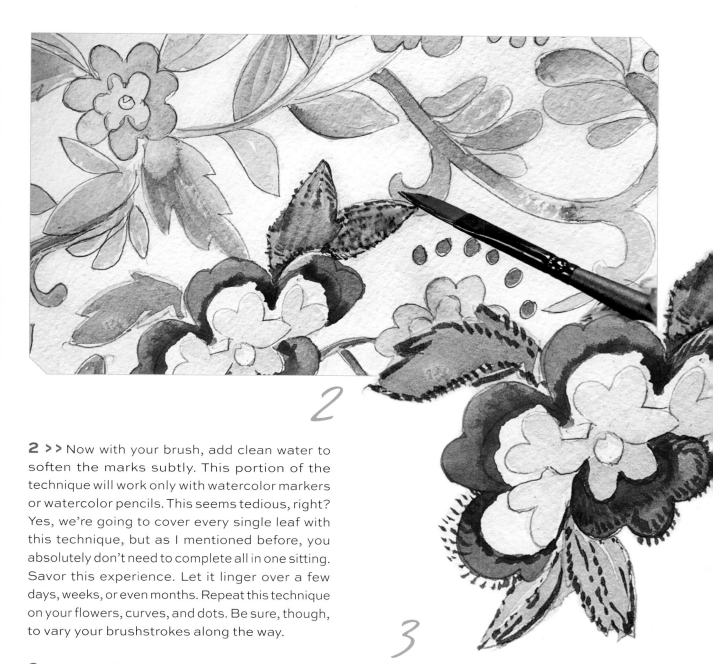

2 >> Now with your brush, add clean water to soften the marks subtly. This portion of the technique will work only with watercolor markers or watercolor pencils. This seems tedious, right? Yes, we're going to cover every single leaf with this technique, but as I mentioned before, you absolutely don't need to complete all in one sitting. Savor this experience. Let it linger over a few days, weeks, or even months. Repeat this technique on your flowers, curves, and dots. Be sure, though, to vary your brushstrokes along the way.

3 >> Now grab the peach marker. We'll use this throughout the background. Starting from the edge of a red flower, stroke down with the marker as far as color is still obvious on the page. The peach marker literally pulls red flower pigment down into the pattern's background. If you're not getting enough color from the downstroke, add more red to the edge of the flower and then continue. What results is a textural ombré of colors.

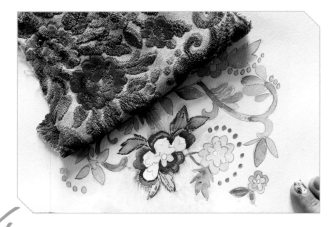

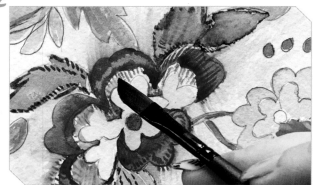

Use this technique around your green leaves, as well as pulling some of the green color down into the peach background. Continue with the peach marker, scrubbing in more background color. Load clean water on a brush to smooth out and spread the background color around.

4 >> Now, using a golden marker, add shadow and interest to this focal-point burgundy flower.

5 >> Start adding in some randomly placed cross-hatching. Crosshatching is essentially thin lines placed next to one another, and then that same grouping of thin lines is repeated at a different angle over the top of the first. This texture really says fabric to me in an unexpected way. Remember, this project is more about creating your impression of the fabric, not replicating it.

6 >> One of my absolute favorite watercolor marker colors is an indigo blue. It's fantastic for creating dark, rich texture and shadow pretty

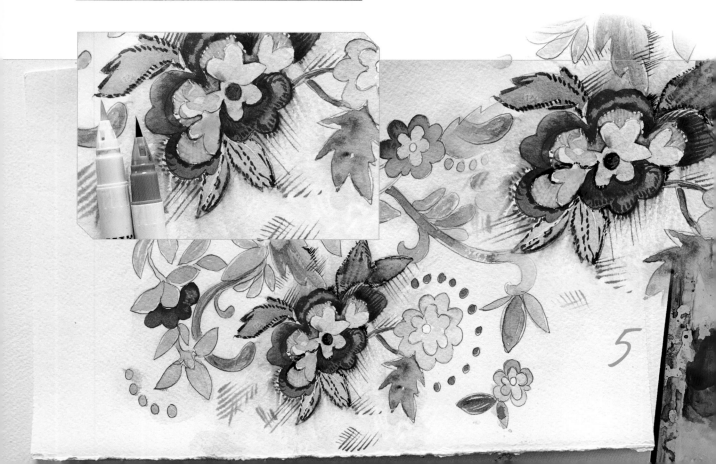

much anywhere. I wouldn't suggest outlining necessarily, since I feel that will take away from the soft feel of the fabric we're trying to capture, but it's perfect for going into areas throughout, dabbing, dotting, and adding interesting contrast. You can easily go overboard with this addition, so keep the pressure light and don't go overboard.

Continue these techniques over, around, under, and in between every nook and cranny of this composition until you're happy. This stage of the painting can feel rhythmic, peaceful, and intensely cathartic.

6

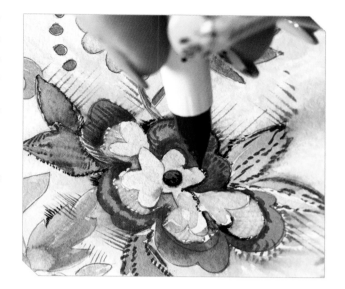

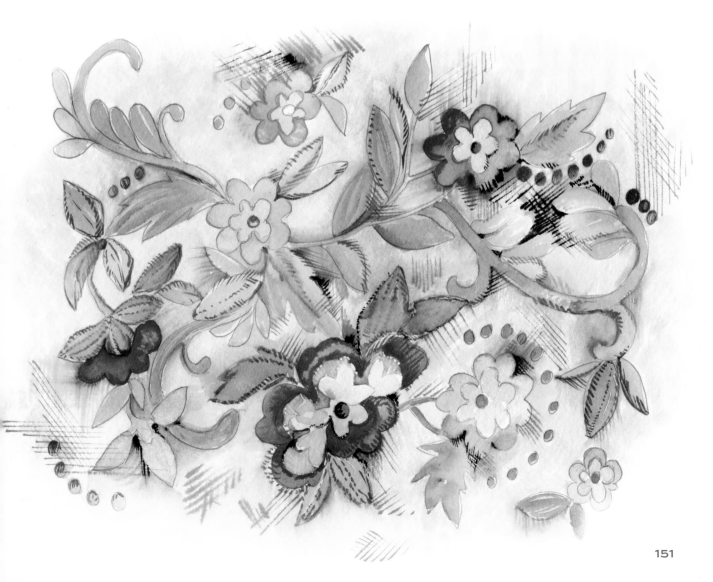

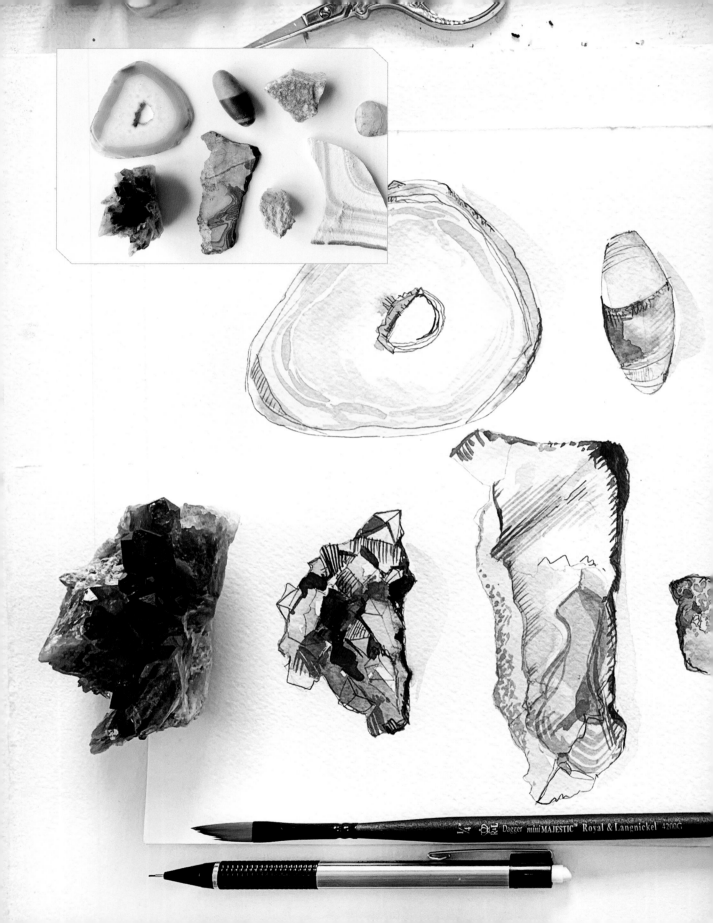

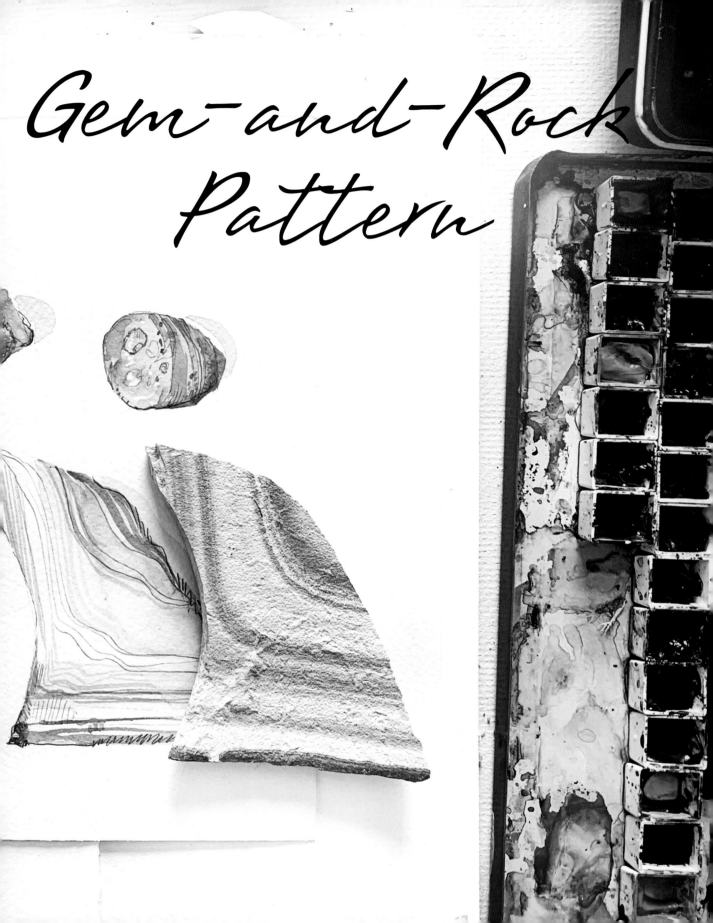

Gem-and-Rock Pattern

Before you begin, head to page 162 to see my finished pattern. I'm purposely not revealing too much in the photos of this chapter. My descriptions are detailed, and you'll see how the painting unfolds in photos, but with fewer visual steps revealed. Now, don't get angry with me; I promise there is a method to my madness. You are here; you've come this far because you said yes to big tries, and even bigger fails. You've seen successes on the page and are starting to understand the secret to this whole painting thing . . . right? Every time you sit down to paint, you're taking a risk. You risk disappointment and frustration, but with great risk comes great reward. You have everything needed in your hands, mind, and heart, right now, to be successful. Sooo, get ready to fill in the blanks I've left for you!

Watercolor rock-and-gemstone patterns are so incredibly popular but at first glance can be really intimidating. For this project I've chosen a variety of rocks, gemstones, geode fragments, and an agate slice. Don't feel like you need to go out and buy something specific; you can literally use what you find at home. A collection of interesting everyday rocks is all well and good.

As a more stress-free way of starting this composition, I decided to trace the bases of each rock.

Hold the rock in front of you and, while constantly looking back and forth from rock to paper, sketch in some of the identifying marks or lines that you see.

Think about the following as you decide what marks to make:

 How is the rock shaped; does it resemble something else?

 What lines do I find most interesting? How can small circles, dots, and dashes work to create a convincing texture here?

Sketching Chart

I know we haven't covered sketching in much detail, but if you can make a variety of marks with a brush, you can also do that with a pencil!

1 Straight lines repeated to create a sense of direction and shading

2 Curved lines repeated to create volume

3 Small irregular shapes sketched in a group to indicate texture

4 Compressed zigzags for shading

5 Crosshatching to create dimension

6 Uneven typographic lines repeated to add interest

7 Haphazard x's close to one another adds shading and texture

8 A combination of dashes, dots, and squiggles to create shadows.

Feel free to embellish as you work. For this project the pencil lines will ultimately be seen in the finished piece.

1 >> Now to add color! We'll be using a wet-on-wet technique. Start with the agate, loading your brush with a golden or ocher color. With the short side of your brush, add marks around the perimeter of the slice. At the very middle, add darker-brown strokes to resemble shadow. Load a bit of burgundy

on the tip of your brush and dab in some very subtle accents, using a wet-on-wet technique.

2 >> Let's move on to the next stone to the right, using the wet-on-dry technique with the short edge of your brush. The lighter area of this stone resembles coffee with a lot of milk. Use this color or even very watered-down, muted blues to create shadows.

ART FOR JOY'S SAKE IS KNOWING WHEN IT'S TIME TO JUST BUY THE TUBE OF PAINT!

>> *Cobalt turquoise will change your life. You know I'm all for being resourceful and using affordable materials, but there are just some colors that simply cannot be mixed, and cobalt turquoise is one of them. Go get it.* <<

3

4

3 >> Moving on to the next stone, add wet-on-dry pink washes with the broad side of your brush. A touch of dirty purple from the corners of your palette is a wow accent color here.

4 >> And now the turquoise! Select a turquoise blue from your palette. Or mix a blue with green and even a bit of yellow to create the classic southwestern color. Paint the turquoise stone, dabbing a touch of green and yellow here and there.

5 >> Now on to the smoky quartz. Wet the page in areas, but not all, before painting dark browns, grays, and even a touch of reddish brown. Avoid any overly harsh lines at this stage. Don't be afraid to leave white space.

6 >> Next, onto the sandstone. Start with a few sandy tones in the stone—rusty pink, peach, brown, and various amounts of water on the brush. Follow the pencil lines, painting with the tip and short side of the brush. Really soft and subtle

5

peach tones will be your friend here. Keep working around the rock, adding touches of pigment. Wet on wet, dry, and damp will all happen here, so clear your mind of which of the three to use. Dab a bit of peach and rust color here and there . . . nothing terribly defined at this stage.

7 >> Next, another bit of turquoise. Paint a soft greenish blue with the wet-on-dry technique. Flood in a bit of green and brown.

8 >> And finally, the last piece of sandstone. Add peachy colors with the short or broad side of the brush (or both). Dab in touches of pink, using the wet-on-dry technique. This stage is really about getting just a little bit of color on the page, nothing terribly intense. But if you're feeling the need to add strong color at the bottom of this rock now, go for it!

9 >> Now it's time to add some definition with pencil. I'm looking for the dark areas on the rocks to indicate where I should add simple scribbling, scratching lines to indicate a shadow.

Refer to the graphite-mark-making chart on page 155 for ideas as you work.

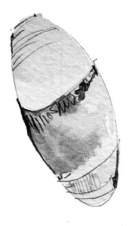

With more jagged rocks, try scratchy scribbles or crosshatching to define edges, shadows, and shapes.

On the smoother rocks, make softer, repetitive pencil lines to indicate striations.

Continue using various marks with your pencil to add shadow.

Press hard for a darker mark.

Let's start adding a bit more detail in each rock with watercolor. Using the very tip of my brush, I paint around the perimeter of this agate slice with varying thicknesses of stroke. I'm using a muted golden color.

1 >> Load your brush with a blue-gray color and a lot of water to define the agate slice's center. Obviously this slice isn't blue, but the color makes sense for a shadow.

Using a medium brown with some water, add a broad stroke or two at the middle of this oval stone. Add linework on the right side, using hints of darker color along the entire right edge Use shadowy color from the crevices of your palette. Load your brush with clean water and make a simple stroke down the length of the rock, adjacent to the darker color just painted. Smooth together the two.

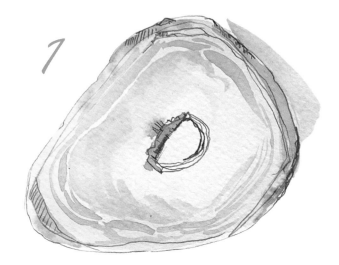

2 >> Load up your brush with a muted pink and start dabbing brushstrokes. Vary the intensity of these marks with varied pressure. Use an up-and-down dabbing motion, painting many imperfectly shaped dots right next to one another. Add a touch of blue or dark purple or a mixture of the two on for depth. Remember that you can always use a drop of clean water to smooth any areas feeling too heavy.

3 >> Load up your brush with a turquoise color. Using the short side of your brush, start making long, linear marks in the direction of the turquoise stone's shape. Load up the very tip of your brush with a bright, intense blue and just dab along the bottom edge of the rock.

4 >> Load your brush with a dark brown and just a touch of red, going into the center of this smoky quartz. Make some small square marks with the short side of your brush while trying to preserve the previously sketched crystal shapes. Along the right side, use a dark pigment. Mix together blue, orange brown, green, and red to produce a beautiful, rich, dark color that isn't necessarily black. Dab in some contrasting brushstrokes right along that edge.

>> I use a lot of linear marks in painting. I like to think of topographic maps to better explain this technique. My brush + soft color + undulating thin lines, varying widths from one another that follow the object's contour, can create dimension, voluminous shape, and unique textures as I need them. <<

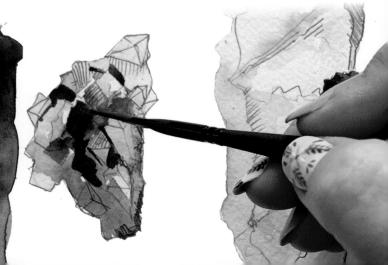

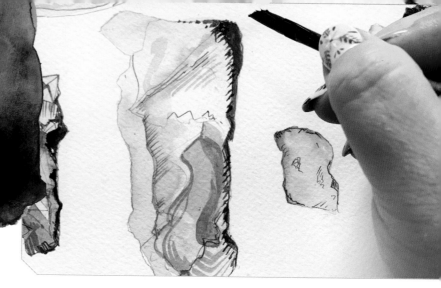

>> As with most things in life, simple is often best. To keep your painting fresh, stop just before you think you're done. Take a step back from your painting from time to time to gain some literal and figurative perspective on how to proceed next. <<

5 >> Load your brush with a rusty orange, nothing too bright, so feel free to add in a touch of blue to tone things down a bit. Consider adding purple to create an intense rusty-orange option. Using the tip of your brush, along the right edge define the strong shadow with a dry-brush technique. Add subtle linework to just the shadow toward the center of the rock, using more short and quick marks. Continue adding shadow along the top of your stone and along the left edge, creating dot groupings to suggest a sandstone-like texture.

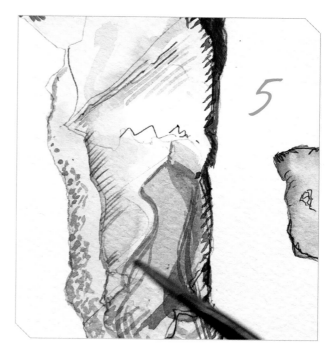

6 >> Mix or choose a medium turquoise. Using the tip of your brush, add texture marks to mimic shadows of the rock's darkest places. Load the tip of your brush with a medium green and repeat in the green areas of the rock. This is a small stone, so we don't want to overdo it. Get in, get out, be done. Load an intense blue on the tip of your brush to suggest a touch of shadow along the bottom-right corner. Next use a light yellow, dabbing a bit into the rock, then rinse the brush and load it with clean water to finally smooth.

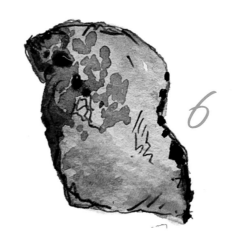

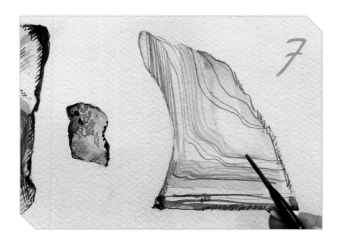

7 >> Load or mix a soft pink. If you don't have soft pink, just use red with a lot of water on your brush. Using the very tip of your brush, add some very thin strokes throughout to mimic the rock's striations. Remember to keep looking back and forth at your rock or inspiration photo, not in an attempt to copy but just to keep your mind fresh with subject matter details. Change up your brush color when the rock color changes. Now paint along the bottom here with a more golden color and then a bit of purple. Remember to vary the width of your strokes to keep things interesting and fun. Follow the contour of the rock. Rocks like these are so interesting and beg to be painted.

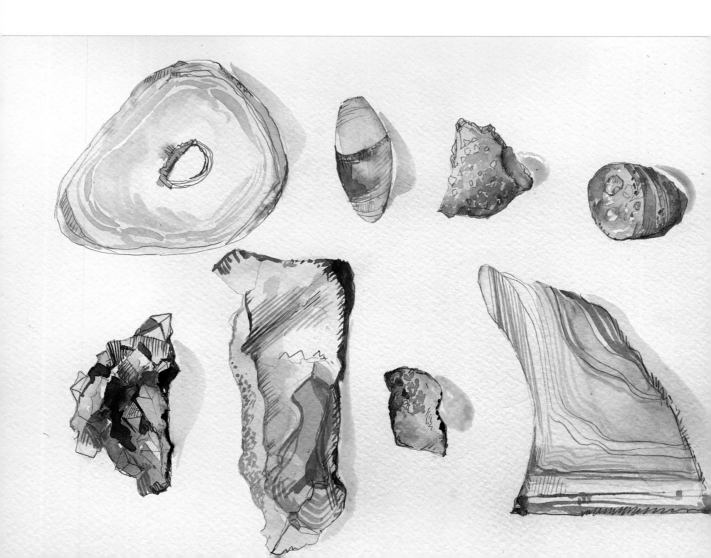

This is a great time to take a step back, give it a look, and see how you feel about things. Want to add more detail, more pencil? I think everything looks really good; I just want to add in some actual painted shadows. Mix a touch of blue with a lot of water, and next to each rock add subtle shadows. The stroke you'll use here is similar to painting a leaf. If you're not sure how to place the shadows, just take a look at the actual shadows and follow. Adding shadows to certain paintings like these can be fun, especially if you post your work on social media. What an amazing trick of the eye.

There are countless ways to approach any of the projects in this chapter. Perhaps you envision this composition, but without pencil lines? Or perhaps painting first, pencil lines last? Love it. Love it all. In fact, I started without pencil when first envisioning this chapter. Thought a peek at my first try (below) may inspire your next painting!

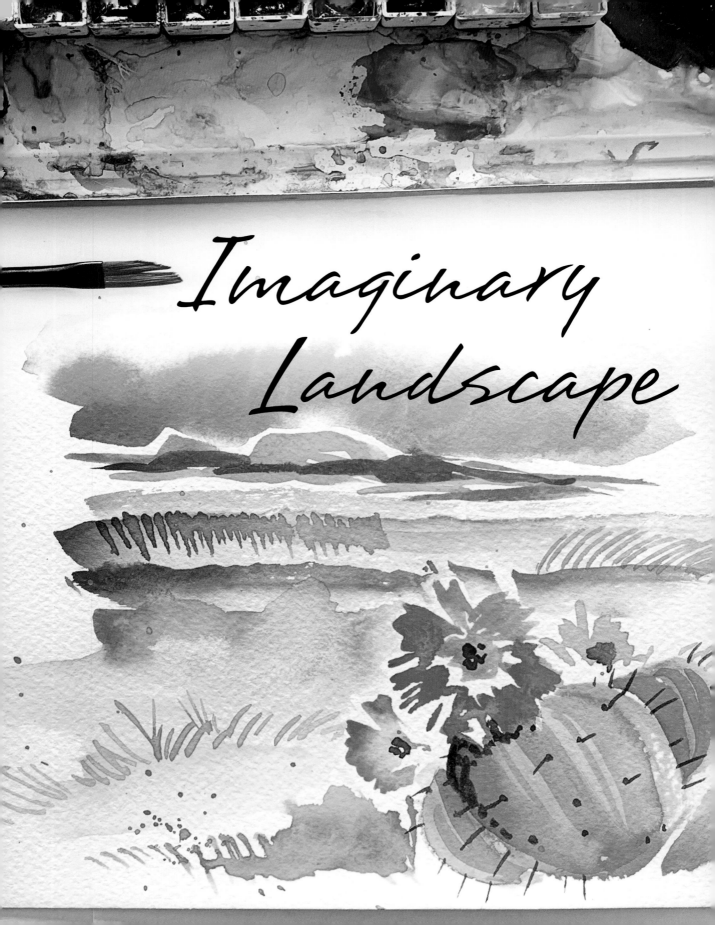

I want you to think of your favorite place in the world. Pull up a few photos of that place . . . soak them in. Notice details in the foreground (very front of the photo), the middle ground (very middle of the photo), and the background. Do you see mountains, rock formations, fields, rolling hills, a sunset? Absorb what you're seeing for a few minutes, but then put the images away. Yup, buh bye!

As we start to paint, I don't want you attempting to replicate the photo. I want you to use the photo as a little bit of creative insurance as we dive into painting an imaginary landscape.

One of my absolute most beloved places on earth is near Zion National Park in southern Utah. And so here we'll be creating a southwestern red-rock landscape of sorts in the very foreground. We'll add splashy, juicy desert flowers and greenery. Feel free to follow along with me first and then create your own vision next.

1

1 >> Let's start with a bright orange on the short side of the brush. Paint, with light pressure, a southwestern-style mountain. Just a few marks to suggest the horizon line and a few more strokes rising from the horizon will do the trick. Mix a touch of purple and orange and, with the tip of your brush, add a few accent marks around the right side of the mountains.

2 >> Let's move right into the foreground now. It just feels right! Use the broad side of your brush loaded with a favorite green. Press down and drag the brush upward, curving just slightly. Repeat this green stroke about 2 inches away from the first. We're creating a cactus pad here. Finish with a third stroke in the middle, then use clean water to blend all strokes together. Feel free to flood in some interesting colors as you smooth. Using the short edge of your brush, paint a simple pink "textury" flower. Use a zigzag motion around the center. Let's add another flower, a bit smaller, peeking out from the side of the cactus. Now add a third flower in pink.

2

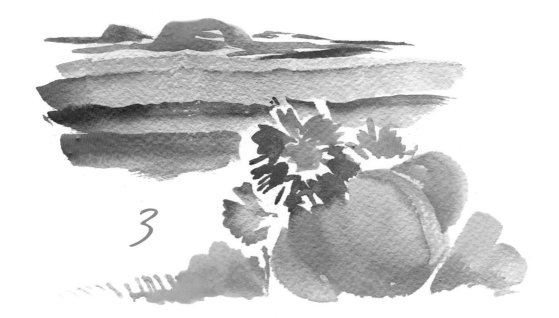

3 >> Let's add a suggestion of additional greenery up in the foreground, using the short side of the brush. Use a variety of greens and yellows here, along with your favorite linework details. Now it's time to add some interest to the middle ground. Using a dusty green (green and a bit of pink or blue), make some horizontal stripes just under the mountains. Vary your pressure so each stripe has its own character and personality.

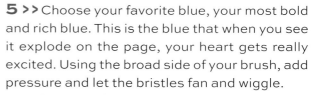

4 >> Let's add some soft yellow to the area just above the cactus, just a soft, juicy wash to fill the space. Use a soft yellow with a lot of water on the brush. I'm purposely leaving a little bit of white space around paintings for some little breathing room on the page.

Now let's tackle the sky. With a clean brush loaded with clean water, paint a cloudlike area in the sky.

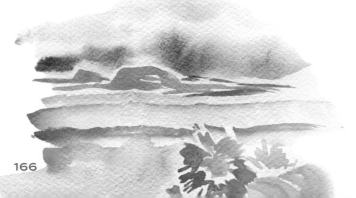

5 >> Choose your favorite blue, your most bold and rich blue. This is the blue that when you see it explode on the page, your heart gets really excited. Using the broad side of your brush, add pressure and let the bristles fan and wiggle.

Rinse your brush and add a clean stroke of water above the blue to soften and bleed out the color into white.

6 >> Load your brush with a bright green and then a bit of dark green on the tip. Add some contrast detailing to the edges of each cactus.

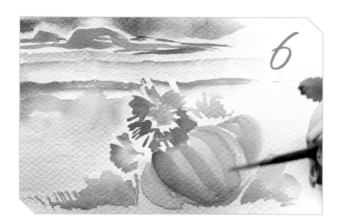

7 >> Add some linework into the main cactus. The obvious choice would be green, but feel free to try something completely wild and out of the ordinary.

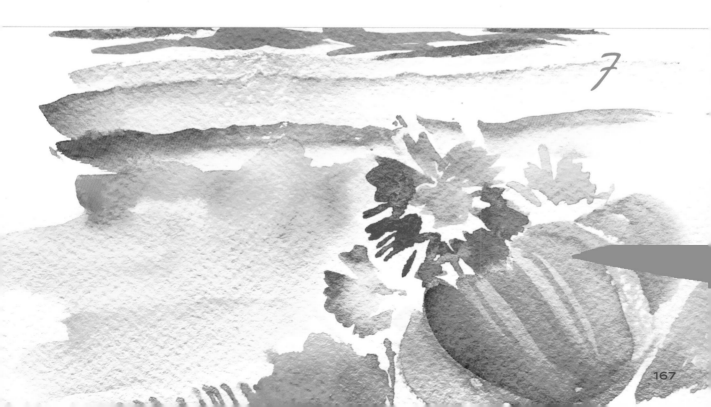

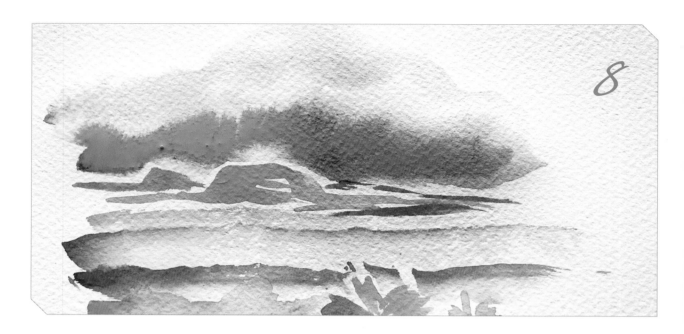

ART FOR JOY'S SAKE IS TRUSTING YOUR MIND'S EYE.

8 >> The sky is still wet, so let's take this opportunity to add more blue intensity there. Dab in extremely saturated pigment and let it blend and smooth naturally. If your sky was dry, just rewet it with clean water first, then dab in the additional blue.

9 >> At the very bottom of the middle ground, add some yellow-green hints of grasses. Just some texture elements that one might see out in the desert, and yes, there is grass in the desert!

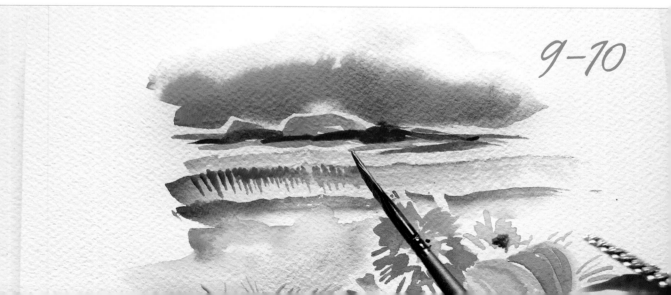

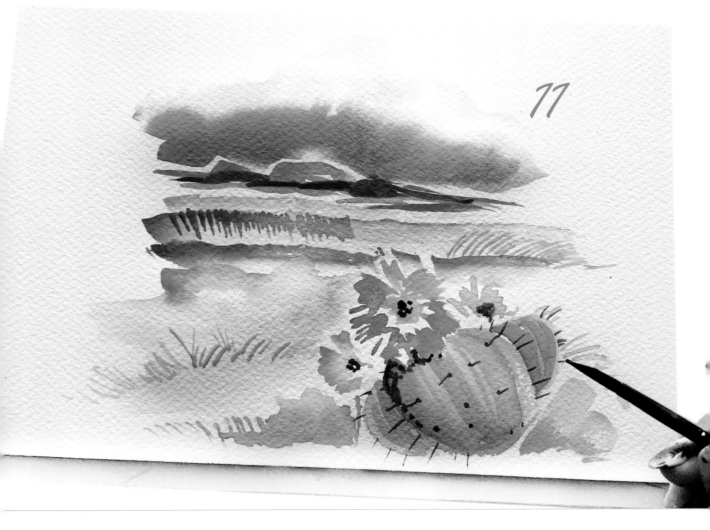

10 >> Let's go ahead and define those mountains in the background. Mountains in the distance often take on a blue, purple color. This is called atmospheric perspective. And while prickly pear cactus blooms don't have black centers, I'm going to add them here because it just feels right!

We're adding just a few casual strokes of an orange mixed with purple in the distant mountains. Use the short side and tip of the brush to add subtle details.

11 >> Continue to add linework throughout as you see fit. Additional detailing in the cactus, such as spines and dots, are always a favorite last-minute detail to add. Scratchy marks in the middle ground can suggest a distant field.

Fight the urge to overfuss this panting! It's feeling fresh and light, so time to step away.

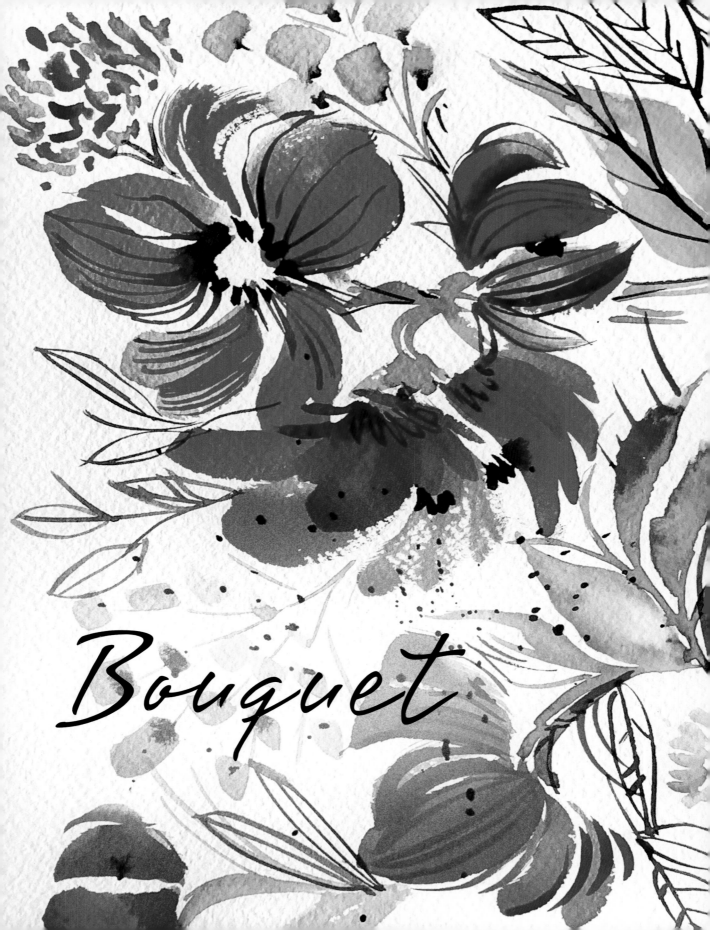

Bouquet

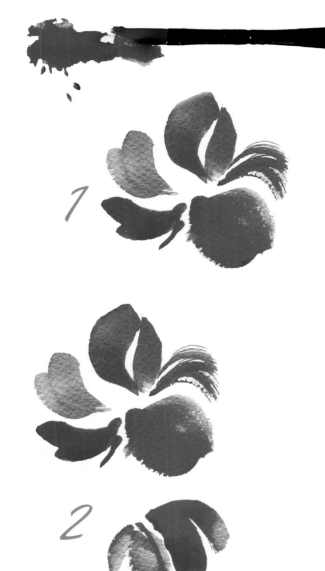

LET'S PAINT A FLOWER BOUQUET ART FOR JOY'S SAKE STYLE.

I'll be using a 2B pencil and my beloved dagger brush!

1 >> Load your brush with a lot of juicy red watercolor. Using the broad side of your brush, make a curved petal. Repeat and continue making curved petals next to one another. Some will be wider and curve upward; some may curve down. Load your brush with red and some pink.

2 >> Using the broad side of your brush, create another flower facing downward. Create big strokes; let the color run out as you paint, leaving the curious texture behind.

3 >> Using the short and broad sides of your brush, create more large petals to the left of the first two flowers painted. We're creating a side-view flower here, so just three petals are ideal. Curve your brushstroke upward a bit as you make the stroke.

4 >> Right now it feels messy. Don't worry, we're gonna bring it all together. Load your brush with your favorite green, whatever green. You know . . . the green that is nearly empty on your palette because you use it so much! Add a stem just below that first red flower that was painted.

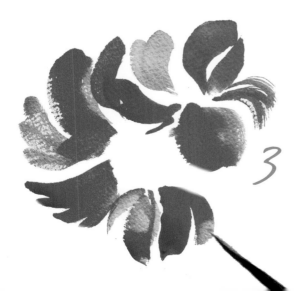

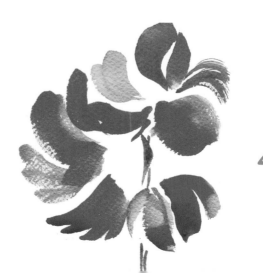

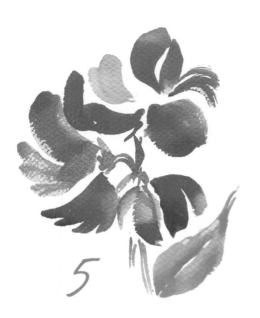

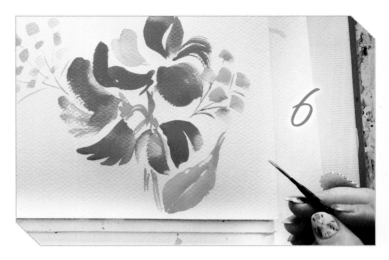

5 >> Then add a stem near the last pink flower painted, and add a stem near the second flower you painted. All will overlap and mingle with one another. Add a big leaf. By now you've painted enough leaves to own this and not need me!

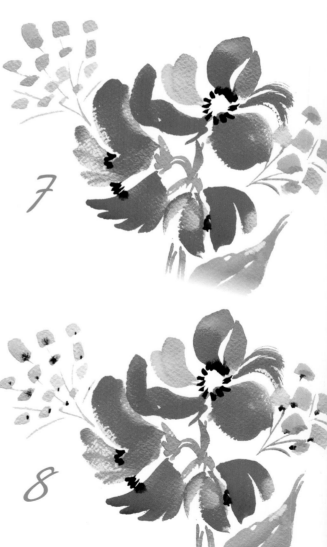

6 >> Let's now add peach square marks in a haphazard grouping. Then load up that favorite green again and, with the very tip of your brush, using barely any pressure, add very thin, very wispy stems. You will see some bleeding happen when the green hits that peach color. You love it, right??? Add another bunch of these peach blooms where your composition most needs them.

7 >> You're likely wanting to feel more progress on those first flowers, so let's go ahead with a deep, dark black. Make sure the red is dry before adding black. Let's add some centers on these beautiful flowers you painted. Create short marks right next to one another in a circle. Now just a hint of black in the very center of that downward-facing flower. Finally, a few black marks on the third flower you painted. Take a moment to revisit linework (see page 59) for a refresher.

8 >> Take a watered down version of that same black color on your brush and dab ever so lightly at the base of each peach square.

9 >> Load your brush with pink, and add another bloom in the bottom left. Create big strokes surrounded by curving smaller strokes. I had a bit of the black on my brush when I loaded up that pink, but it's all right. Add a few leaf accents.

10 >> Think about adding some wispy lines throughout the composition. Repeat colors you've used before, and maintain very light pressure on the brush as you work. I've introduced a bright red into the linework, but ultimately you should choose a color you love here.

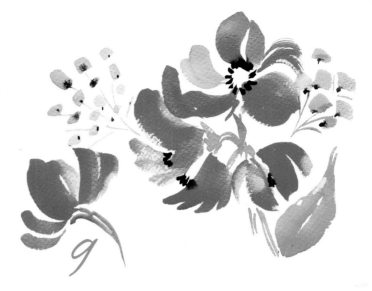

ART FOR JOY'S
SAKE IS COMING
BACK TO LIFE

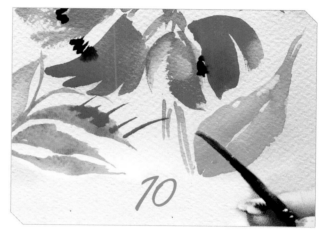

11 >> The first flower painted when we began is a perfect place to play around with linework. Start by defining the petals with very thin linework on each petal.

Are your black brushstrokes at the center of the flower painted earlier still wet? Good. Think about painting some strokes through the wet black areas, using extremely light pressure.

This is a great place in the painting to ask yourself, "What do I want to do here? What do I want to see happen? What will make me feel good about continuing to paint here?" My answer will almost always be "more linework!" As you continue, keep your hand loose; I always use my pinky finger to brace my hand on the page as I work. It gives me stability.

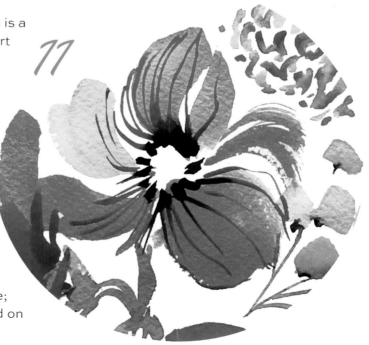

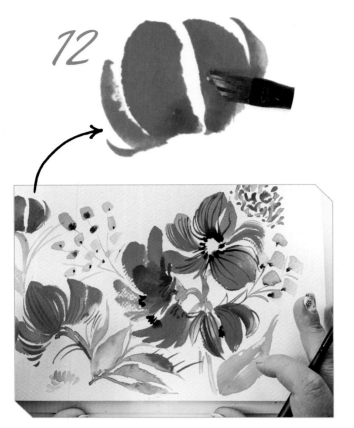

12 >> Load up your brush with equal amounts of a red and water. In the upper left corner, create a few strokes with good pressure, lifting up slightly so your strokes don't come to a point. Repeat to create a medium-sized flower. Add a bit of dark red at the bottom of each petal for contrast, allowing the wet on wet to do its thing.

With your brush loaded, see if there's anywhere else in the painting that you'd like to add linework. I'm thinking the flower petals in the bottom-right corner need additional detail.

13 >> Load your brush with a dark red and, using the tip, sketch added petals curving upward. You can sketch with your brush much like you would with your pencil. Add additional linework into the petals.

Things are looking pretty good at this point, but I do feel that the bottom left and bottom right corners need a bit of fullness.

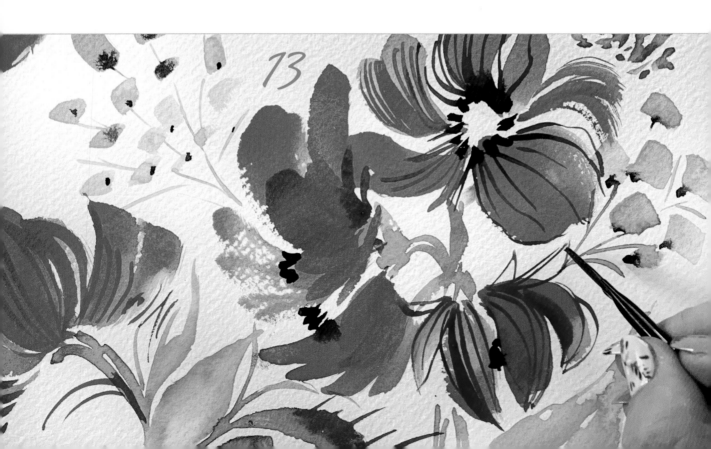

14 >> Load your brush with a dark green. Add linework to leaves near the bottom of the composition. Don't be afraid to take your linework outside the leaf's edge for added wow factor!

With the same green on the brush, add a few more leaves, but this time imagine you're sketching with your brush. Just using the tip of your brush, sketch leaves and stems to finally balance and complete your painting.

These will likely be the very last few brushstrokes you apply, so keep examining to make sure you've added the moments of interest you wished for this painting! For the final touch, I'm adding a bit of dark-green spatter.

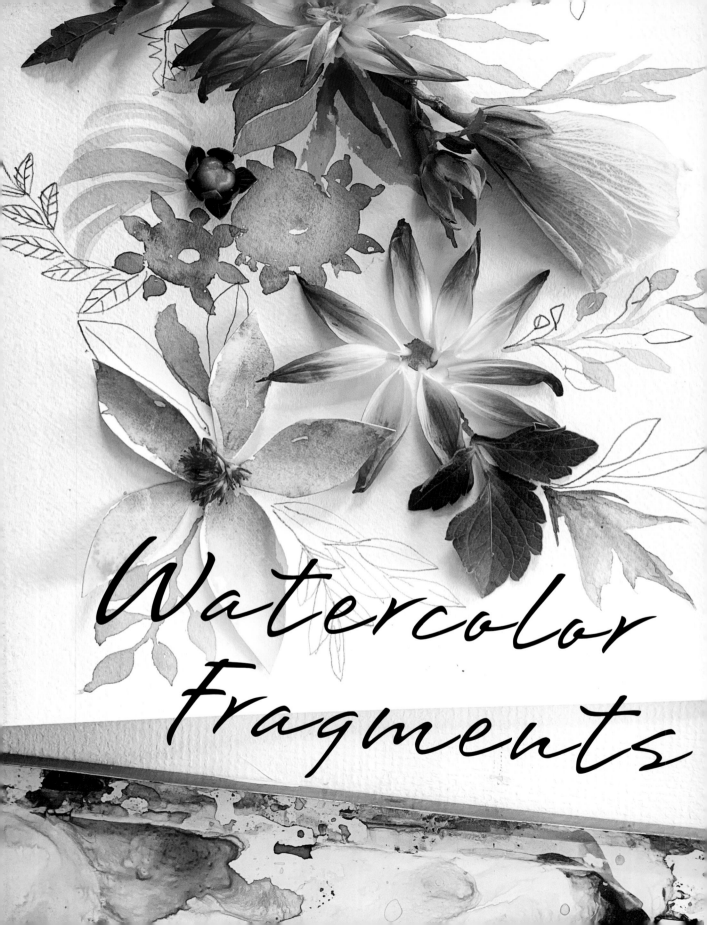

Watercolor
Fragments

*Three-dimensional, using
Mission Gold palette*

About two years ago I began creating these interesting compositions I call watercolor fragments, with fresh floral materials, torn paper, and paint on the page. A whole new world of art making opened to me by combining the two- and three-dimensional. If I'm in a creative rut, I can always rely on a watercolor-fragments painting session to revive me. And so I'd like to pass along this technique to you.

1 >> Start by choosing a selection of flower elements. A leaf pod, seeds, petals, flower stems, berries... Make sure you also have scrap watercolor paper on hand, because you'll be using it to create paper leaves and petals. A small pair of scissors is a wonder to have on hand, as well as a pencil for sketching.

At this point you're probably wondering, "Well, that's all fine and good, but what happens to this artwork after it's complete? Won't the flowers just die?" Yes, absolutely, the flowers will die, and so you'll need to photograph your composition. I'll also be covering how I take photographs and edit them for the best possible result. Now you might be thinking, "Why in the world would I want to create artwork that I can't keep?" But please, trust me and give this a try. There's something so magical about creating artwork that really only lives as you create.

You'll want to consider working on a flat board of some kind, so that you can transport your finished composition outside once complete, for photographing. Trying to manage live flowers on a sheet of paper without anything rigid underneath will be quite the challenge, and you could lose your composition in the process.

1

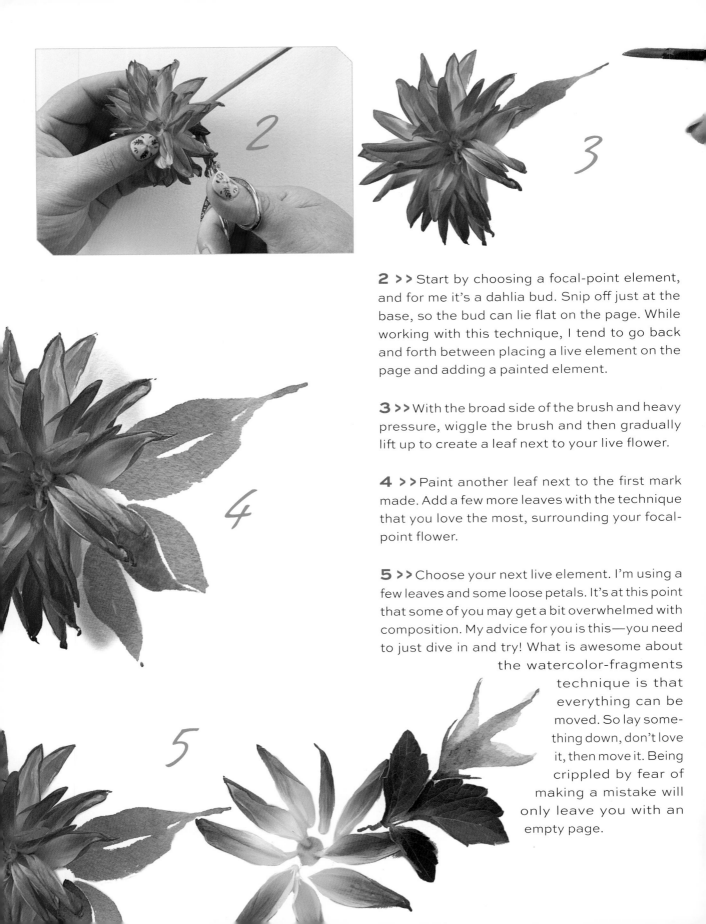

2 >> Start by choosing a focal-point element, and for me it's a dahlia bud. Snip off just at the base, so the bud can lie flat on the page. While working with this technique, I tend to go back and forth between placing a live element on the page and adding a painted element.

3 >> With the broad side of the brush and heavy pressure, wiggle the brush and then gradually lift up to create a leaf next to your live flower.

4 >> Paint another leaf next to the first mark made. Add a few more leaves with the technique that you love the most, surrounding your focal-point flower.

5 >> Choose your next live element. I'm using a few leaves and some loose petals. It's at this point that some of you may get a bit overwhelmed with composition. My advice for you is this—you need to just dive in and try! What is awesome about the watercolor-fragments technique is that everything can be moved. So lay something down, don't love it, then move it. Being crippled by fear of making a mistake will only leave you with an empty page.

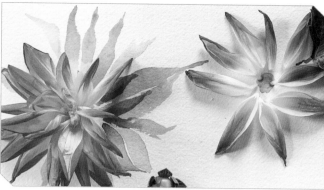

Always look for opportunities to juxtapose fresh elements with painted. This is a good place to add a few painted petals around your focal-point fresh flower. Continue adding petals juxtaposed with fresh until you are happy with the result.

6 >> I'm bringing back in several discarded petals to create a new type of flower. This work can be a bit tedious because we're not gluing down any of the fresh elements. We're literally placing them on the page and are trying our best not to sneeze or breathe too hard. LOL! Paint the flower's center, perhaps a peach color, and continue to place petals around the center. Don't be afraid to move already placed elements to make room for painting. Just bring them back to the composition when you're done.

7 >> Add a few painted leaves nearby the natural leaves that you previously placed on the page. Pay attention to where fresh elements and painted elements connect, and use linework to connect the live and painted in a convincing way.

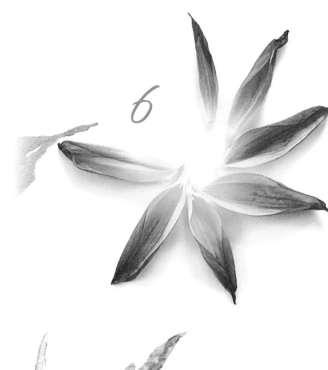

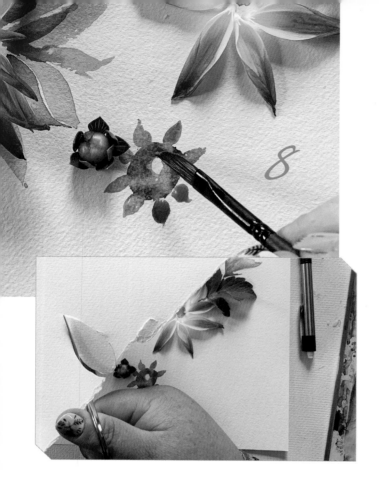

As you paint, think about ideas we covered earlier. Consider adding opaque or unexpected color here and there. What did you get most excited about earlier in this book? Decide and add these ideas to this painting. If there are any fresh elements not sitting flat enough on the page, you may need to snip more off the bottom to make it level.

8 >> Continue to add live and painted elements. Small buds are one of my favorites to add. Load your brush with a green you love. Make a lazy circle, with not too much pressure. Load up your brush with a contrasting green and dab around the edge of the lazy circle. You'll notice some bleeding of color, which is exactly what you're hoping for, right? Add a few leaves, using just the tip of your brush radiating from the bud.

9 >> Now for the paper blooms. Use scissors and scrap watercolor paper to cut out five simple, teardrop-shaped leaves. This should be quick and easy.

Each petal will look different, so don't get too hung up on identical petals.

ART FOR JOY'S SAKE IS MORE SEEING, LESS THINKING.

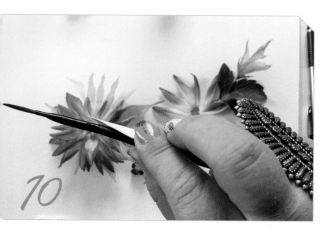

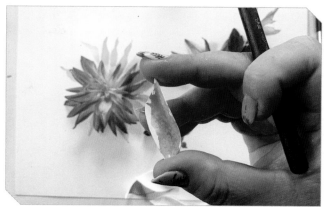

10 >> Take a pencil or brush and roll each petal slightly around the handle of the brush. Maybe just the tip, the side, or both sides of the petal can be curled.

11 >> Now let's paint the petals! Add a few simple wet-on-dry washes. No need to cover the entire petal.

Leaving a bit of white creates an eye-catching effect. Use colors you love. I'm going with bright pink and touches of peach.

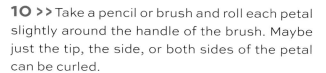

Since you're handling so many different types of elements, it's likely that you'll drop a brush or a bud will stain the paper. Don't let that derail you. A little stain or a splash can easily be covered up with the paper flower, a leaf, etc. As you continue your painting, think back to various ways we've painted leaves, flowers, and details in this book. Rally your confidence and know that you don't need me to dictate every mark you make!

12 >> It's time to start placing the petals into the shape of a flower. Don't be afraid if your new flower overlaps an existing flower on the page. In fact, I recommend layering when possible to give everything on the page a more natural vibe.

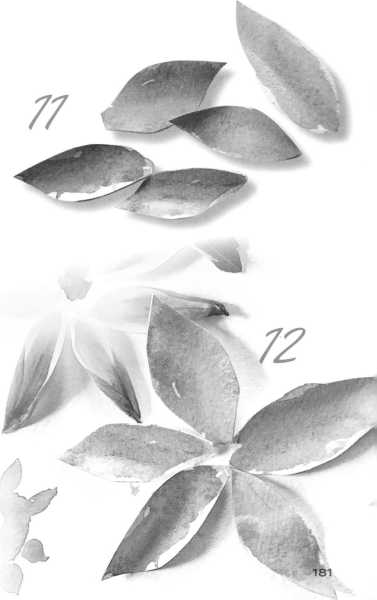

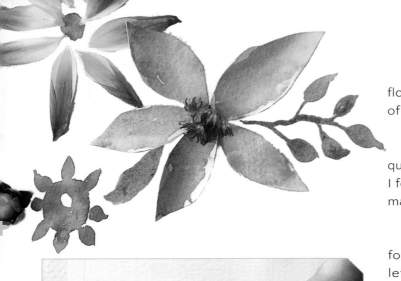

Now choose something interesting for the flower center—think a pebble, seeds, a gathering of dried bits, etc.

I can honestly say I've yet to find anything quite as satisfying as creating these compositions. I feel like a botanist, a botanical illustrator, and magician all rolled into one, and it's empowering!

Now it's time to examine your composition for lack of balance or empty areas. The upper left-hand corner has some empty space that needs to be filled, so let's start there. Take stock of live or paper elements left over. Try a few on the page, envision painted details, and, eventually, instinctively forge ahead.

Maybe it'll work, maybe it won't. As you play with different elements, don't forget that you can alter a flower, a branch, or whatever it may be. You can snip off leaves, trim buds, use cutting scraps for vine tendrils, etc.

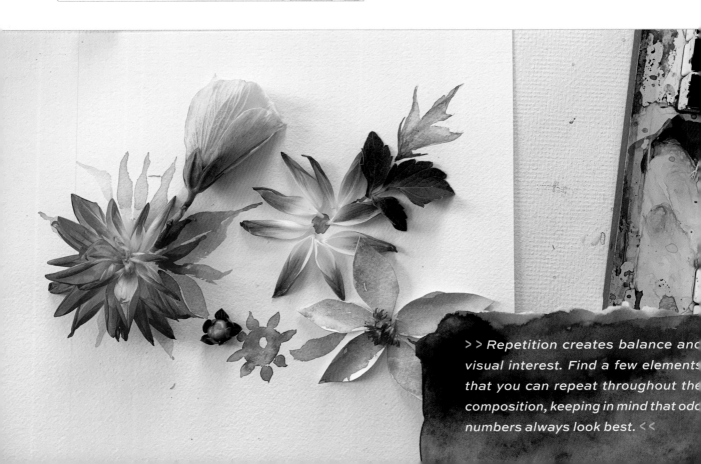

> > Repetition creates balance and visual interest. Find a few elements that you can repeat throughout the composition, keeping in mind that odd numbers always look best. < <

>> A small pair of scissors can be a great tool for nudging elements around on the page. <<

In the bottom left-hand corner, I'm adding three petals pulled off a flower earlier to create a side-view bloom. I'm also adding a leaf from the pink flower I was working with earlier. It combines perfectly with the stem I just painted. Make sure to add a bit of color to the stem, matching the leaf just placed on the page, for seamless effect. Yes, that is right: you can add paint to the live elements!

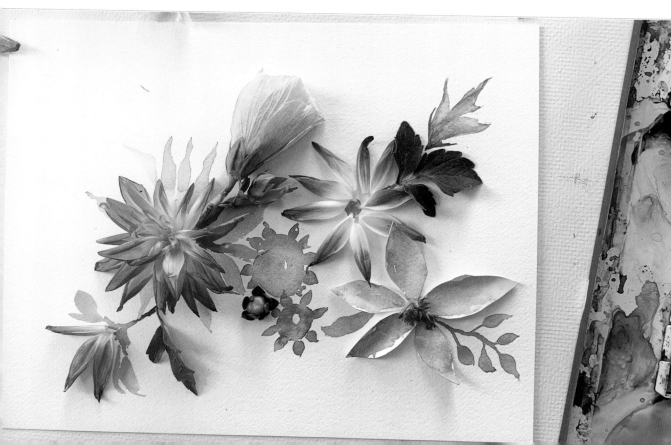

PENCIL SKETCH CHART:

To create the final pencil sketches for this painting, I used a few simple marks: arches, almonds, dots, and dashes. Re-create this chart for a quick warm-up before accenting your project with pencil.

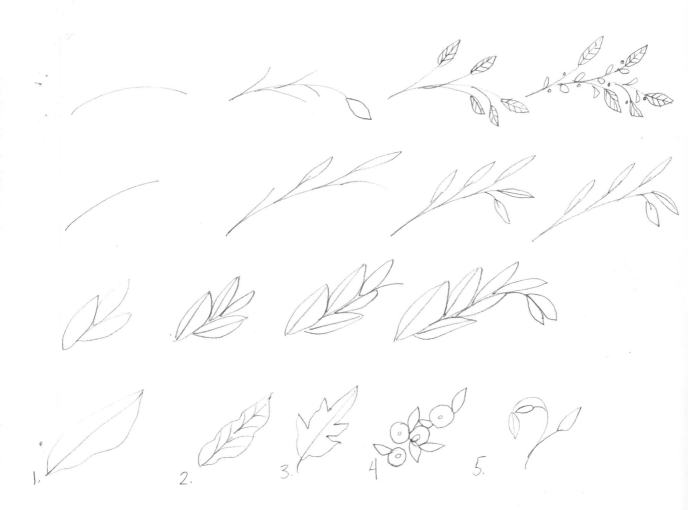

For a fun finish, let's add some pencil sketches throughout. Think about your pencil just like you would your brush. Don't panic if you've never really sketched before, because if you can paint you can certainly sketch. Just add a few simple leaves here and there. A teardrop shape is all that you're after!

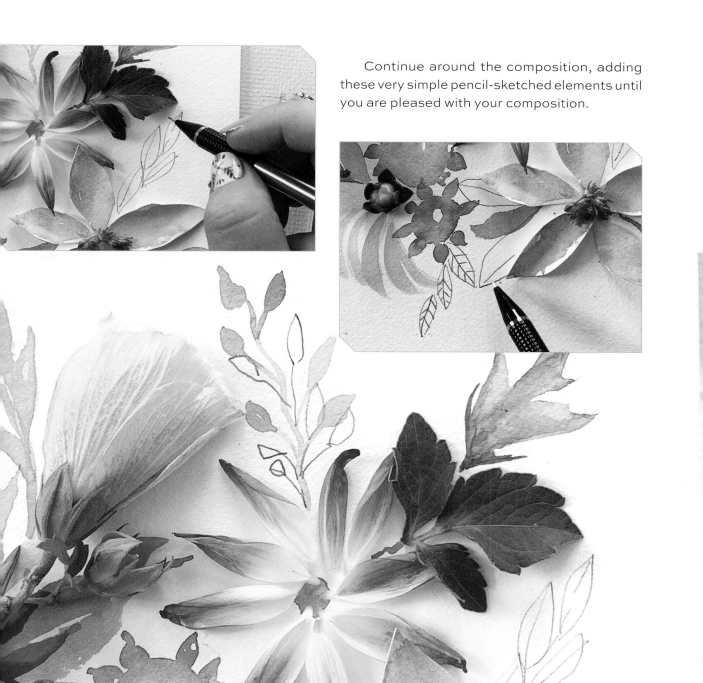

Continue around the composition, adding these very simple pencil-sketched elements until you are pleased with your composition.

Good news! You have a few hours to add or change your painting before these flowers start to wilt and die. So by all means, step away for a time and come back to see if you'd like to add any last details before taking your final photograph.

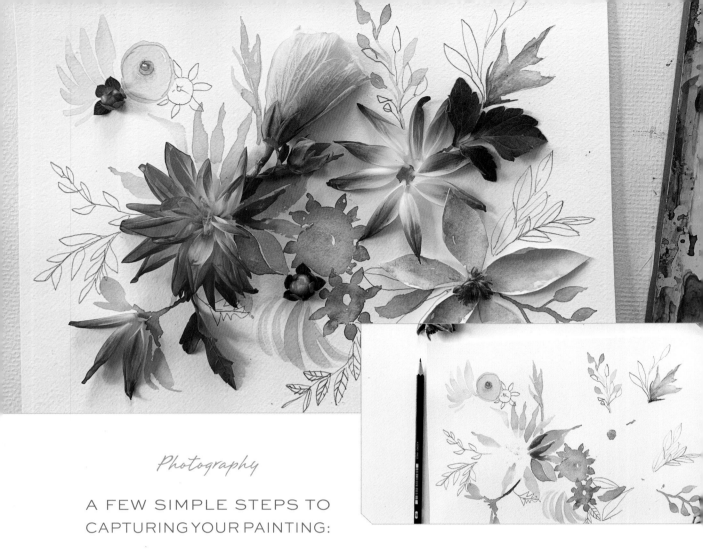

Photography

A FEW SIMPLE STEPS TO CAPTURING YOUR PAINTING:

 Stand up. You'll be capturing your painting from above. Stand up or even stand on a chair to get far enough away.

 Ensure your camera is held just above the painting, perfectly parallel.

 Daytime is best. Position yourself near a well-lit window or head outside to a shady spot.

 No flash, ever!

 Edit with your phone's basic editing tools. I usually add a bit of contrast, a good amount of brightening, and a smidge of sharpening.

>>*Once you've removed the wilting blooms from your page, save it! What's left is the beginning of a new painting.* <<

Kristy Rice's personal obsession with paint and paper has evolved into an innovative brand, Momental Designs, which garners global attention from media, celebrities, and some of the world's most creative individuals and iconic brands. Rice's style has been featured in *People*, *OK!*, *The Knot*, and more, and her designs are featured at places like T.J.Maxx, Papyrus, and Bed Bath & Beyond. Along with a team of inspiring women, Kristy continues to innovate in the worlds of styling, stationery, design, and art licensing. Kristy lives with her husband, Adam; son, Isaac (Izzy); daughter, Irie; and lots of furry friends on a 40-acre retired farm near extended family.

About the Author